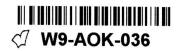

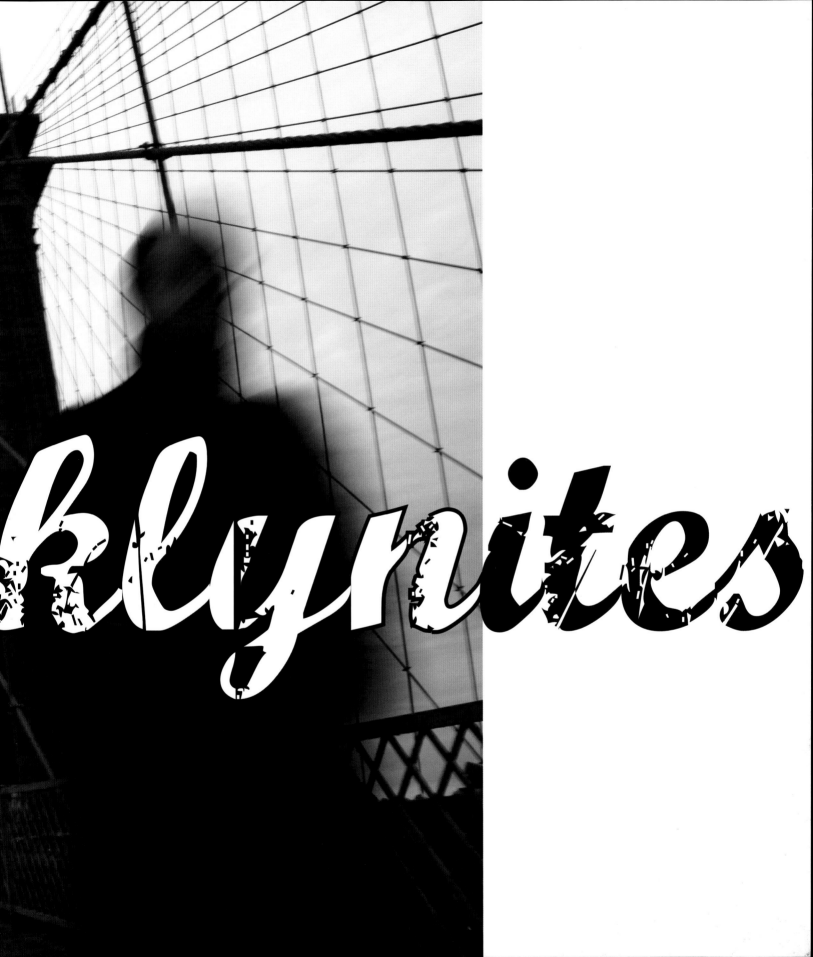

bklynites

SETH KUSHNER ANTHONY LASALA

 powerHouse Books, Brooklyn, NY

guy. I was down in Virginia on vacation recently and someone asked me to say something in Brooklynese. So I said 'Give me your wallet.'" Dick Velde

'People from Brooklyn—if you don't know them they can be the coldest people out there. But if you get to know them they are the best people on earth. The best. You know what I mean?"

Yoel Judah

"We know that we are special and that everywhere else is just, well, not as equal."

Marty Markowitz

'When the Brooklyn Dodgers won the World Series in 1955, it was like Christmas, Chanukah, New Year's and the 4th of July all rolled into one."

Ron Schweiger

"And while the cost of living is high here, it's sort of like the cover charge. You pay 40 bucks to get into a great theater or a great club. You pay $800 a month to get into Brooklyn. Membership has its privileges."

Craig Finn

"If I leave my apartment any time early in the morning, any day of the week, the street corners and bodegas are lightly filled with Dominican, Puerto Rican, and a few Cubano elderly. All of them speaking Spanish softly to each other. It's 100 degrees out, they still have long pants, and their guayaberas on, and all the while they are calling 'Buenos dias' to one another from across the street—I love it."

Grace Villamil

Everybody from Brooklyn, I don't care what part they from, I swear they just the shit. We came

"I wake up on a Sunday, I walk to 13th avenue to get a bagel, I don't need a car. What more do I need?"

Mike DeBernardo

"I used to know this guy I lived near that was 72 years-old and had never even been to Manhattan. I asked him why one day and he said 'What for?'"

Tim McLoughlin

"The first time I came to Brooklyn it was love at first sight. It was an epiphany. It was a place I could not believe existed. I decided to move here and haven't looked back."

Michael Showalter

"Brooklyn is the conscience of New York. While Manhattan tears everything down and changes everything, Brooklyn tries to do a similar thing, but fails miserably at it. It is a crazy quilt of a place. A mongrel place of sorts. It mixes old and modern in a haphazard way. It represents a tiny microcosm of the world—a functional utopia."

Jonathan Lethem

"There are so many fucking weird people here. And they only get weirder. It is a land of characters."

Johnny Temple

"You know you are from Brooklyn when your car costs $500 and your sound system costs $2,500."

Danielle Smollar

"Growing up in Bed-Stuy prepared me to live anywhere in the world. I can go to fucking Palestine right now. Seriously."

Garnett Thompson

Preface

Wherever I go, whatever city or country I'm in, whoever I meet—they know someone, they have a friend, a relative, an uncle, or a cousin who's from Brooklyn. It's happened to me so many times that I'm sure I could make a convincing argument that civilization began not in Africa, but somewhere near the intersection of Flatbush and Nostrand Avenues.

No other place you can mention elicits that spark in people, that flash of recognition and understanding. Tell someone you're from Brooklyn and they immediately know what that means. Brooklyn is attitude, chutzpah, swagger. Street smarts, a wicked sense of humor, and a certain toughness. When Sinatra sang "If you can make it there, you'll make it anywhere," this is the New York he was talking about.

I was walking in Coney Island with a friend one time and a small group of tourists asked us which subway they should take to get to the Empire State Building. "What do I look like?" my friend asked, "The fuckin' mayor?" The tourists were appropriately horrified and slinked off. "What the hell did you do that for?" I asked my friend. "Are you kiddin', they expect that kinda shit. Now they can go back to Kansas or wherever

the hell they're from and tell their friends they met a real Brooklynite." Thank God there's a lot more to Brooklyn than people like my idiot friend.

There are the trees of Prospect Park, the boats in Sheepshead Bay, the beauty of the Botanic Garden, the majesty of Grand Army Plaza, Coney Island in summer, Green-Wood Cemetery in winter, the Academy of Music, the subway, the street fairs, and an endless array of churches, bridges, and brownstones. And oh my God, the food! Pizza, knishes, meat pies, zeppole, pierogi, bagels, jerk chicken, Nathan's hot dogs, Junior's cheesecake, a ribeye from Peter Luger's; if you can eat it, you can get it here.

But of course at its heart Brooklyn is really about its people. Without them, it's just a massive expanse of flat, "broken land," as the Dutch called it. Our alumni range from Arthur Miller to Jackie Gleason to Lauren Bacall, Woody Allen to Barbra Streisand to Jackie Robinson, Carl Sagan to Pete Hamill to the Three Stooges (if you count Shemp instead of Larry.) Artists, criminals, writers, captains of industry. The blue collars of the construction workers in Marine Park, the white collars of the executives in Cobble Hill, the dog collars of the freaks in Williamsburg.

In *The Brooklynites*, Seth Kushner and Anthony LaSala give us an intriguing look at these people, a small cross section of a city of millions, in some ways the same and yet all completely different. All inhabiting the same city at the same time, yet no two having exactly the same experience. Every religion, every country on the planet, every subculture you can imagine is represented here, and somehow we all manage to coexist. The Brooklyn I love is the greatest and truest example of the American Experiment that ever has or ever will exist—and to live here is to know that it works.

Terence Winter

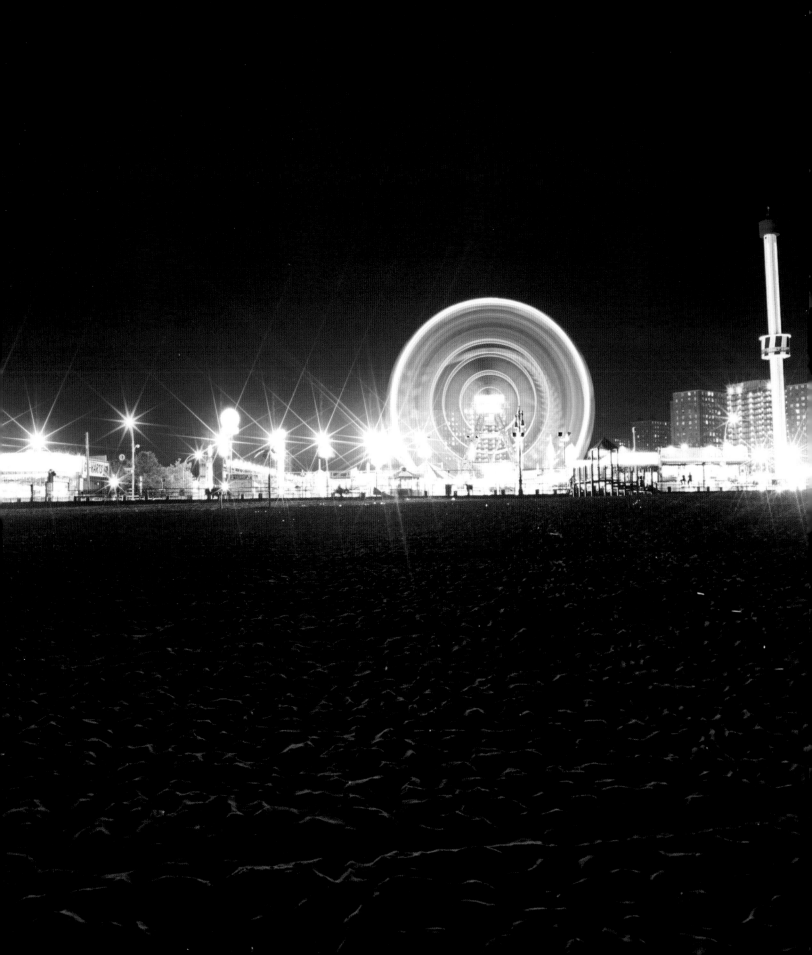

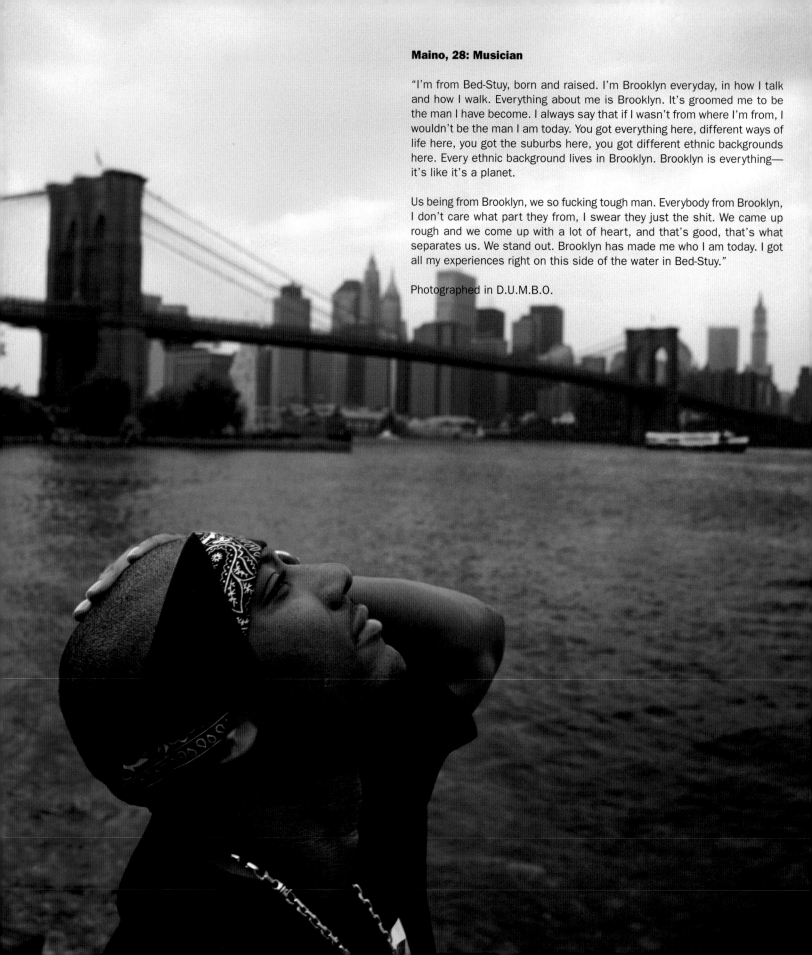

Maino, 28: Musician

"I'm from Bed-Stuy, born and raised. I'm Brooklyn everyday, in how I talk and how I walk. Everything about me is Brooklyn. It's groomed me to be the man I have become. I always say that if I wasn't from where I'm from, I wouldn't be the man I am today. You got everything here, different ways of life here, you got the suburbs here, you got different ethnic backgrounds here. Every ethnic background lives in Brooklyn. Brooklyn is everything— it's like it's a planet.

Us being from Brooklyn, we so fucking tough man. Everybody from Brooklyn, I don't care what part they from, I swear they just the shit. We came up rough and we come up with a lot of heart, and that's good, that's what separates us. We stand out. Brooklyn has made me who I am today. I got all my experiences right on this side of the water in Bed-Stuy."

Photographed in D.U.M.B.O.

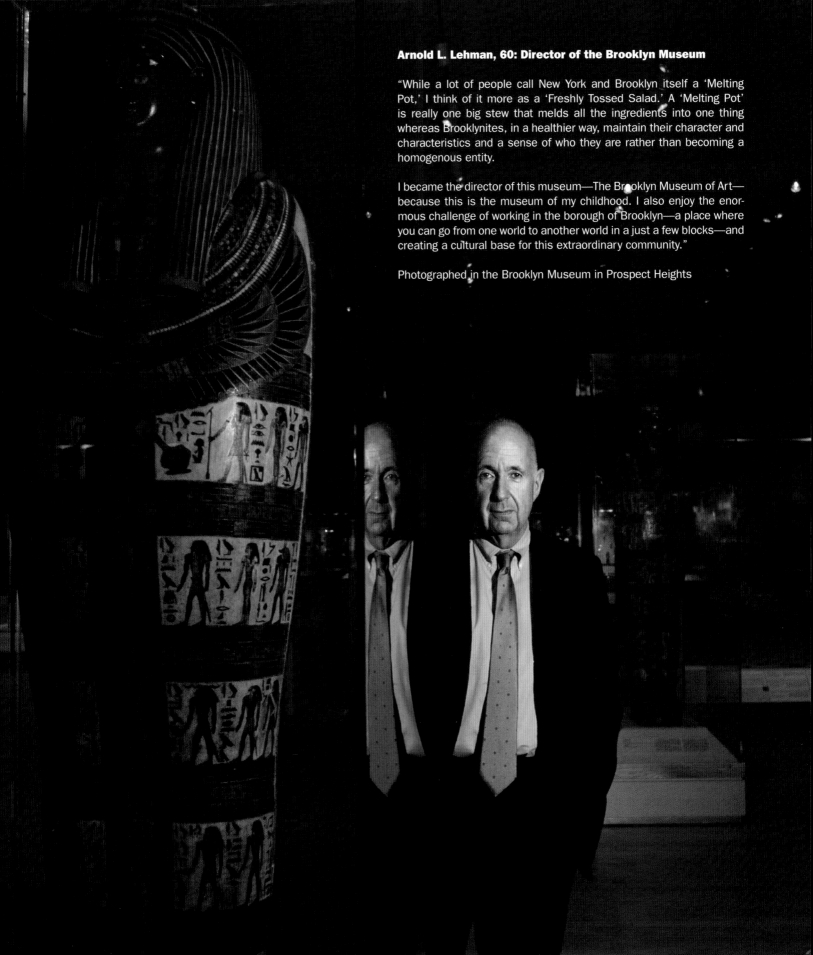

Arnold L. Lehman, 60: Director of the Brooklyn Museum

"While a lot of people call New York and Brooklyn itself a 'Melting Pot,' I think of it more as a 'Freshly Tossed Salad.' A 'Melting Pot' is really one big stew that melds all the ingredients into one thing whereas Brooklynites, in a healthier way, maintain their character and characteristics and a sense of who they are rather than becoming a homogenous entity.

I became the director of this museum—The Brooklyn Museum of Art—because this is the museum of my childhood. I also enjoy the enormous challenge of working in the borough of Brooklyn—a place where you can go from one world to another world in a just a few blocks—and creating a cultural base for this extraordinary community."

Photographed in the Brooklyn Museum in Prospect Heights

The gaping heavens. Wide open and yawning.

For all the talk about how the city of Brooklyn is a place where the sinewy roots of a nation grew, it's the sky that you first feel when you enter this borough. Driving over rivers, exiting the dimness of the subway on cracked stone stairs—you enter and it's as if someone took an infinite, finely honed silver scythe and lopped off the concrete and steel to take back the firmament. Here you can sit and feel the weight of light and clouds. Here you can watch thunderstorms approach, leaves twisting upwards in an electric pull, the limbs of the black clouds jangling down towards the earth like the legs and arms of marionettes. Here an enormous cathedral of sky broods each day, like a massive pestle,

crushing the ingredients and rituals of hundreds of cultures into a mortar made of tar, grass, trees, and iron.

And within those cavernous spaces there exist the breathing stars of Brooklyn—not celestial bodies (New York City, after all, is its own star—a place that ignores the heavens and cast out those flashing beams from its sky decades ago), but tribes of people and their words. Millions of people, from hundreds of places, with billions of ornate stories. If the energy of stars is generated by thermonuclear reactions, the power of Brooklyn is developed in the bellies and vibrating vocal chords of its inhabitants. In their endless stream of words and tales and thoughts that burn tiny holes in not only your mind, but the very fabric of the world around you—smoldering within the cracked sidewalks, the tightly parked cars, the crooked stoops and the tilting trees.

With this project, we wanted to sever Brooklyn. This place is our fable. Our myth. Our addiction. Our crush. We wanted to get beneath the facade, the name, the stories, the reputation, the place we grew up in. We wanted to find out who the people were and what they loved, hated, and added to this historic locale. What we found was a place that is even more than its illustrious repute.

Brooklyn is first and foremost a labyrinth of ethos. A place that brims with the other. With handfuls of footsteps you traverse continents—and we sought them all. We traveled everywhere, seeking a piece of each neighborhood. A taste of everything. We hunted

the familiar and the foreign. The landmarks and the veiled. From the promenade in Brooklyn Heights—Brooklyn's own front porch—to the edges of Brownsville and East New York along the imaginary border with Queens. From the faded colors of Coney to the skin-and-bone ledges of Greenpoint and Red Hook and Sunset Park, where salt water does battle with the barriers of Brooklyn and where trolley tracks awaken through tar, like extended childhood scars.

We also searched for every type of person. People who lived here, left here, worked here. Old and young. Every culture. We wanted each and every tribe of Brooklyn. All their habits in all their habitats. All their emotions—in words and expressions.

Asking people about this place was nothing short of fascinating. Some people were born to tell stories—their tales rupturing through their lips and into your ears in infinite surges. With some it took only a few minutes of comfort. A slight nudge, a small pluck, and levees would break—fables would flow. Other people were hesitant to speak—their sagas and legends wrapped up tight in paper and string, deep within their stomachs, their eyes the only thing conveying words. Their stories, we hope, came through in their portraits, not their quotes.

For a number of people, their descriptions for this place were not kind. They hated the noise, the crowds, the prices, the parking. They longed for larger spaces, cleaner air, a change of scenery. They mourned the loss of their own people moving away to different neighborhoods, others taking their place. Corporations replacing Mom and Pop, stadiums being built, simplicity being drowned by waves of development.

But for most, the words were positive. Almost everyone pointed out the sense of community, the variety of people, the range of foods, the sense of nostalgia. Everyone mentioned how people all over are connected to it—how one of seven Americans has ancestors in Brooklyn. And everyone, whether they embraced or rejected the borough, spoke with passion. People here have their opinions. There is no middle of the road in Brooklyn.

And when you ask people in Brooklyn what it is that is special about living here, about knowing here—when looking into their eyes, their gestures—you can tell there is something more to being a Brooklynite. Something inherent and hidden. And how do you explain that something more?

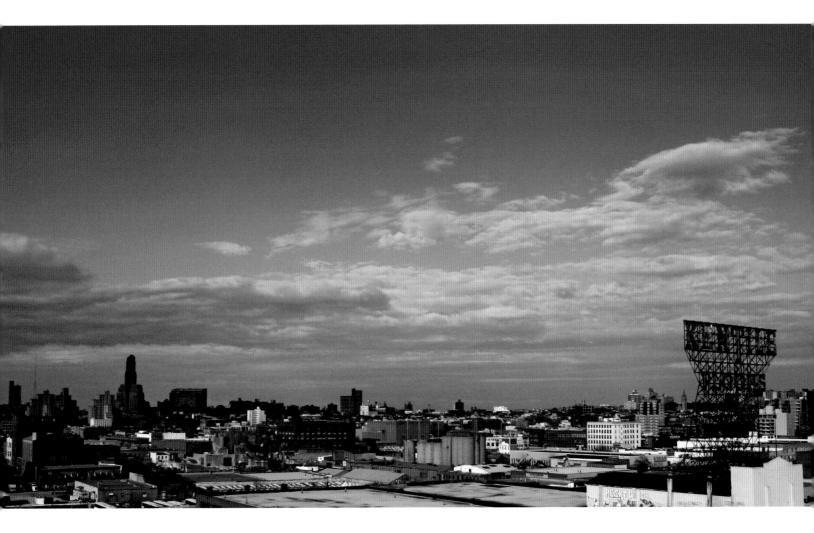

Well, it's sort of like when you're from here, or when you live here for a number of years, you are taught this really amazing magic trick. It's the most incredible trick anyone has ever seen. Better than levitation, better than making enormous objects disappear. And the knowledge of this magic—the mere fact of knowing it—is as powerful and fulfilling as anything you will hold inside you for the rest of your life. It's your trump card forever hidden in the folds of your sleeve.

This project was no easy task. Each time we interviewed one person, five more came to our attention through that subject. Each time we photographed a place, we unearthed ten more that we hadn't covered. Some of the most remarkable people and places are not in this book at all. And we can already hear the screams of, "What about this place?" and "What about that person?" But Brooklyn is such an enormous creature. It is a constantly moving entity with no true center. At times we felt like two explorers moving through constellations of strangers, trying to examine a galaxy with a magnifying glass and a notepad.

And there were so many journeys. Journeys within journeys. We always seemed to be rushing somewhere or sitting in stillness listening and looking. Rushes and pauses. Rushing to meet Spike Lee when we could not find a parking space in Fort Greene. Pausing to listen to the stories of Paula Fox in her beautiful Carroll Gardens backyard. Rushing down 4th Avenue as the Williamsburg clock tower mocked our belatedness. Pausing in a sidewalk Bed-Stuy café to chat with a local woman about the architecture—she later secretly bought us lunch. Rushing through the streets of "Little Odessa" to catch the last bits of light drift over the fur coats on the Brighton Beach boardwalk. Pausing inside a tiny motorboat, listening to miniature waves somewhere between the coast of Bay Ridge and the Verrazano Bridge, after passing through the Gowanus Canal.

In the end, this was an undertaking that gripped us and pulled us into the depths of so many unexpected places and people that we never really wanted it to finish. And those moments between photographs and interviews—the instants that we simply lost ourselves in the dance of the streets, the throngs of faces, and floating footsteps that swarm and flurry around you like darting sparrows—those were the brilliant moments. Those were the instants we stuffed deep into our pockets—two wandering Brooklynites, enveloped by the warmth of millions.

—Anthony LaSala

Kevin Bennett, 24: Owner and Designer of Gifted Apparel NYC

"I liked growing up in Bed-Stuy because of the people. Everybody's different, but everybody's the same. You know?

Everything about Bed-Stuy is incredible. Even when it wasn't the safest place to be, it was still great. Playing handball, playing basketball, climbing over fences, playing in abandoned houses. All the things you see on TV that kids do, all of that is all rolled up into one here. You also learn survival here. And you take that with you everywhere."

Photographed in Bedford-Stuyvesant

Jonathan Lethem, 43: Author (*opposite page*)

"Brooklyn is the conscience of New York. While Manhattan tears everything down and changes everything, Brooklyn tries to do a similar thing, but fails miserably at it. It is a crazy quilt of a place. A mongrel place of sorts. It mixes old and modern in a haphazard way. It represents a tiny microcosm of the world—a functional utopia.

There is a weakness for nostalgia here, but it is a flinty and cold-eyed nostalgia. Brooklynites sort of have a built-in shrug about nostalgia while still caring about it."

Photographed in Boerum Hill

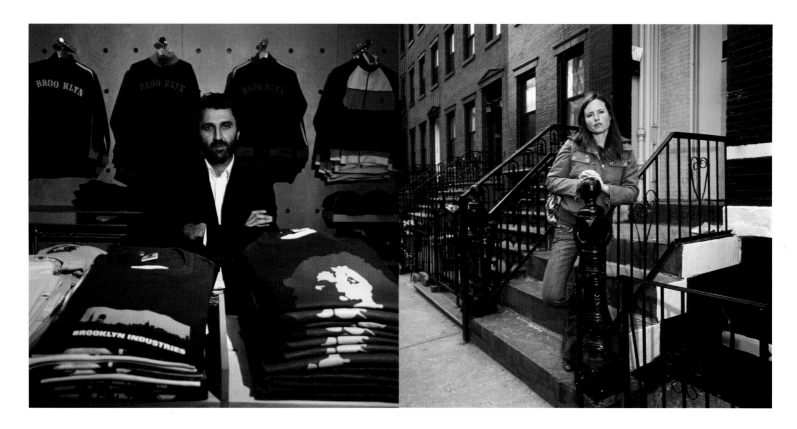

Vahap Avsar, 41: Co-owner and Founder of Brooklyn Industries Clothing

"I came to Brooklyn in the summer of 1995 on my way to an artist residency program in upstate New York. I have these two artist friends who live in Boerum Hill and invited me to stay with them for two weeks. They picked me up at JFK and then we went for dinner on Smith Street. The first thing I noticed was the scuba diving store on the corner of Atlantic Avenue and Smith Street. I remember thinking that store across from the jail in this urban jungle looked so surreal. The store ended up being available ten years later and became a Brooklyn Industries store. The second thing I remember is walking to the Brooklyn Heights Promenade and seeing the first glimpse of the shimmering downtown Manhattan skyline at night.

I met my partner Lexy Funk at the artist residency program, and decided to stay in New York. My first job was working at a drag queen restaurant in the East Village called Stingy Lulu's. That is where I met a lot of downtown personalities and artists. After a year Lexy and I started a company and made music videos. In 1997 we transitioned from making videos to designing bags and eventually set up a factory in Williamsburg to manufacture bags. We were living and working in this factory and we called the operation Brooklyn Industries. The name resonated with the people in Williamsburg and we decided to also call the product the same name. Our product and brand is unmistakably Brooklyn, as we live and breathe this culture. We feel the reason for our being is to promote the Brooklyn lifestyle and to work towards improving the art and culture of this place."

Photographed in Carroll Gardens

Lexy Funk, 35: Co-owner of Brooklyn Industries

"I was born in Manhattan, grew up in London and then moved to Williamsburg, Brooklyn in 1991 after I graduated from college at age 21. Williamsburg at the time was an artist outback, a hidden Polish and Hispanic enclave that had a reputation for being dangerous and cheap. My first apartment on South 2nd Street was a rambling three-bedroom walk-through complete with peeling paint, indignant firemen landlords, and plenty of room to build an art studio and darkroom. The first month I was there I heard gunshots almost every night, saw a dead body from a shooting across the street, and befriended the corner drug dealers as insurance for the walk home from the subway. The art community was steadily growing around this mix of gangster activity. There were art shows, and studio visits, and lengthy conversations in coffee shops. It was an interesting mix of bohemia and culture clash.

Over the next ten years Williamsburg evolved at lightning speed. Living in the neighborhood, I experienced these changes slowly—a new restaurant, rising prices, friends moving out and moving in. I left in 1995 to travel and take photographs in Poland and Russia, looking, in part, for new experiences. But two years later, my partner Vahap and I were searching for a large factory to live and work in, and we found one in the industrial zone of Williamsburg, 13 blocks from my first apartment. I had traveled around the world to come back to Brooklyn."

Photographed in Williamsburg

Rina Ortega, 26: Mother

"After living in Manhattan for the past few years, I wanted more space to be away from the chaos. Brooklyn seemed more peaceful to me. I call this spot my urban beach. Looking out into the water, it's a place where I can think and relax and forget about everything that worries me."

Photographed in Williamsburg

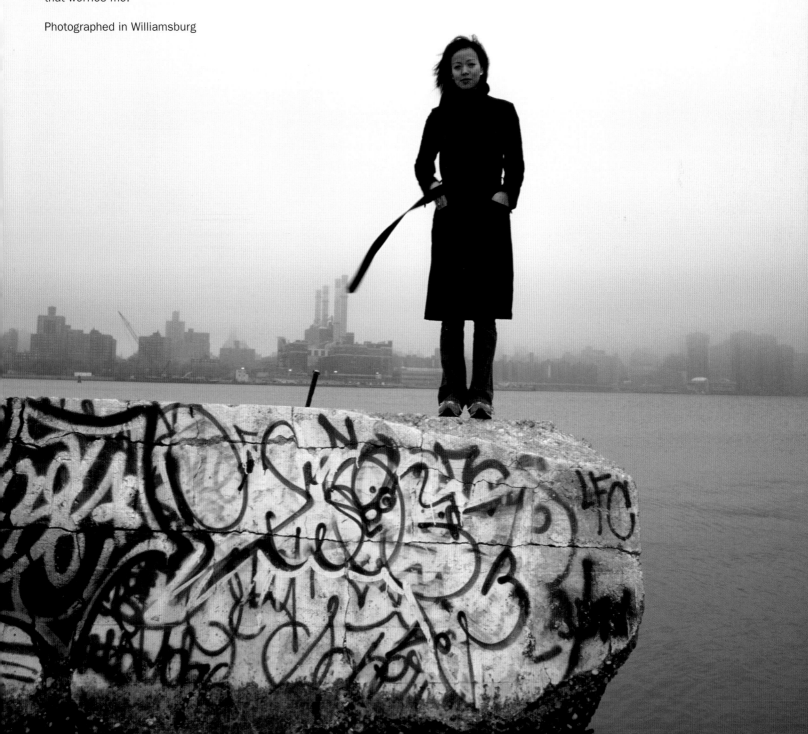

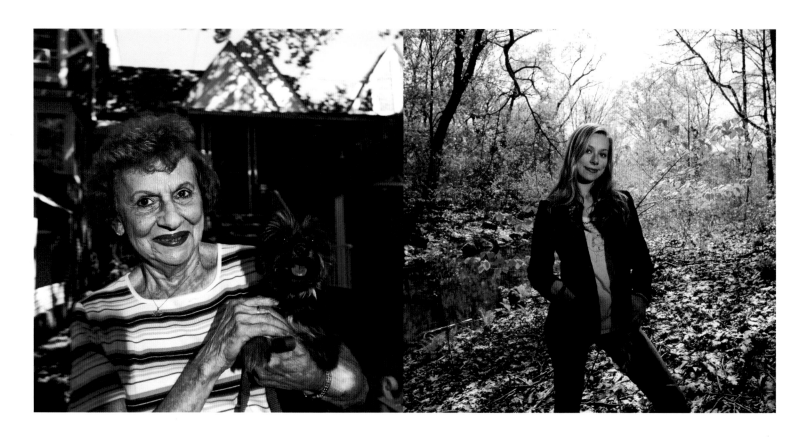

Evelyn Walder (no age given); Missy, 2: Retired

"I was born in Brownsville and then we moved to Crown Heights. Now I live here in Sheepshead Bay, where I've been for 25 years. I actually moved to California for five years and Florida for one year because I needed a break from Brooklyn. I missed it though. I missed the hustle and bustle and the people. In California people are laid back. And in Florida they were so slow. They all would see how I would walk and act and say 'You're from the East, aren't you?' I'm geared very fast. Even now."

Photographed in Sheepshead Bay

Alyssa Ritch, 24: Actress

"I'm more of a small town kinda person but I'm an actress and a musician as well so I felt like I had to be in New York. When I came down here, Manhattan scared me, but when I got to Park Slope I was like 'Aaah'—this is like a small town. People know you here, as opposed to Manhattan, where it's all action."

Photographed in Prospect Park in Park Slope

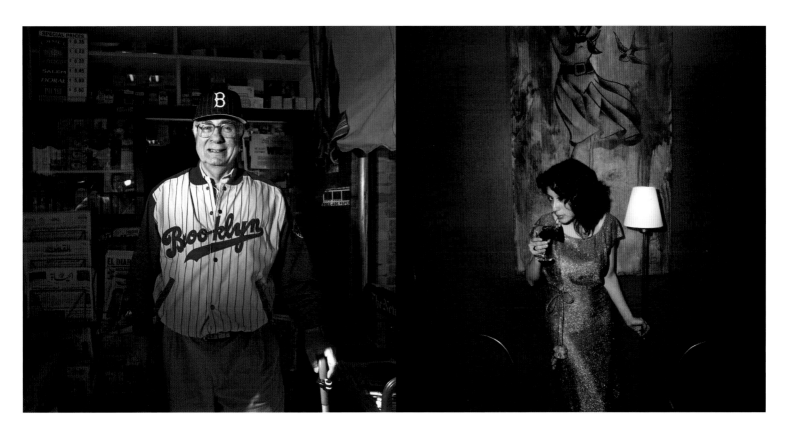

Maury Allen, 75: Sportswriter

"When I was younger I wanted to be a sportswriter for the Brooklyn Dodgers. But they left before I could do that. No team has ever connected to a place like the Brooklyn Dodgers did with Brooklyn. They were adopted by the people of Brooklyn. They were so much a part of the community. The players lived here, their wives shopped here, their kids went to school here. The team gave Brooklyn an identity unequaled by any other franchise."

Photographed in Dyker Heights

Katherine Toledo, 23: Artist

"I officially moved back here last year from Miami. As a kid I often visited Coney Island. I remember the beach and finding four-armed starfish and a dead sea horse that my fifth grade teacher let us keep in class floating in water so we would be familiar with all stages of life.

I love this neighborhood. The people are awesome. So warm and funky. There are these older guys who hang out at a garage on my block and they just play oldies until two in the morning and the songs leak into my apartment. For some strange reason the songs always seem to match what's going on in the house.

This bar was a catalyst for me moving here. While in Miami I would never go to local bars or dives. Then I came here to find out the joys of going to a place 'where everybody knows your name.' They run film festivals, open the grill for the summer, and feed basically anyone that walks into the bar—it's comfortably communal."

Photographed in Bar Rope in Clinton Hill

John Carluccio, 37: Filmmaker and Inventor (*opposite*)

"This is my old block, where I lived from 1992 to 1997. I lived at 230 St. James Place between Fulton and Gates. Everybody on the block called the neighborhood something different. Artists like myself called it Fort Greene, yuppies called it Clinton Hill, and thugs called it Bed-Stuy. I did my first film with my neighbors on that block, I had conversations with my next door neighbor Biggie Smalls on my three-step stoop, and since I paid so little in rent ($250 a month) I found more time to create and invent."

Photographed in Fort Greene

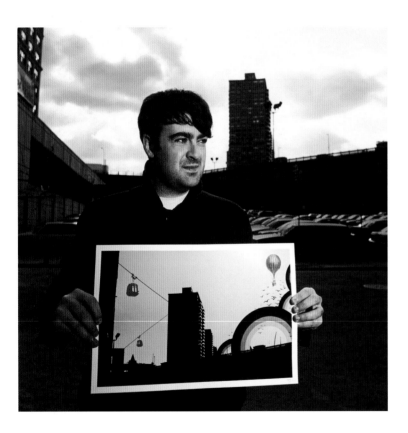

Jon Setzen, 30: Graphic Artist, Designer

"I'm originally from South Africa but I grew up in Toronto and San Francisco. I've been in Brooklyn for four years. I wanted to get out of San Francisco and I had a friend in New York, so I came here to work for myself and ended up loving Brooklyn. It's the only place I've ever lived here.

I spend lots of time going around Brooklyn with my camera looking for stuff. Once I spent a good day out on Avenue U taking pictures, and there was a Chinese fish store I went into. They had a shrine in the back where all the dead fish were put. It was Buddhist or something. There were all these dead fish and there were egg rolls. They were all together, like an offering.

Living here, I'm much more inspired by what's around me. The one thing that's great about Brooklyn as far as inspiration is the little bits of nature amongst all the urban sprawl. The day I worked on this D.U.M.B.O. poster, the sun was behind the building and it created this perfect silhouette. As I took the picture a flock of birds came out of nowhere and I was thinking it would be cool if I had a gondola going across the top, so I added it. I think everywhere you go there's so much to look at; the patterns on the buildings, the different colors, the 'geometric-ness,' if that's a word, of the cityscapes. I think Brooklyn is really obviously changing now and it will be interesting to see what happens with the cityscape soon, but I kinda like it how it is."

Photographed in D.U.M.B.O.

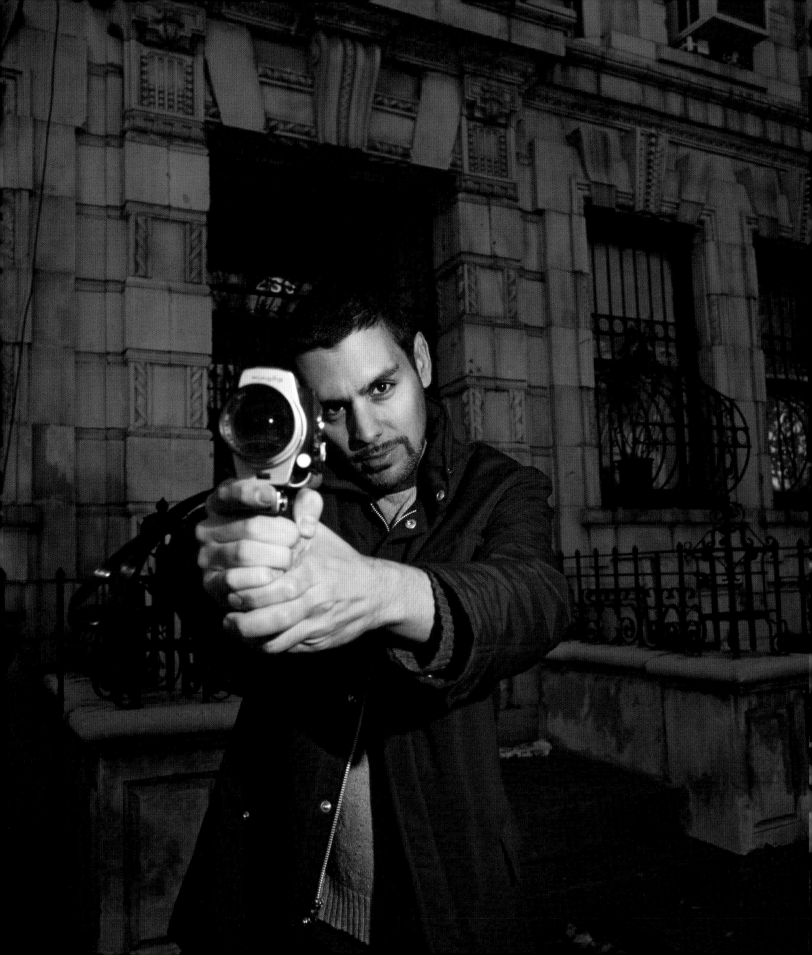

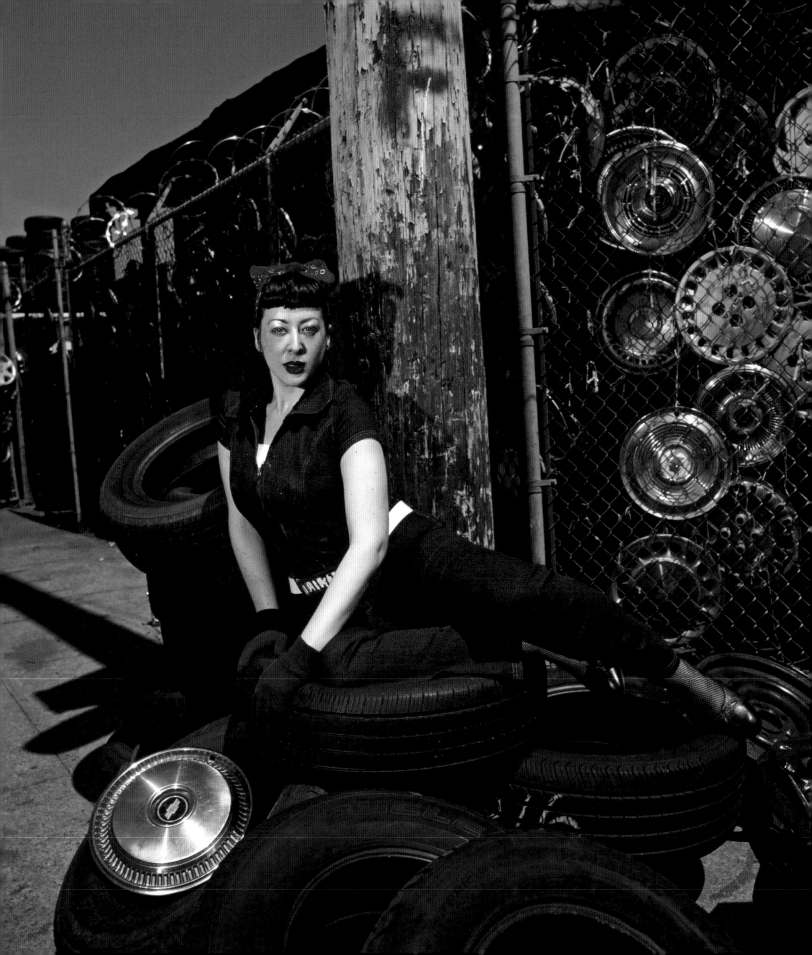

Danny Simmons, 51: Artist and Founder of the Corridor Gallery

"I grew up in Queens but I came to Brooklyn in my early 30s because Brooklyn was the hippest place in New York. Why travel all the way from Queens when Brooklyn was the place I was always hanging out in?

I've been in Fort Greene for ten years now. I like this neighborhood because it is a neighborhood. People know each other, people speak to each other, you know your neighbors, you know the kids on the block, the kids know you—they all call me 'Mr. Danny.'

This gallery has played a major role here in Fort Greene. It has helped to bring people together. It is one of the things that have brought black artists and white artists into the same space where they got to meet each other. I think this gallery has become a focal point for people in and around Clinton Hill and Fort Greene for arts and culture. It's added another dimension to the neighborhood that makes it kind of cool. I've also been accused of being the first gentrifier—because when you bring in art galleries, that happens. But a gentrifier in a good way.

Brooklyn has also given me an artistic community to be a part of—we know each other, we collaborate on many different projects and we are all sort of in on the beginning of things happening. So it has given me hope that the arts can be more than just white walls and things on them. That it's really a community. A place where people fight for change and diversity at all levels. I think this neighborhood has helped sustain my feeling of hopefulness for humanity."

Photographed in Fort Greene

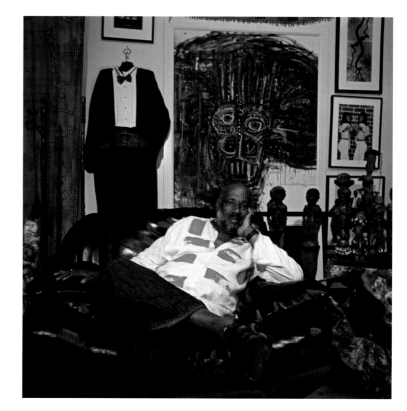

Little Brooklyn, 31: Dancer (*opposite*)

"Brooklyn is special because it houses me. I've been here my whole life. I grew up here with all different types of friends, surrounded by all different types of experiences. It's a place for all people—a place that opened its gates to everyone."

Photographed in Gravesend

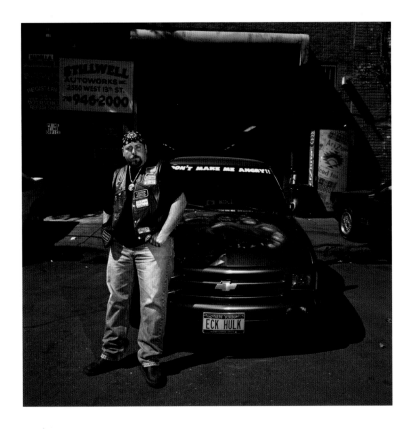

Chris Beeson, 32: Founder of the East Coast Cruizers

"In Brooklyn you always see something different or someone different. You think you know everybody and you get the one oddball who comes out of nowhere. You have everything here. I'm sure the Bronx and Queens and Staten Island have good things, but when you are from here you can say, 'Yeah, I'm from Brooklyn.' Saying, 'Yeah, I'm from Queens' just doesn't sound as good.

We started out as Brooklyn Cruizers and now we are the East Coast Cruizers. We have chapters now in other states. We are all about love and peace and helping people. I've always been involved with the community, even before becoming the founder of East Coast Cruizers. A lot of people take us for a bike club, or a gang, but we are about helping people.

I've always been a car freak. This truck is a 1994 Chevy S-10. I change cars like I change shoes, but this truck I've had three years. I usually do them up and get rid of them. I get bored. But this one I hung on to. I've had 68 Novas, a Mustang, the IROC up and down 86th Street, a family wagon Corsica that people saw and said, 'Wow, you actually made it cool.' I like to be different. Everybody has a Honda Civic. What are you gonna do with your Honda Civic?"

Photographed in Gravesend

Dean Haspiel, 39: Cartoonist (*opposite*)

"When I first moved from my native Manhattan to Carroll Gardens, a decade ago, it felt like I was moving to the country. I was shocked to discover how loud a quiet night could be. For the first time ever there was clarity to my thoughts and ideas, sans sirens and the hustle and bustle of 24-hour activity. I could ride my bike in relative safety from the Brooklyn Bridge to Coney Island, and it came with its own back-yard in Prospect Park. I soon realized Brooklyn was a place where people could find good romance, respite, and resolution. However, like a Sergio Leone 'spaghetti Western,' Brooklyn is criminally aware of territory and personal honor. There is nostalgia running rampant through Brooklyn's varied neighborhoods steeped in unapologetic history, from original gangsters to original cartoonists, where immigrants formed their necessary niche. Brooklyn was the stomping grounds of my favorite comix authors, Jack Kirby and Will Eisner.

Brooklyn is bigger than some developing countries and sometimes acts like one, too, yet furnishes an oasis of crossroads. Where else can I grab a variety of culinary delicacies in the spirit of SoHo on the recently converted Smith Street yet stumble a few blocks away towards my home and still find the racist skeletons of NBC sticks ["Nigger Be Cool"] made from the business end of a broom handle hidden up the sides of trees? Or, how about Red Hook, the sexy blue-collar ghetto of Brooklyn, hosting the ghosts of Elia Kazan's *On the Waterfront*. It's too far away from easy public transportation, yet pulls me, hipsters, and anybody worth their salt towards its streets and sea like a soul-mollifying magnet, where the Statue of Liberty shines a beacon of light at the last watering holes on earth."

Photographed in Red Hook

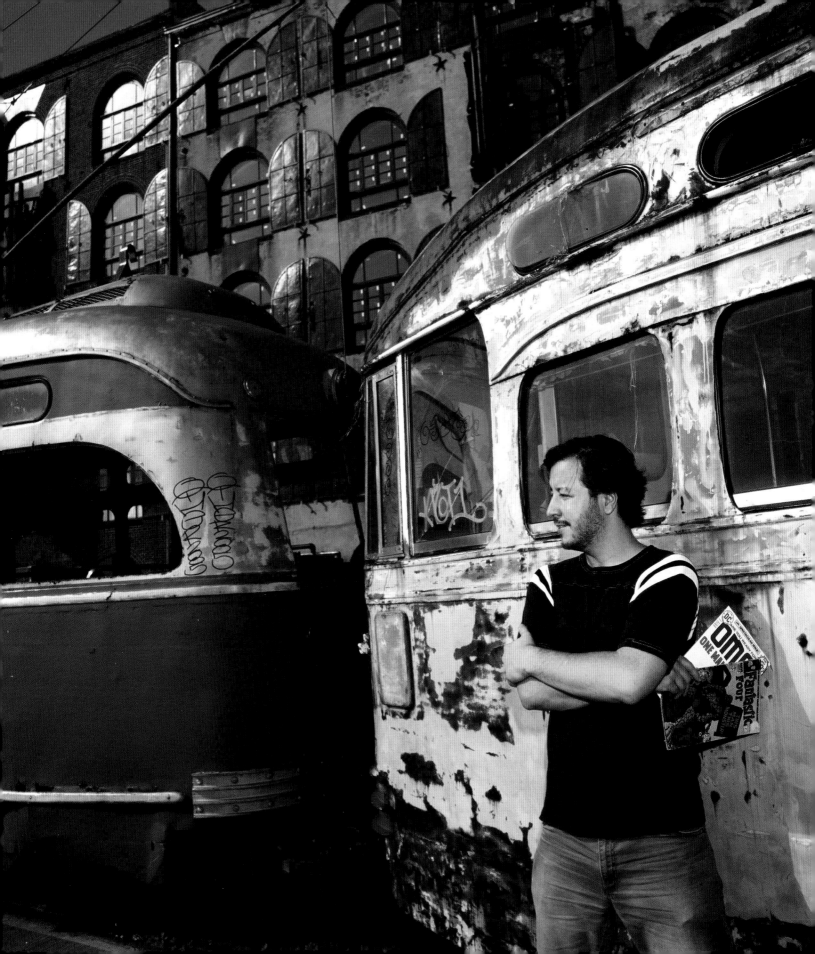

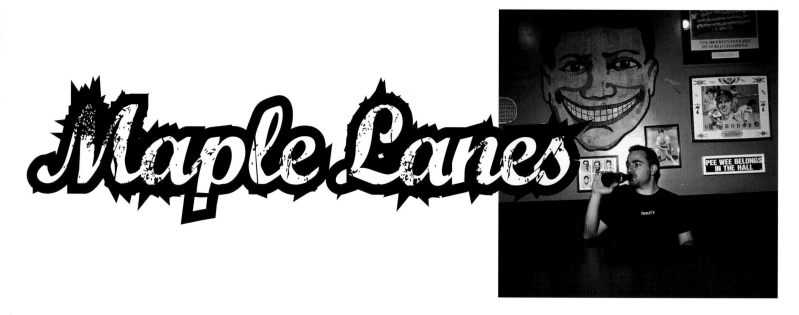

Maple Lanes

Augie Allegretti, 33: Executive Assistant

"Brooklyn! There is no place better to get a canoli. And this bowling alley—Maple Lanes—it's where you get the best egg cream ever made.

I love all my memories of a candy store near the house I grew up in. It was called Tessie's and John's Candy Store and it had a beautiful soda fountain, mountains of jellyfish and Bazooka for three cents.

The best memory of all is my dad Big Augie waking up the block I grew up on out of a dead sleep with his bugle the morning of a block party. Kids came running out in their pajamas. Parents would watch from the stoop, barely moving a muscle. The day was always filled with games for the kids and so much food it was overwhelming."

Photographed in Maple Lanes in Bensonhurst

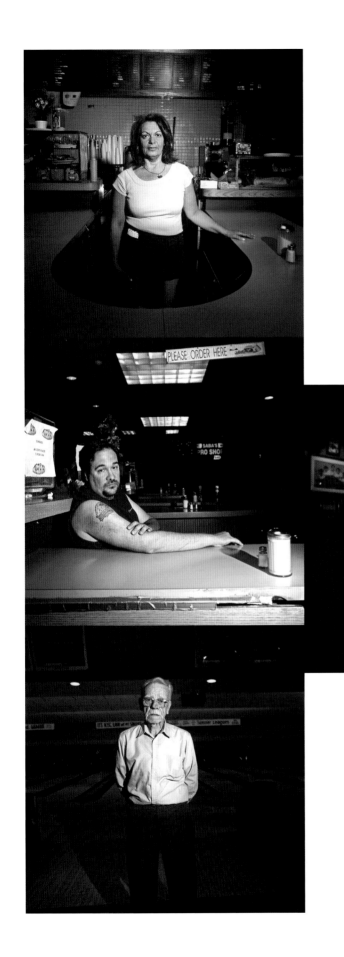
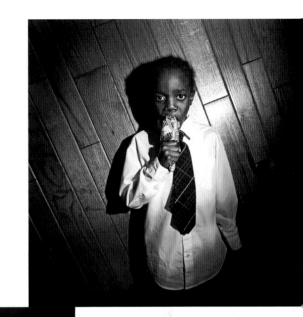

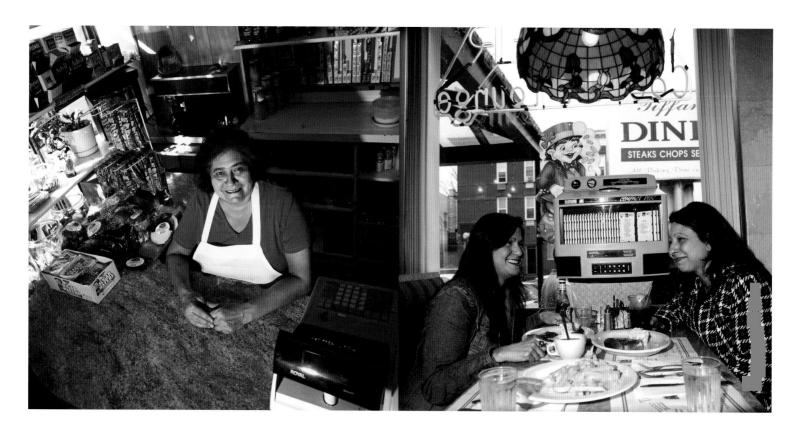

Gada Hatoum, 54: Deli Owner

"I was born in Aleppo, Syria and I came here with my family when I was 14 years old. My parents came to settle in America because they were refugees of the 1948 war. We lived in Hempstead, Long Island and I came to Brooklyn when I married my husband because that's where he lived.

I started this business (Gada's Deli) in 1988. I know the names of everyone who comes in here and I'm familiar with everyone's lives. It's the same people who walk in every day. There are customers who have been coming in since the beginning—we're very attached."

Photographed in Bay Ridge

Rosemarie Saccio, 37; Alicia Costas, 37: Teacher; Headhunter

Alicia: "As a teenager, 86th Street was the place to be. It was filled with John Travolta wannabes. But who cared when you were a pubescent 14-year-old girl? The guido was IN. There was always a good song blaring from a Monte Carlo or Caddy and each corner had a different group of people 'hanging out.' I even remember people bringing beach chairs to sit on while on the corners.

My memories of Brooklyn diners? There are sober memories and not-so-sober memories. Then there are memories that you did not actually remember yourself and your friends had to remind you about the next day. Those are usually the best. The Brooklyn diner became a staple of every Brooklynite's diet. Who knew that the cheeseburger deluxe with extra cheese on the fries and gravy on the side would become your best friend after a night of partying? And the diner was like going to an after-party. I remember seeing everyone from the club that you were just at, but the lighting in the club was a lot more forgiving than the lighting in the diner."

Photographed at the Tiffany Diner in Bay Ridge

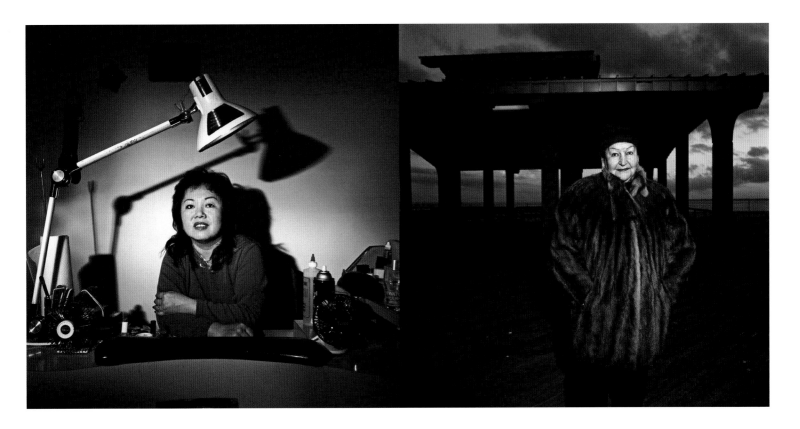

Kim Lau, 47: Kim's Nail Salon *(above left)*

"I moved away from Vietnam and communism because of the freedom here. Everyone talked about the freedom."

Photographed in Bensonhurst

Etya Rubenstein, 84: Retired *(above right)*

"Every day I open my eyes and say 'God bless this place.'"

Photographed in Brighton Beach

Erika Valdez, 16: Bakery Worker (*right***)**

"I like the fact that everything is here and so close—if you need to get something, you can just walk to it. Grocery stores, Laundromats. There are so many different cultures to learn from. I've been here my whole life.

I enjoy working at the bakery. People travel from the Bronx, Staten Island, Queens, and Manhattan just to come here. They always say 'I wish I could buy the whole store because there is nothing like this place in my neighborhood.'"

Photographed in Sunset Park

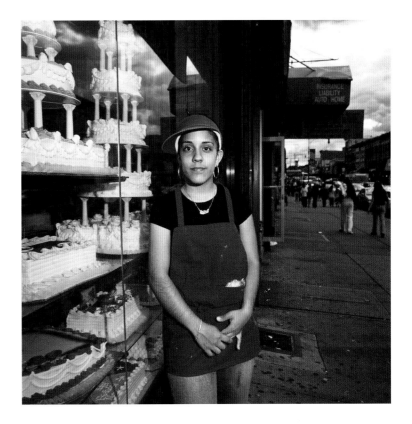

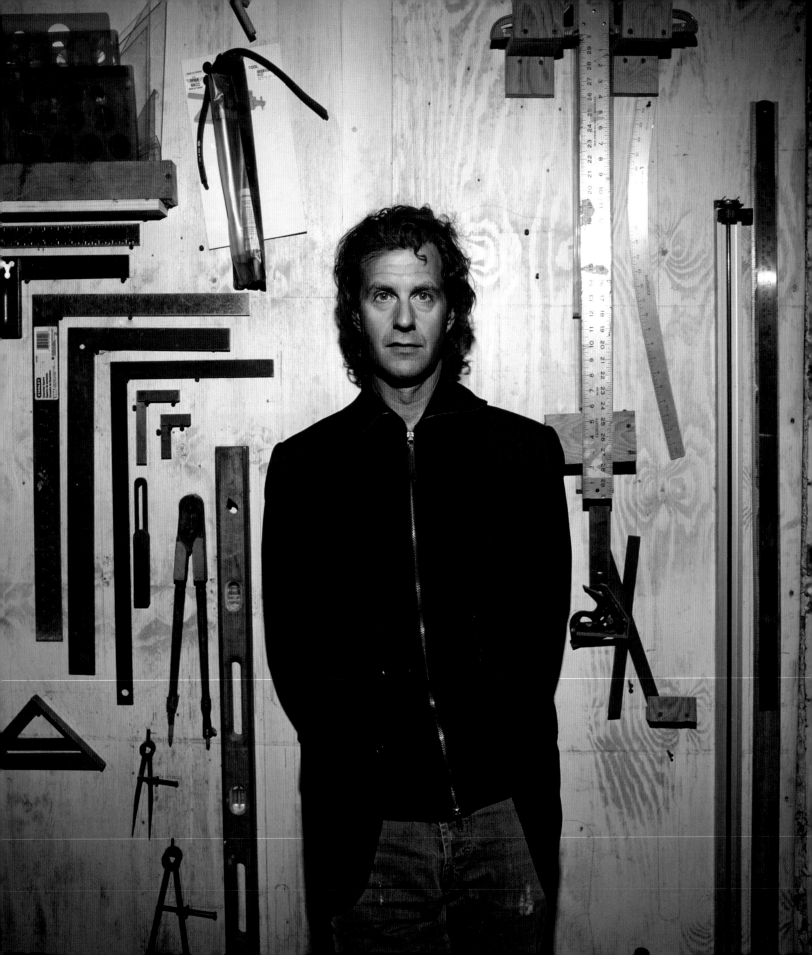

Jon Kessler, 48: Artist (*opposite*)

"After attending SUNY Purchase for art school I did something called the Whitney Independent Study Program, which is an exclusive program that the Whitney Museum runs—and that brought me to New York City. I lived in the East Village for six months and after six months it was like, 'Fuck this.' It was a tiny little hole in the wall on Avenue D. I had a Polish friend then who had grown up in Williamsburg and told me about it. The first day I came out I found like ten places. It was literally like my generation's experience that the older generation had in SoHo or Tribeca—which was to approach a landlord who lived in a factory who then says 'You wanna live in a factory? Sure!'

I paid $150 a month for this whole building when I first moved here in 1980. It was actually a functioning paint factory when I got here. Now I own the building. I bought it in 1985. It was the only smart thing I ever did with my money in the 80s.

In the early days there were a couple of artists in the neighborhood— we would huddle together and have dinner. We hung out at an old place called the Warsaw Bakery and also this other very informal place that was run by two guys covered in tattoos. They would basically open up their kitchen on North 6th Street—which used to be the slaughterhouse street and now it's got like American Apparel on it. They were literally across the street from hanging carcasses of meat and they would open at 5 AM and you would sit at their table in their house eating fried eggs. It was just so cool.

There is something about my history in this building that is special to me. I look at these walls and I see the holes that are up there and I think about my pieces that were hanging in 1985. I made all my work here and it's all been hanging on these walls or sitting on this floor. I have my own ghosts here. My own memories and history and the imprint of all my work."

Photographed in his studio in Williamsburg

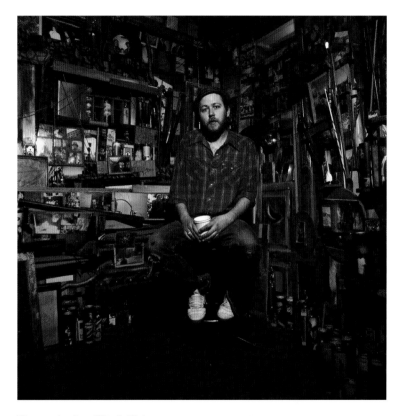

Kenan Juska, 28: Artist

"When I was younger, about 19, I was going to live in California for a while. I had never been out there before and I didn't really know what to expect. I remember being nervous about living so far away from home. A few days before I left I was talking to my godfather about the trip, and he said, 'Hey, you're from Brooklyn. You're already two steps ahead of everybody else.' When I got out there I realized pretty quickly how right he was, and I still think that way, even today, wherever I go.

When I first started building this room it was never supposed to be this big. It sort of got out of control. It's become an ongoing analysis of where I'm from and the environment that made me who I am. It was my way to reflect on this place and a way to record my experiences here in a tangible way."

Photographed in Park Slope

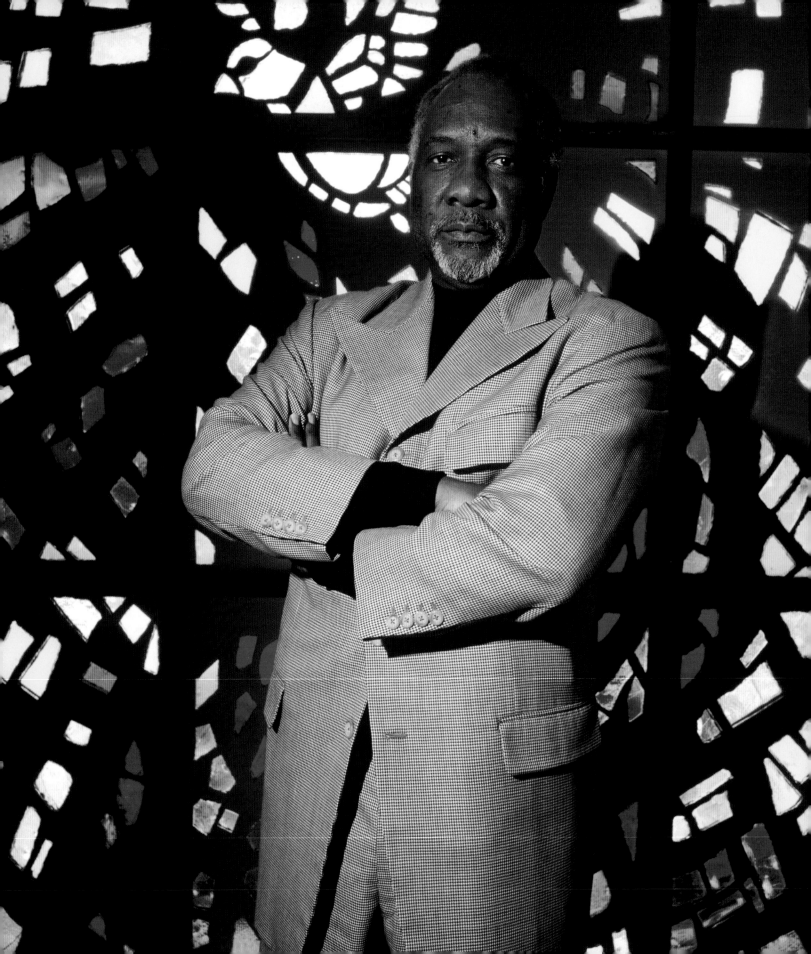

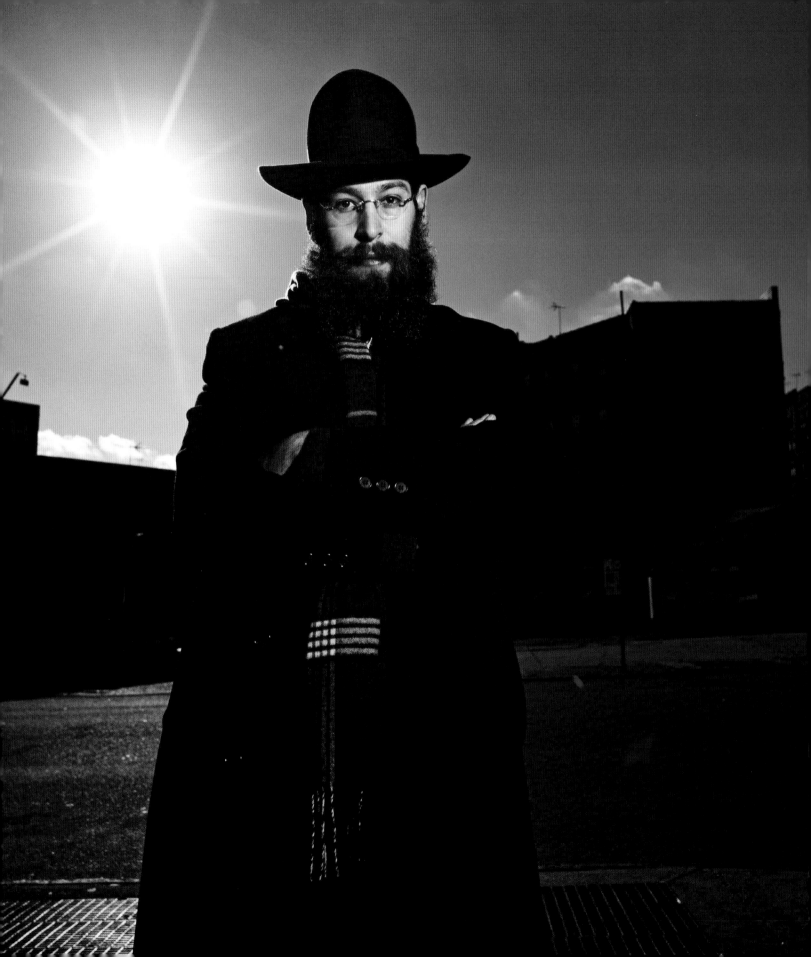

Reverend Youngblood, 57: Reverend (*previous page left*)

"I was born in New Orleans and I arrived in Brooklyn in June of 1974. I was invited to come to Bedford-Stuyvesant to assist Dr. Jones at Bethany Baptist in Brooklyn and a year later I came to St. Paul's. I have now been here 32 years.

East New York is important to me because when I first came here—Brownsville and East New York—I could almost see Siamese Twins. It was said by someone that this place looked like the beginning of the end of civilization. Burma after the bombing. All of these kinds of things were said about East New York and Brownsville. And because I am a Christian I take great pride in the idea of the resurrected Christ. So when our communities are treated and written off as cemeteries—to be able to not run from it, stay with it and resurrect it, that makes it worth it.

I take pride in being a minister in the borough of churches. I always have. There have been some disenchantments. It is the borough of churches, but sometimes the borough does not reflect the churches. I have been privileged to come into Brooklyn. After a year with a great man at Bethany, I wanted to make an impact. I found 84 members and they were doing $125 on a good Sunday. Now the congregation has increased to about 3,000 we can count on, and about 10,000 who have come through. We have been able to put our school together so I have been able to make a difference as a churchman. The borough has to reflect our presence. The interesting thing about Brooklyn is it is a marvelous place, but there is a sinister 'impersonalism' in it, where you can live right next door to people and never know them. We need to see what we have in common and focus on that."

Photographed in East New York

Matisyahu, 25: Musician (*previous page right*)

"Brooklyn is a real place. Crown Heights has blacks and Hasids living door to door in the same apartment building—nowhere else is like that. It's such a mix. As a religious man, the neighborhood has everything I need: kosher food, rabbis, friends to study Torah with. On Rosh Hashanah, people walk. I decided to walk from Crown Heights to Williamsburg. I went through Bed-Stuy, through the Satmar community in old Williamsburg, and finally I ended up where all the hipsters and Internet cafes were. When you walk through Brooklyn, it's like crossing every country in the world."

Photographed in Crown Heights

Pete Miser, 34: Musician (*opposite*)

"I was born in Portland, Oregon. I came to New York in 1998 to keep from sleeping with my ex-girlfriend! I figured moving across the country would facilitate that goal (it did). I lived in Manhattan for about three months before I moved to Brooklyn.

The best thing about my neighborhood is the sense of community I have here. I have close friends in nine out of the ten closest blocks. It's the kind of thing they used to depict in *I Love Lucy* where the neighbor is coming over to borrow some sugar or something. And someone is always down to go get a donut or go to B's for breakfast. B's is the local spot right behind me where you can still get breakfast for less than $2.

I remember DJing a party in a one-bedroom apartment in Fort Greene from 7 PM until 7 AM (for some reason, Manhattan is afraid to dance these days. All the parties with the positive vibrations seem to be in Brooklyn now.) I got to my homeboys Ibrahim and Ben's place and started setting up the turntables while their crew sat rolling blunts and lounging out. Soon I was just spinning some beats and hanging. By 11:30 the party was bumpin' and way too crowded and hot. Around 2 AM the neighbors come knocking on the door. I assumed that they wanted to shut the party down. It turned out that they were percussion players. They brought congas and played along to the music I was spinning. By 6 AM only die-hards were left but everybody was still dancing. By 7 AM we were all just kind of buzzing off of the music and sleep deprivation. We bounced out and had breakfast at Junior's before people stumbled home. That was a defining Brooklyn night!"

Photographed in Greenpoint

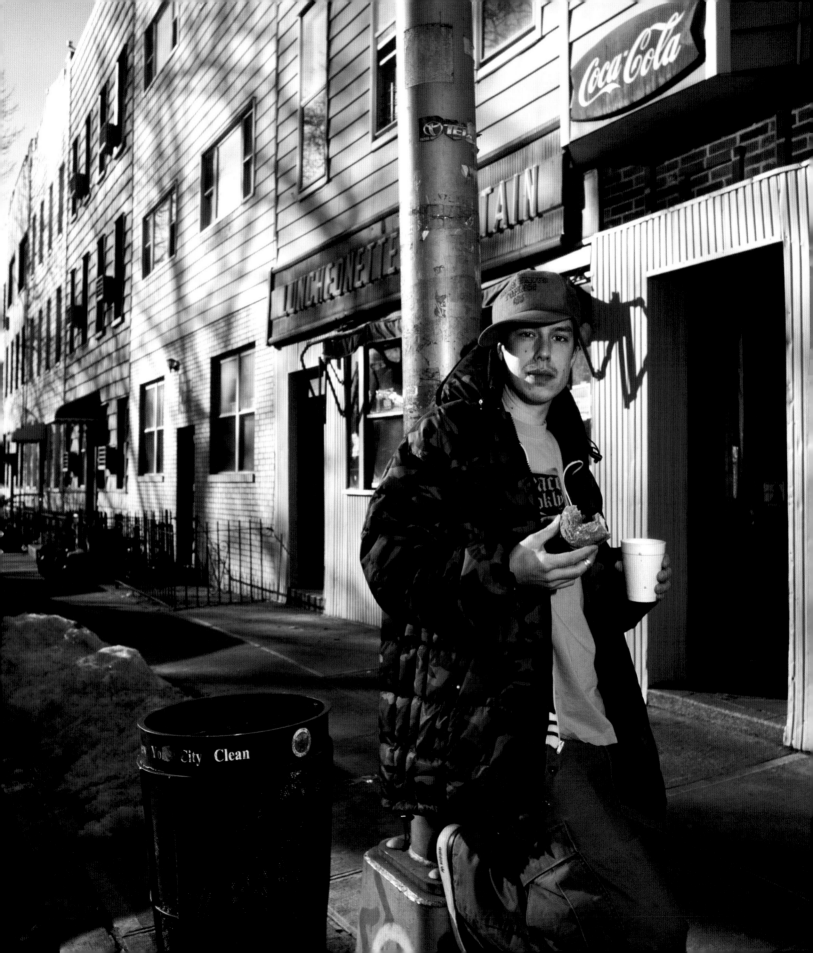

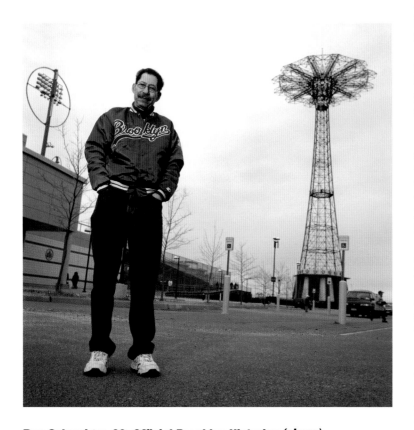

Ron Schweiger, 60: Official Brooklyn Historian (*above*)

"When the Brooklyn Dodgers won the World Series in 1955, it was like Christmas, Chanukah, New Year's, and the 4th of July all rolled into one. We all ran outside and started banging my mother's pots and pans.

Brooklyn has a history that no other borough can really compare with—and one in every seven Americans are in some way connected to Brooklyn."

Photographed in Coney Island

John Turturro, 49: Actor, Director (*opposite*)

"I was born in Lutheran Hospital in Brooklyn and my mother is from East New York and Williamsburg. I grew up in Hollis, Queens and then we moved to Rosedale. I lived there until I was 18 before going to New Paltz and then living in the city. In 1987 I was looking for a place with some more space. We looked around and found a place in Park Slope. When we first came here it wasn't what it is now. Now it's unbelievable.

Being here helps me as an actor and filmmaker because Brooklyn is a good in-between place. There is a lot going on but you can have your own space. I remember when I first moved out here my friends said, 'You're moving to Brooklyn? Why are you doing that?' I said, 'Well, I'm just gonna try it out.' I think as long as you are around people wherever you are, that's always helpful. If you are just in your car and you only interact with the same people, it's limiting. I like to walk around here and experience the mixture of people. I used to just eavesdrop on people. But that's harder to do now. I'd have to schedule an appointment. But this has been a place we feel at home with. The neighbors, the community book shop. It's unfortunate with Starbucks, but hey, every place has a Starbucks. Change is inevitable. Look at Times Square. I used to like walking down 42nd Street. I would get robbed and I would look at all the dirt and smut, but I kinda loved it in a way. Even though it was disgusting I always kinda liked it. Now it's like a horror. It's the exact same thing but the other side of it. And you can't walk over there. So many tourists who don't know how to walk. I was driving down the street one day and the light was green and a woman was in the middle of the street. So I honked the horn and she was like, 'You must be one of those rude New Yorkers.' And I said, "Yes I am, ma'am. And if you don't move I will run you over.'

Another thing I loved were drives back from my mom's on Eastern Parkway. It was great—all the sounds you would hear, the sea of Orthodox people, the Arabic mosques, the music from the Caribbean homes. There are some nights you hit it coming home late and you're like, 'Wow, now I'm in this country, now I'm in that country.'

As for films that really display the soul of Brooklyn, it's tough to pick one. I think it really influenced a lot of films. You would have to go through different periods of time. Brooklyn and a lot of areas of New York influenced the 30s films that were mostly made out on the West Coast. Then it was forgotten about for some time. In the 70s there weren't really many Brooklyn films. *Dog Day Afternoon* didn't really say it was in Brooklyn. Sidney Lumet did a lot of stuff around New York City. Spike Lee is an obvious choice. *Do The Right Thing* of course. He should make a sequel to *Do The Right Thing* where everyone is really old. I own the pizza place now, I have a black wife. That's what happens when you run out of ideas; you go into the recycling business.

But I've shot a lot in Brooklyn, and actually my fantasy is to do something about the Brooklyn Bridge. I read the book *The Great Bridge* by David McCullough. You probably could do it theatrically. I've talked to B.A.M. about it. That would be amazing."

Photographed in Park Slope

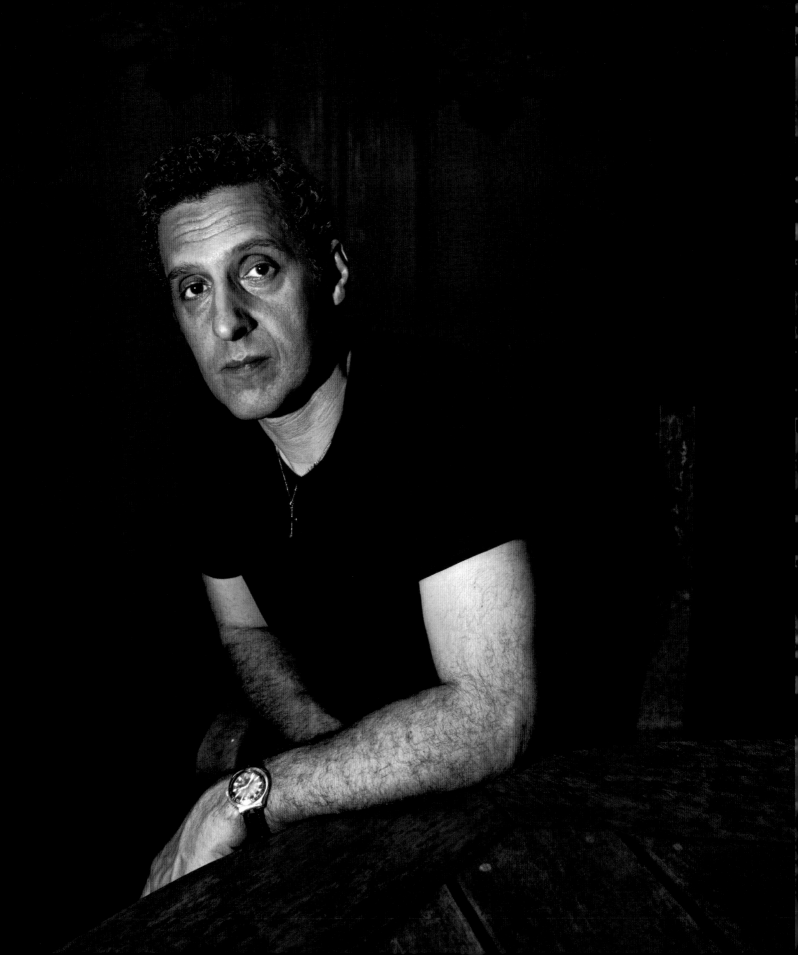

Molly Crabapple, 22: Illustrator

"I grew up in Far Rockaway and I made my way to Brooklyn three years ago. Before that I was living in a horrible slum in the East Village. It was basically one room, no natural light, two Korean fundamentalist Baptist virgins and their mom for a month, with a shower in the kitchen. I realized living in Manhattan was not worth that. My apartment now is great. When I was in school I had this fantasy that I would live in a cool Parisian garret. This reminds me of a garret even though it's not garret-priced.

I'm actually a fourth-generation Brooklyn native. Both my parents are from Brooklyn. My great-grandfather moved to Brooklyn after he got booted out of Russia for being a Commie before it was okay. He was a crazy hippy artist who decided it would be a good idea to have a vegetarian chicken farm in the middle of the Depression. My family has lived in Brooklyn ever since.

I've been drawing forever—my mom is an illustrator, so I've been drawing since I was young. I also run Dr. Sketchy's Anti-Art School, which is this burlesque life drawing session. We meet every other week and we take these awesome burlesque dancers, pay them money, and 50 people get together and draw them."

Photographed in Williamsburg

Siri Hustvedt, 50: Author

"I grew up in Northfield, Minnesota and came to New York in 1978 to study at Columbia University. I never left.

My mother, who grew up in the most southern town in Norway, heard about Brooklyn her whole childhood. In the late part of the 19th century, there was a huge emigration from Norway to the United States. Some of those people moved to the Midwest, as my father's grandparents did, but many moved to Brooklyn. For years my mother thought that only Norwegians lived in Brooklyn. She thought it was an exclusively Norwegian borough, which I find wonderful.

After I met Paul [Auster] in 1981, I moved to Brooklyn. I had spent a lot of time visiting him in Carroll Gardens before moving in with him some months later. I didn't know Brooklyn at all and there was a part of me that thought, 'I've spent my whole life trying to get out of Minnesota and into Manhattan and now I've fallen in love with this man in Brooklyn.' But very quickly I became a Brooklyn booster.

Our first apartment was in Cobble Hill on a romantic, mid-19th century street.

Just before we bought this house, we were finally able to afford a bigger place to live. Paul said to me, "Okay, we can do anything you want. We can move back to Manhattan. We can go to the suburbs, anywhere you want. I realized then that I had no intention of going anywhere else. I wanted to stay in Brooklyn very much. I was terribly happy here."

Photographed in Park Slope

Suzanne Fiol: Director of Issue Project Room

"I started this place in April 2003 and we moved to Brooklyn in June 2005. Someone had to be dumb enough to start a not-for-profit space that is devoted to experimental culture during the Bush administration. It's something I've always wanted to do.

When we lost our space in the East Village a friend of mine called and asked, 'How would you like to have your space in a cylinder?' And I asked her, 'What drugs are you on?' The landlord who owns this silo, which was a storage silo, made it easy for us to come here—he cares about art and the transition was great.

It's a much bigger space. It took some time to get used to. We are also in a less reachable destination. But I think we have done okay so far bringing people here. Brooklyn really appreciates culture and they care about the work. They are very appreciative of what we do here in Brooklyn. We are sort of in the center of a lot of communities and liberal places that care about art."

Photographed in Gowanus

Judy Zuk, 53: Former President of Brooklyn Botanic Garden

"I was offered the job to become the president of the Brooklyn Botanic Garden in 1990. When I was asked to come up here to talk with the committee I knew that I had to come here. It was as if I was being called to come home in a way. Given the chance to direct what I believe to be the finest botanic garden in the world, but most certainly the finest urban botanic garden in the world—that comes around once in a lifetime.

We provide an anchor for the community. But also a garden is something that people can grasp and feel comfortable with quite quickly even though it's a work of art and it has history behind it and all of that. You don't necessarily have to know all of that or experience that to love the garden. You can just feel welcome from the minute you step in the gate. A garden is someplace that resonates with everybody, whether they are a three-year-old kid or a ninety-year-old grandma. And it will never cease to thrill me to see people getting such genuine pleasure from a space, and to witness the diversity of humanity that comes here and seems very happy to coexist with each other—whereas out on the street they may not be so obliging. I also think people have a need for beauty in their lives almost as much as they need food—being able to provide that is a privilege."

Photographed in the Brooklyn Botanic Garden

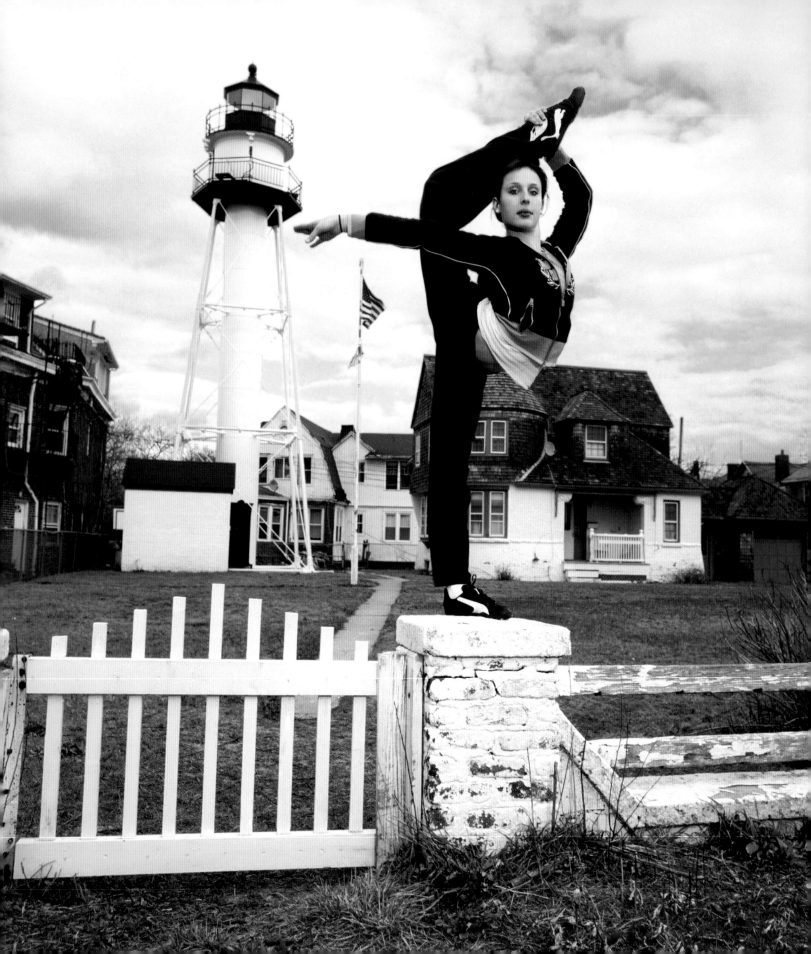

The entrance to the end of the world is protected by one uniformed man in a booth the size of a hall closet. He asks for IDs and intentions. Reasons for our visit. I smile and hand things over. Convinced of our purpose, he gives us directions and lets us through the gate, raising a padded orange and white barrier. We press forward, Columbus and Martín Pinzón in a black Chevy Cavalier, looking for a tower and a girl.

We creep through a shifting labyrinth of houses on the verge of collapse. Victorians with cavernous wounds in their sides, the elements slipping through their exposed ribs. Homes held together with ropes and pulleys. There are no Starbucks, no corner bodegas, no ShopRites, no ATMs. The townsfolk are hidden away and for a moment I speculate aloud if there are any. Could this all be a ruse? An abandoned movie set? Have all people deserted this place—moving inland for security? Convenience? Warmth?

But we see the girl. We find her beside a large, three-story dwelling. Dressed in colors, she's the only thing around for miles that's not grey or beige or broken. We bring her to the edges of things.

"We come here to see the fireworks on the 4th of July," she says as we walk along the water.

I imagine the tinted boom and crack. The lip of existence lit up and trembling below evaporating mushrooms of fire.

Here at the end of the world there is also a lighthouse. A long, white column encased in a white metal skeleton, it's a breathing exclamation point among a cluster of periods. It was cared for by only six men—Thomas Higginbotham, Mike Bailey, Daniel W. Bailey, Herbert Greenwood, Adrien Boisvert and Frank

Shubert—before it was completely handed over to the custody of the Coast Guard and machines. Shubert looked over it for 43 years, spending most of his time in a house huddled next to the tower. Each day he took care of the soaring pillar, climbing its 87 steps, painting its 1890 body, regulating and adjusting the burst and beat of a revolving, exposed, 1,000-watt heart. He was the last of them when he died here a few years ago—the final civilian lighthouse keeper in the country. Close up, Shubert's structure appears so much larger than one would imagine. Plunked down in the midst of tiny things, this might as well be the coast of Alexandria, the tower a seventh wonder.

The three of us find our spot between liquid and artificial light. In seconds the girl has scaled a stone fence. The wind is pushing with purpose, rushing to that somewhere else it's always searching for. Behind us the sea is wide awake and livid, all caps and frothy curls, clawing and chewing. A chalk moon dangles above like a watchful holy ghost. Olga Karmansky, a 19-year-old gymnast from Moldova, stands before us, posed on one slender limb—an elastic flamingo on a white rock barrier. Her leg and her torso hold still, resisting everything. Seconds later she is twisting in the air, a poised weathervane, defying nature, laughing at the airstream, 4,140 nautical miles from her European homeland. A preposterous 4 AM dream splintered in two by consciousness. I wonder silently if she could balance atop a tornado, or perhaps an eyelash.

I'm looking at this immigrant and this house holding light and the dramatic swatch of sky and water and I'm trying to pin the metaphors I'm conjuring to the skin of my palms and the insides of my lips, but all I can think about is how startling this all is. It hurts to know there are so many secrets embedded in the tiniest spaces of this city—things we will never see or photograph or write about. Hidden behind gates and uniformed men. Locked up in the remnants of crumbling houses. Teetering, with such poise, such staggering grace, on the abyss.

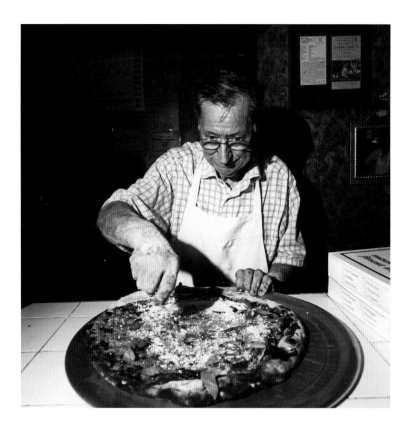

Dominic DeMarco, 69: Pizzeria Owner

"I was born in Caserta, Italy and my family came here in 1959. My father was a bread maker. We opened this place in September 1964. When I came here I didn't even know Avenue J existed. I came over here on a Saturday night with my father, we took a ride, and we saw how there were people everywhere. All up and down the block. It was so crowded on a Saturday night. Then we saw that this store was for rent, so we grabbed it right away—the first place we saw. It was the best move I ever made.

I am the only one left, out of the old pizzerias. You don't even have any Italians around here anymore. The neighborhood started to become kosher about 20 years ago and all the Italians left. But I didn't give it up and it was the best thing I ever did. Some people can't believe there is an Italian pizzeria in such a religious neighborhood.

People come from all over the place to eat my pizza. There were articles on me overseas. When people come on vacation to New York, they come over here. Here, guys, have a slice."

Photographed in Midwood

Fred "The Great Fredini" Kahl, 40: Performer (*opposite*)

"I moved to New York when I was 17. Eventually I started getting interested in magic and illusion. I began doing this levitation trick and performing on the street and as a joke started calling myself 'The Great Fredini.' From there I started performing in Coney Island and the sideshow. Dick Zigun had this place up on the boardwalk, Sideshows by the Seashore, Coney Island USA. When I first got out there it was even before the sideshow was up. It was really this empty theater with a stage. Eventually I kind of stepped into place as the head M.C. I did magic and human blockhead and all the talking to bring people in. I started swallowing swords around 1992.

What was great about Coney Island at the time was that it still had all the great urban decay with all the original buildings. There was the old Thunderbolt Rollercoaster with all the vines growing all over it. So you really had a sense of the history of the place. And likewise with the sideshow at the time. There were a lot of performers sort of ending their careers. Like Melvin Burkhardt, the original human blockhead, and Otis Jordan, the human cigarette factory. The oral history of all the sideshow talk was sort of handed down to us. It was a special time.

Coney Island is great. It is the quintessential melting pot of the world. With all the people that live in New York City you can have one audience that is completely hipsters from Williamsburg, one that's all Hispanics who hardly understand English, one that is half-Hasidic 'cause it's a Jewish holiday, or one that is filled with Muslims. Every single people is represented out there and that kind of strange chemistry of them mixing all along with beach, sun, amusement park, and alcohol always makes for some great connections with the crowd."

Photographed in Greenpoint

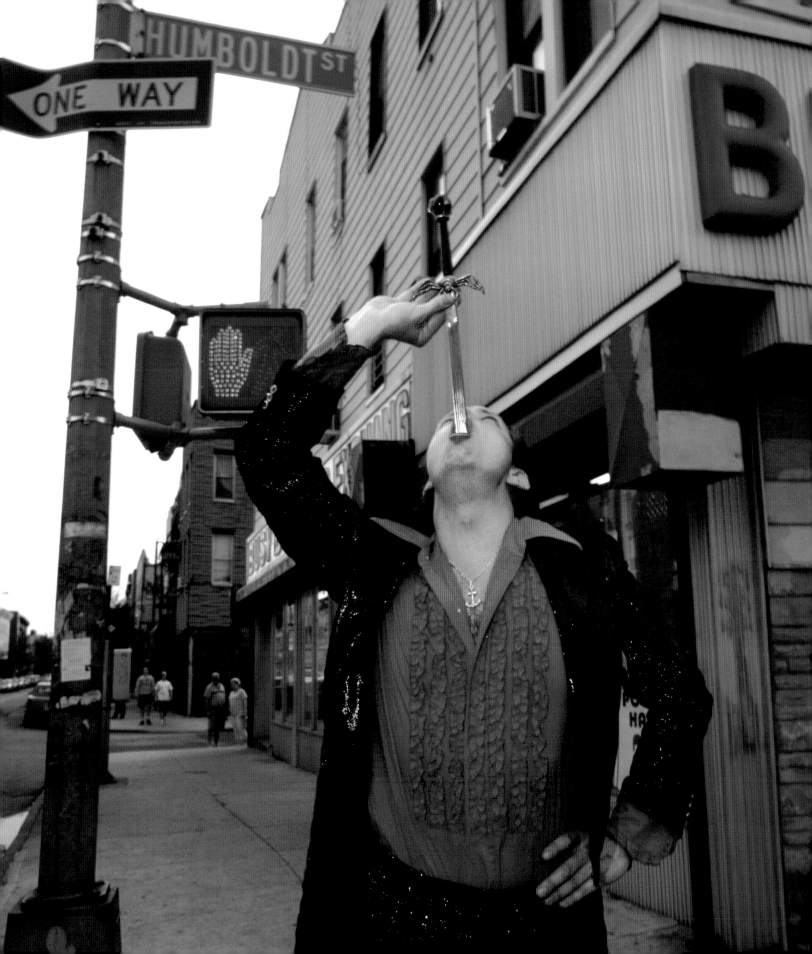

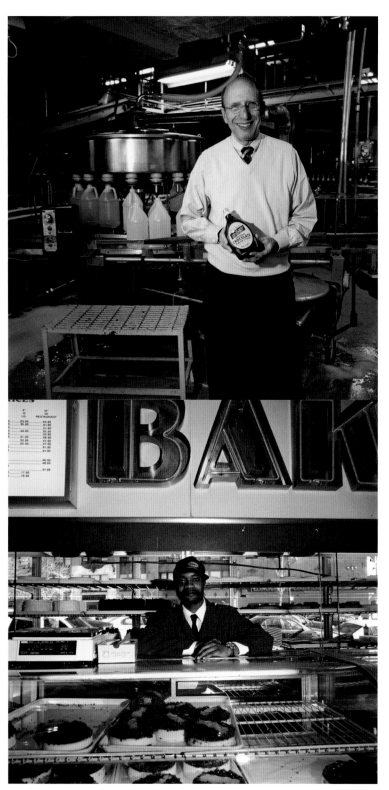

David Fox, 65: President of Fox's U-Bet Syrups and Toppings

"The company was established around 1900. My grandfather started this business. I came here full time when I was 21. Our business was much different then. Our business was all about going to candy stores and luncheonettes. There was a candy store on every street corner. Diners weren't a big deal. There were no fast food restaurants. You went to the movies and you went to the candy store afterwards. On Saturdays you went there. You went for penny candies, you went for comics, you went for the Sunday papers, you went for coffee. It was the hangout and played a central role in communities. But candy stores have disappeared now—there are only a handful left.

We used to have hundreds of retail accounts and back in the day there were probably 30 syrup companies in New York City. Everyone was very local when they started. Around the early 1900s there were no cars—it was horse and wagon—so everything was local. You had two places in East New York, two places in Williamsburg, places in the Bronx. And as transportation improved they spread out further. Then Coca-Cola came and everyone thought that was panacea. No one sold cola at the time; they sold chocolate, vanilla, strawberry, cherry, lemon, and lime. Coke built a business—a cola business. There was no such animal. And everyone at the time turned around and said, 'This is great. We'll let them put out the machines and sell Coca-Cola and we'll put out everything else.' The tail wound up becoming the dog. Coke wound up with 90 percent of the sales and very few places now sell chocolate and vanilla malteds or anything else. So the business changed dramatically and we changed as well. Now we only sell to distributors. And we have done well.

How do you make the perfect egg cream? There is some controversy, but we always say it's the syrup first, then the milk, and then the seltzer."

Photographed in Brownsville

Adrian Rose, 28: Worker at Junior's Restaurant

"I love working in Brooklyn—especially here at Junior's. I have a gift for putting smiles on people's faces and it's great to see the people of Brooklyn happy."

Photographed in Downtown Brooklyn

Aldo, 22: Worker at Ray's Tire Shop

"I came here for the job. I came here to find money. But I need to improve my English. I want my feelings to speak."

Photographed in Brighton Beach

Keith Apaman, 19: Fishing Boat Captain

"I'm the youngest captain on the fleet—I've been hanging out around this place since I was a kid. Fishing is something that is passed down from generation to generation. I hope this tradition and this life never fade from Sheepshead Bay."

Photographed in Sheepshead Bay

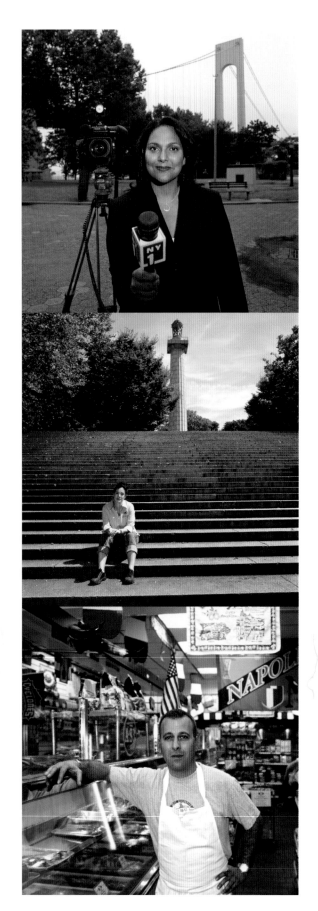

Jeanine Ramirez, 35: Reporter for NY1

"Growing up in Sunset Park was great. My mom and dad were born in Puerto Rico, but they met in Sunset Park, they got married in Sunset Park, and my mom became a teacher and then a principal in Sunset Park. We have very, very deep roots in the community.

I've been at New York 1 for nine years. New York 1 really likes to get borough reporters who are from the borough they're reporting from. When we're hired, we have to sign a contract saying we're going to live in that borough, because they want you to be able to know what's being talked about at the local grocery store and the diners. Even just driving to the supermarket in your daily routine, you may pass by a construction site and say, 'Wait, this is funny,' and you might happen on a story. Of course, I would have lived in Brooklyn anyway."

Photographed in Bay Ridge

Kara Gilmour, 36: Coordinator of Fort Greene Park

"I am 36, born in Miami, Florida, and grew up in a small town in Vermont. I moved to Fort Greene in 1997.

Brooklyn is a series of small towns in many ways. Similar to the small town I grew up in, I feel a part of the community here. I know my neighbors, the shopkeepers, the local politicians and community leaders. There is an unmistakable sense of community that is very special.

A big part of what makes this neighborhood so special is the park itself. Officially, I am the 'coordinator' of the park. I am involved in many aspects of park management, including developing free programming and other community outreach, as well as recruiting volunteers and day-to-day oversight. It's an oasis for all neighborhood residents, a beautiful landscape with rolling hills and majestic trees, along with a dazzling history."

Photographed in Fort Greene

Michael Paolillo, 36: Worker at A&S Deli

"I used to hate working here so much that I joined the Marines. When I was a kid I used to go out from the store to pick something up around the corner. I wouldn't come back for an hour because I had to say hello to everyone in the neighborhood. You had this guy to say hello to. Another guy to talk to. It was never ending. There's always something to talk about in Brooklyn. The people make it all worthwhile."

Photographed in Gravesend

Garrett Oliver, 42: Brooklyn Brewery Brewmaster *(top)*

"Around the turn of the century, Brooklyn had 48 working breweries. Not many people know that. This place was one of the brewing capitals of the world. When I moved here in 1985 there was nothing here to drink. There was Bud, Heineken, and the some of the other typical beers. When I started working here I wanted to bring that history and that feeling back to Brooklyn."

Photographed in Greenpoint

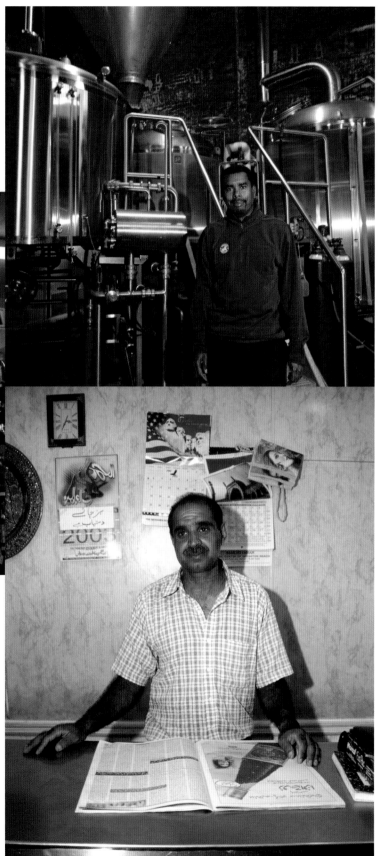

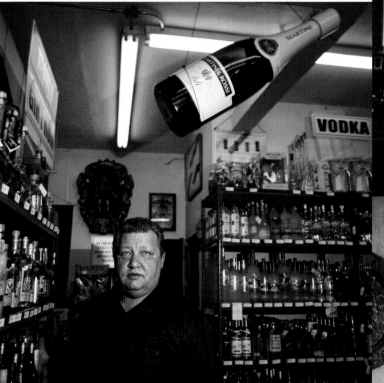

Yakov Bresler, 52: Liquor Store Owner *(above)*

"I only like to do business in Brooklyn. I want to live upstate. There's better air there. It's clearer. When I cross the Verrazano Bridge I have the vacation feeling."

Photographed in Sheepshead Bay

Chaudhary Afzal, 41: Restaurant Owner *(bottom)*

"When we come, we come to Brooklyn. I've lived here for more than 22 years and I love the beach more than anything else here. I go every day."

Photographed in Brighton Beach

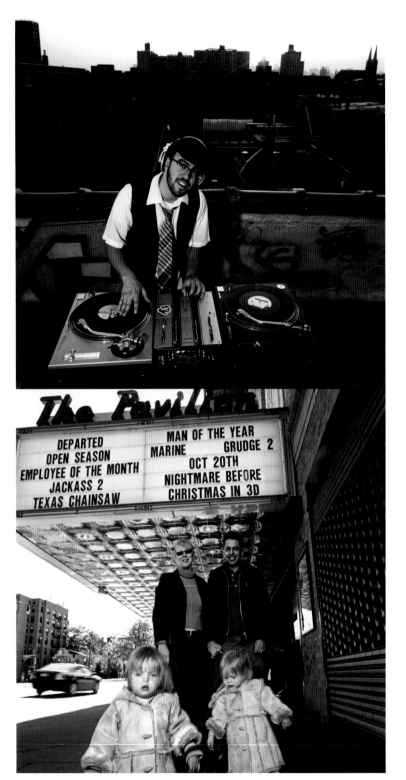

Erez, a.k.a. DJ Handler, 26: CEO of Modular Moods

"I'm a Navy brat from San Diego. I came here about two years ago, pretty much the second I graduated from Maryland. I knew that my music would do a lot better in New York. I live in Bushwick/East Williamsburg. It seems the people who live in Manhattan think coming to Brooklyn will put them in some 'Jews lost in the desert' scenario and so they don't do it that often. They have no clue what they are missing.

I once saw a hipster say hello to a non-hipster. But for real, I see crazy stuff everyday. People paint canvases and nail them to street signs in my neighborhood. I think that is really sweet. I've seen rich kids dumpster diving loft building trash for records. I've seen Hasidim talking to hot girls just so they could fill another loft space. The list goes on, cuz in Brooklyn, 'we crazy like that.'"

Photographed in Bushwick

Reuel Golden, 43; Emma Golden, 36; Freya, 1; Rafi, 1: Editor; Sales Executive

Reuel: "I was born in North London and I've been living in Brooklyn since 2004. Before I moved to Brooklyn, I never felt entirely settled in the States. Manhattan was exciting to begin with, but by its very nature, it never feels quite like a place where you want to settle down. It has a transitory quality to it. Brooklyn by comparison is home.

Frankly the amount of children in this area is pretty overwhelming and this is coming from a father of twins. I can see how the rest of Brooklyn and even Manhattan see Park Slope as 'stroller central' and home to right-on parents who are obsessed with their children eating tofu, but we love it here. Yes it does have too many stores selling overpriced kids' clothes and toys. Eight hundred dollars for some Danish minimalist dollhouse anyone? Yet it also has fantastic restaurants, second-hand bookshops and stoop sales—another great Brooklyn phenomenon. The best thing about it is of course the Park, which is a microcosm of all that I love about Brooklyn. It is a beautiful and grand park that also has a nice neighborhood feel to it. It is the one place that we always take visitors to, whatever the season.

I still feel conscious that I am English and living in a different country, but having children has diluted that feeling somewhat. It will even more so once the girls start talking with Brooklyn accents. When we fly into JFK after visiting England, I feel like I'm coming back home."

Photographed in Park Slope

Tone Elin Charlotte Balzano Johansen, 39:
Artist and Co-owner of Sunny's Bar

"I came here from Norway in 1994 on a P.S. 1 grant. I'm an artist. I didn't even know what the Brooklyn Bridge was when I got here. After living in a true roach motel in Manhattan that was filled with transvestites and smelled like coconut oil, and then the Webster Apartments for women in Midtown, I saw a flier there about an apartment in Red Hook and I jumped at the opportunity.

A lot of people say that when they come to Red Hook they can breathe, there's a lot of air and good headspace. You want friends and you want to be able to have an open mind for things that go on in your own brain, and this place allowed me that.

When I met Sunny, his uncle that helped him run this place had just passed away. This bar that has been here since the end of the 1800s was really run down. The floor was gone from leaks and there wasn't enough money coming in to do all the repairs. So we made the decision to rescue it. And now it's a well-run business. And we have such a connection with the people here. This is really the only place in Red Hook that survived the whole bad period."

Photographed in front of Sunny's Bar in Red Hook

Johnny Kelly, 38: Member of the Band Type O Negative

"I grew up over here by Marine Park and by Brooklyn College. I used to play football here and we used to hang out and drink at night by the clubhouse.

I started playing drums in the 70s. There was a guy who lived on my block who was into hotrods and played drums—he must have had a huge effect on me, because that is what I do now. He gave me and my friends five bucks to wash his super-70s van with the flares and the shag rug carpeting. So he gave me a couple of drum lessons. Later I found out there was a rehearsal studio on Flatbush Avenue and Avenue K. I started meeting up with people who played with bands and we rehearsed there.

Eventually I joined Type O Negative. When I first joined it wasn't like a big-time thing. It was really an elaborate weekend band. We didn't quit our day jobs. We were all from this neighborhood. Josh, Peter, and Kenny. I knew them from just being in the neighborhood. Being in a band with guys from Brooklyn was like taking the neighborhood on a bus with you. I also play in Danzig and that is cool, but there isn't the same sense of camaraderie. Of course with Type O everyone is so self-deprecating. There is always that dry, self-deprecating, glass half empty feel. But we have experienced the highs and the lows together and it never really changed us or who we are. And I always liked that about the band. And about Brooklyn. Brooklyn will always have that same feel about it."

Photographed in Marine Park

Leaping a potent congregation of impossibilities, the Brooklyn Bridge is a flock of prayers answered.

Tethered like a stone stitch to two islands, taming space and water, eras and erosion, it is our messiah—unfurling its long, stiff arms into the very souls of the cities it unites. Its soiled palms lift upwards, accepting all, accepting you. One leg standing knee-deep in the forever murk of the East River, the other stationed firm on the wordless bedrock of Brooklyn.

Like the borough it is named after, the great bridge is a merging of the foreign and far-off. It was dreamed up by John Augustus Roebling, a Prussian who was educated in Berlin before farming the land of Pennsylvania. It was built by German, Italian, and Irish workers. Its paint came from the mines of Wyoming, its granite from the quarries of Maine, its yellow pine caissons from the forests of Georgia and Florida.

On Thursday, May 24, 1883, 124 years ago, its first crossers paid one cent to wear the emotions of holy men and walk above water. The date was declared "The People's Day"—an official holiday for all. Thousands marched 1.13 miles on a structure that stood higher than all but one that day—the Trinity Church.

On March 27, 2006, we are due to meet a songwriter named Sufjan from Detroit, Michigan. Spring is official, but winter has its battered, dying fingers pressed lightly on the city. Ribbons of people move in rows alongside me, flipping coins of conversation around my ears—their secrets and snippets twittering from chapped lips like forlorn bees escaping a hive. Their words get caught in my hair, my eyelashes, before fluttering like sycamore seeds to the river. Will I ever tire of staring at these faces? Absorbing their thoughts through sideways glances? Trying to swallow lives in quick sips?

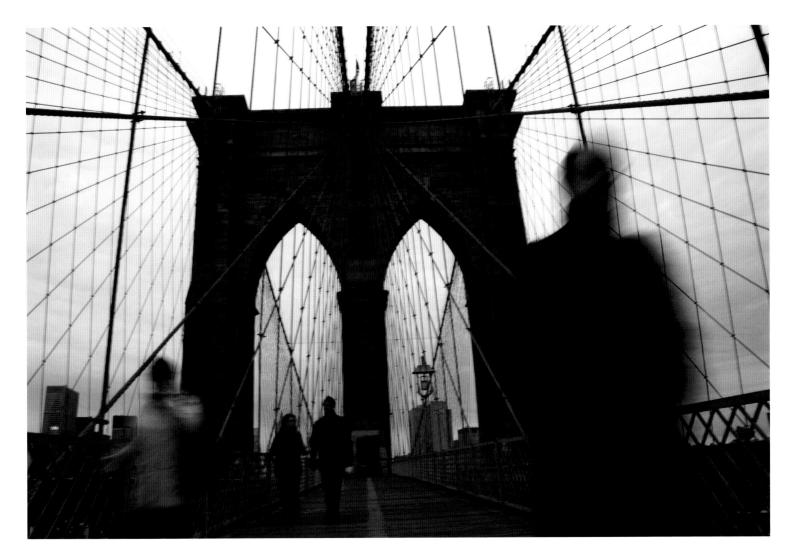

I keep moving through the flesh motorcade and the planks awaken into sky. To my left on the Manhattan Bridge, a subway, like a single strand of tinsel, slowly slides and clicks. As I walk in a steady beat, from Manhattan to Brooklyn, I'm rolling the lyrics from one of Sufjan's songs around my tongue like a handful of Tic Tacs:

"I drove to New York, in the van, with my friend
We slept in parking lots, I don't mind, I don't mind
I was in love with the place, in my mind, in my mind"

We meet him below the Brooklyn arch, beneath the gothic cut. He rides a bicycle to reach us. Mr. Stevens is known for his ability to capture a place, its rhythms, its myths, its buried stories, in song. He is also known as the singer who wants to create an album for every US state. He's completed two, Michigan and Illinois. I wonder, since he's been living here for years, when New York will come up.

"Probably when I leave," he says, looking down between the boards, possibly searching for answers within the swaying broth of secrets beneath us. Across the river, the spires of Brooklyn's churches lift like masts from a pageant of ship-wrecks. We stand between worlds surrounded by dancing steel ropes. Diagonal and looping cables holding us in a place where only spells and rumors existed years ago. Before this eighth wonder, this was nowhere.

"I think the first time I moved here, to New York, it was an infatuation just based on total fantasy. But when I moved to Brooklyn it was a deeper love, kinda like a marriage." With the way he speaks about Brooklyn, the New York album may never come.

Sufjan Stevens, 30: Musician (*opposite*)

"I grew up in Michigan and I eventually moved to New York to attend the New School for the writing program. I think I was always a musician even before I could play an instrument and I think I wanted to be a writer. Writing was more a sort of self-conscious desire through education, classes and reading. It was kind of a personal aspiration, whereas music was my natural language from the beginning. Writing was kind of a way to thwart music because I couldn't really perceive of a way to be a musician as a vocation or practical way of life. I could see myself as a writer or journalist. But when I got here I started meeting lots of other musicians and they just coaxed me into playing and recording songs and participating in their shows. I did it kind of unwillingly at first and I kept saying 'No, I'm a writer. I'll do this because you invited me. But I'm working on my book and I want to get published.' But eventually it took over and now I consider myself a failed writer.

I moved to Brooklyn about seven years ago. I first lived over by the Seaport across this bridge. Honestly I think I'd only been to Brooklyn once while I was living in Manhattan. It was just across this bridge and I kind of saw it as this odd mysterious place that I'd never been to. It's so dumb that I never visited it. I thought New York was Manhattan. And of course what a surprise when I actually moved over the river to near East Williamsburg. The street I lived on was all Puerto Rican. There were those two big Purina Dog Chow buildings that the Brooklyn Union Gas Company owned. I wasn't far from those. We used to say those were our Twin Towers. Then I moved pretty much every year to a different neighborhood, which was intense. I just didn't have a lot of money and someone would move out and I couldn't afford the rent. I had just quit my job. You know how it is.

Now I'm in Kensington. It's kind of like the suburbs of Brooklyn. It's quiet and it's not cool at all, which I like. But it's a short bike ride to all the cool neighborhoods. It's cheap. It's like the last affordable neighborhood where you can buy stuff. There are houses with driveways, which is un-usual here. And it's really diverse. There's no dominant culture there. A lot of Jewish families, Chinese Americans, Polish Russians. It doesn't seem like anyone is entitled to that neighborhood. It's just mixed.

New York and Brooklyn have helped broaden my understanding of reality and the 'American experience.' Coming from the Midwest, there is a particular type of regional characteristic to that area that you see in most people. There are immigrants and different cultures there, but generally there is a consensus of thought and ideology that you can use to describe the Midwest. That isn't true for New York, especially Brooklyn. It's such a melting pot and it's a point of interest for everyone in the world. I don't know anywhere else where you have so many different people and cultures getting together and getting along and tolerating each other. For the most part that is pretty supernatural."

Photographed on the Brooklyn Bridge

Brendan Jacob Smith, 9; Damon Issac Smith, 10; Jack Hatton, 10: Students

Damon: "I like all the different buildings. I don't like suburbia. And my best friends live in Brooklyn. I love the Jacques Torres chocolate factory, Grimaldi's, the baguettes at the new bakery, the water in the playground so we can shoot each other with our awesome water guns. I also really like the view."

Photographed in D.U.M.B.O.

Robert Ferraroni, 39: Metalsmith

"I grew up in the Gravesend, Sheepshead Bay area of Brooklyn. It was fun growing up there…enriching. It was a whole cast of characters. Downstairs there were Syrian Jews; upstairs was a guy from Lebanon. Half the block was Hasidic Jews, across the street was a Mexican Jew, and my best friend was from Cuba. It was really interesting getting a dose of all these people and their lives. Whether it was one kid who couldn't play stickball because they had to go to Bar mitzvah practice—he was a pussy—or all the different foods everyone was eating. It was great.

I grew up in a family of craft. My dad was an artisan—he was a cabinetmaker. I started this place in 1989. It was an intuitive idea to come here back then. At the time the Navy Yard was not lawless, but it was not organized. I pretty much found an abandoned building that used to be barracks for the guys building the ships during the war. No one had occupied it since the 50s. It was like an old Western, you couldn't even drive down the streets because they were just covered in garbage and debris. Eventually I moved here and I took over the whole building and some sheds attached to it. We even set up the forge outside—so we were blacksmithing right on the East River. There were really no people here at the time. Now it's about 97 percent full and I'm paying the real deal. But I think it has pushed us—myself and my partner Jeff Kahn—to make the business better and take it to another level."

Photographed in the Brooklyn Navy Yard

Oona Chatterjee, 35; Andrew Friedman, 36:
Directors of Make the Road By Walking (*opposite*)

Andrew: "I moved to Brooklyn in the mid-nineties, after eight years in Manhattan. My grandparents all lived in Brooklyn, and my parents went to Brooklyn College. I came because I wanted to escape the white noise of Manhattan, and because I love the neighborhoods, parks, food, and spirit of Brooklyn.

Brooklyn is a huge and fascinating world unto itself. Bushwick, where I live, is full of young people, immigrants from all over Latin America and street life. The neighborhood has gotten a raw deal in terms of basic government services like housing code enforcement and quality schools. We know we deserve better, though, and we're fighting to create real opportunity, and to protect the dignity of our families.

The organization I am a part of, Make the Road by Walking, create a space where community residents can come together for support, and build power to realize their dreams. It's a place where everyone has voice and everyone has an opportunity to shine."

Photographed in Bushwick

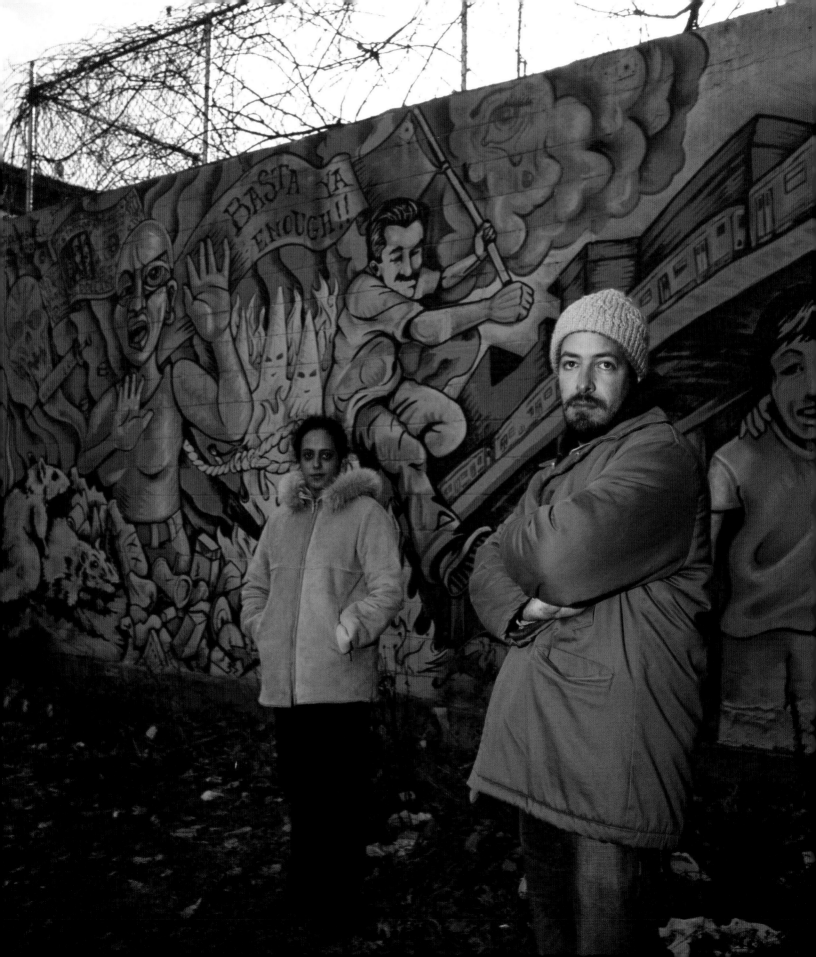

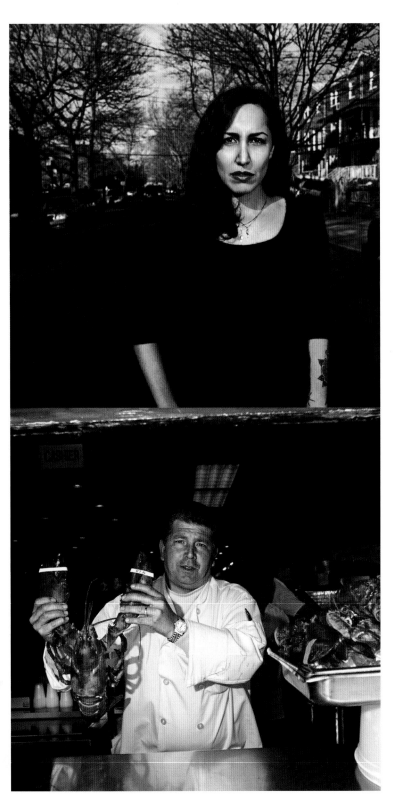

Carissa Pelleteri, 31: Photographer

"I loved growing up in Canarsie because it was pretty suburban for a city neighborhood. Most of my memories revolve around school and friends. One fun memory is the breakdancing phenomenon. Kids getting cardboard boxes and using them to breakdance. I also vividly remember my mom pointing out what a pimp and hooker car looked like. They occasionally drove through the neighborhood, on Flatlands Ave.

I loved my block. Everyone knew everyone. I guess it was like most close-knit neighborhoods where other parents looked out for each other's kids. I would get those Flintstone vitamins from my friend Tara's mom two doors down."

Photographed in Canarsie

Yitzchak Moshe Jordan, a.k.a. Y-Love, 29: Musician (*opposite*)

"I was born in Baltimore and moved to Brooklyn in 1999 to convert officially to Judaism (and eventually to become Hasidic).

What I think is special about Brooklyn is its diversity—I think Brooklyn is an example of multicultural coexistence that much of the world could learn from. Most specifically in Flatbush. I moved here because of its Jewish community—Orthodox and traditional with no compromise in its religious standards, while at the same time coexisting in a multicultural world. Want to know one of the craziest things I have seen here? An Albanian homeless drunk guy trying to tell me about Islam while sitting on the sidewalk by Coney Island Avenue and Foster.

My music is intrinsically tied to my views of G-d and the world, both of which were shaped in Flatbush. I would not have my view of G-d as it is today were it not for the learning that I did in Brooklyn. Brooklyn, in effect, is making my music."

Photographed in Flatbush

Paul Randazzo, 48: Owner of Randazzo's Clam Bar

"I've seen this place change so much. I wish it were quainter like it used to be—with more boats.

People come to Sheepshead Bay to come to my restaurant. But after everything is said and done, we are just a grain of sand on the beach."

Photographed in Sheepshead Bay

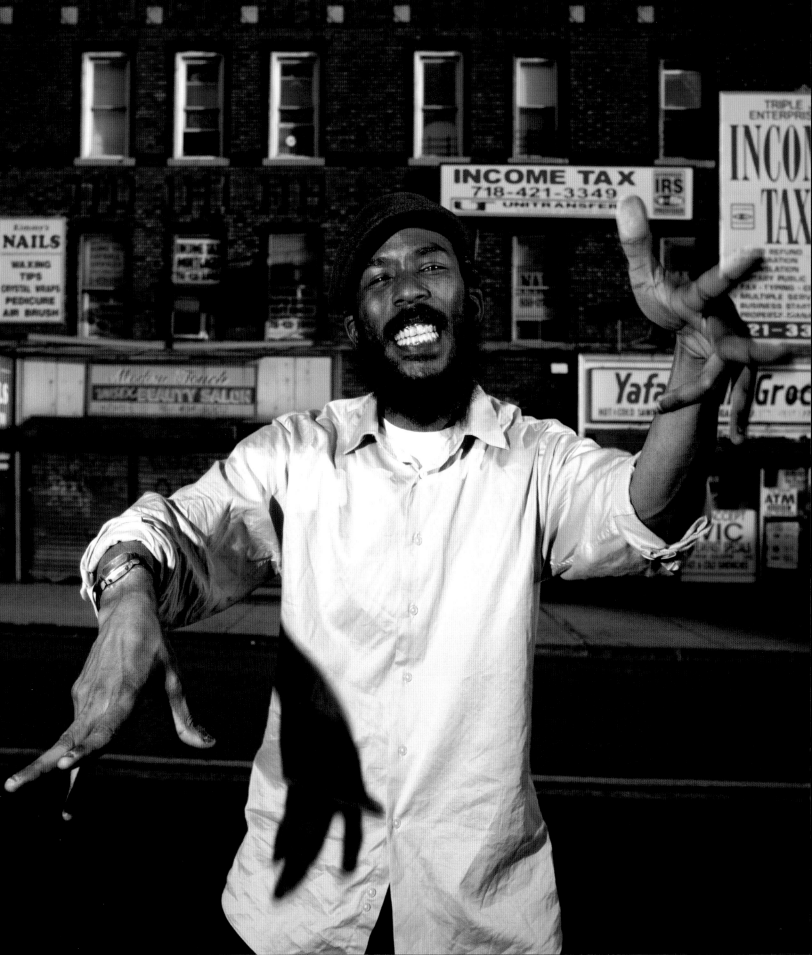

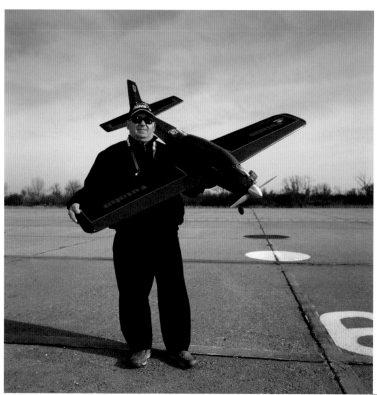

Tony Santelli, 60: Remote Control Airplane Flyer

"I have been interested in flying and planes since I was seven years old. I got into the remote control planes in 1976—my first club was called the Blue Angels, and it's been around since the 1940s.

I own five planes and yes they are expensive. The cheapest ones that I own are about $2,200 and the most expensive ones are $28,000. It depends on what you want to spend.

I fly here at Floyd Bennett because we have so many amenities here and the space is enormous. And this is the only place in New York City that you can fly jets. We have the best luck in the world with Floyd Bennett. People have been flying planes here since the 1950s. I'm here 60, 70, 80 times a year. It all depends on the weather."

Photographed in Floyd Bennett Field

Linda Kushner, 59: Mother

"I grew up in Borough Park. I loved growing up here because my whole family lived in one building. I had my grandmother, my aunt, my uncle, my cousin all in one building. It was family all the time and it was wonderful. My best memories from then were having my brother home and dancing to American Bandstand. All of his friends and all of my friends would hang out and dance and it was great. It was an amazing childhood.

I got married in 1969. All of my friends were moving out to the island and I knew I didn't want to go out to Long Island. My family was here, I couldn't leave.

Now Brooklyn feels secure. I feel very safe living here. I love Brighton Beach and Ocean Parkway. I pass down by where my parents used to live and I love it. It's my whole life here."

Photographed on Ocean Parkway in Sheepshead Bay

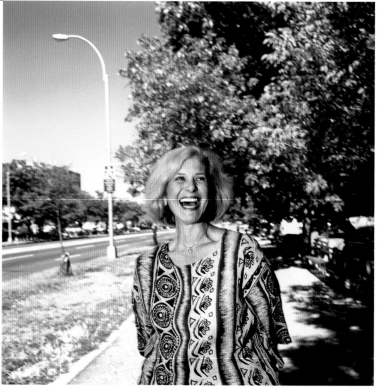

Greg Jackson, 55: Former Professional Basketball Player, Director of Brownsville Recreation Center, "Mayor of Brownsville"

"I was born and raised here in Brownsville and I still live here. I tell everyone it was a blessing being born and raised here. What it did was give you a chance to meet the greatest people in the world—Brownsville people. I met the best ball players. The best sports people in the world—Mike Tyson, Riddick Bowe, Willie Randolph, Zab Judah, and Pearl Washington. Then I had a chance to meet the politicians and all the little people in the neighborhood and it's all been great.

Brownsville helped me become a pro basketball player because it's so competitive here. The competition drove me and drives everyone here. It also brings us together. We could be anywhere—if we were in Iraq and there were a few Brownsville guys together, we know we could take anyone there. I could be fighting 50 guys—if there was one guy from Brownsville with me, I know he'd be there until the fight is over.

We have the best Rec Center in New York City. I joined the center when I was about nine years old. So it was only natural for me to become the director here. I have probably had a better time being the director of the Brownsville Recreation Center than I did playing in the NBA. We do everything that you dream about doing without any money. It is a true community center. Most people only highlight the crime and bad things about Brownsville. But I think if you highlight the good, only good can come from it."

Photographed in Brownsville

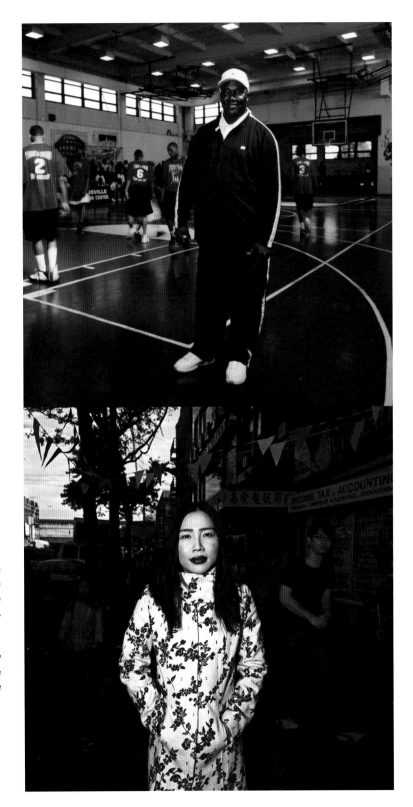

Oi Pin Chan, 27: Photographer

"I moved here from China when I was one. My family moved into the Midwood section of Brooklyn. The block we moved onto was a whole mix of people—Italian, Jewish. We were the only Chinese family there but we were completely accepted. The Jewish families would invite us in for dinner and everything.

Here on Avenue U my family would go shopping for everything. Now my parents still shop here for food. They buy typical things and some not so typical things—eel, frogs, chicken feet, cow tongue. Strange but not so strange. But nothing's too strange in Brooklyn, right?"

Photographed in Homecrest

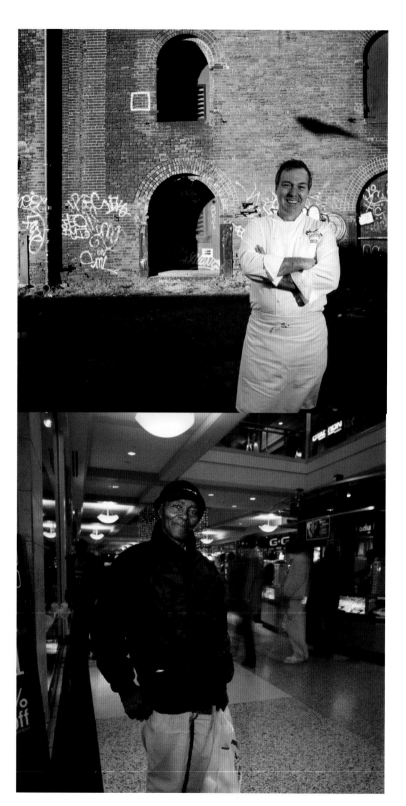

Jacques Torres, 46: Chocolatier

"I grew up in the South of France and moved to New York in 1989. I opened this shop here in Brooklyn on December 20, 2000.

I looked all over for a place but I fell in love with this spot because it is historic, it is full of character and chocolate is something tied to history and culture. You have the Brooklyn Bridge, the old warehouse—there is a lot of history surrounding us. And this wall behind me, I love this wall. The way the light changes on it throughout the seasons. I made this wall behind us in chocolate for a TV show.

When I moved in here there were a lot of working class people and I really connected to them. People watched me actually build the store here for three months, and then when I put the white coat on to sell the chocolate I think people thought, 'Wow, he's real.' And there are a lot of people in this area like that."

Photographed in D.U.M.B.O.

Paul Auster, 58: Author (*opposite*)

Mr. Auster submitted an excerpt from his book *The Brooklyn Follies*: "From a strictly anthropological point of view, I discovered that Brooklynites are less reluctant to talk to strangers than any tribe I had previously encountered. They butt into one another's business at will (old women scolding young mothers for not dressing their children warmly enough, passerby snapping at dog walkers for yanking too hard on the leash); they argue like deranged four-year-olds over disputed parking spaces; they zip out dazzling one-liners as a matter of course. One Sunday morning, I went into a crowded deli with the absurd name of La Bagel Delight. I was intending to ask for a cinnamon-raisin bagel, but the word caught in my mouth and came out as cinnamon-reagan. Without missing a beat, the young guy behind the counter answered: 'sorry, we don't have any of those. How about a pumpernixon instead?' Fast. So damned fast, I nearly wet my drawers."

Photographed in Park Slope

Sidney Bernard, 71: Retired

"I have brought my whole family here from Jamaica. There are the most loving people in the world here. They are always there when you need them."

Photographed in the Kings Plaza Mall in Flatlands

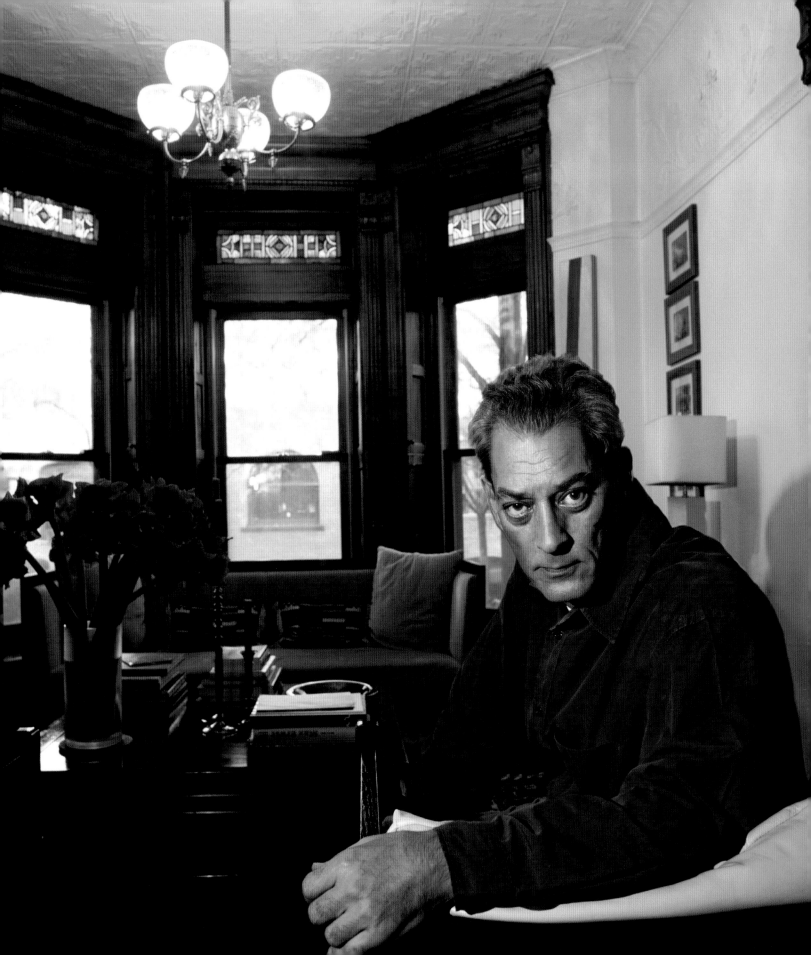

Brooklyn Cyclones

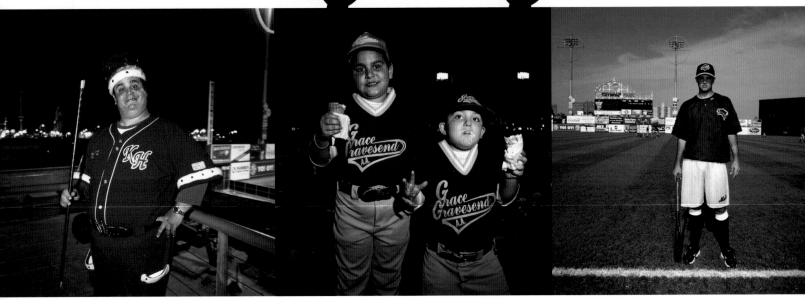

Yury Santana, 22: Shortstop for the Brooklyn Cyclones

"I'm from the Dominican Republic and I love playing in Brooklyn—the fans are good, the manager, Mookie Wilson, is good, and the place is good. The fans are multiracial, which is great, and every time I make a good play they scream my name."

Photographed in Keyspan Park in Coney Island

Kyle Robert Brown, 23: Centerfielder for the Brooklyn Cyclones

The whole atmosphere here in Coney Island is great. The fans here know the game just as well as I do—so when you don't hit that cutoff guy, or when you strike out when you just need to put the ball in play to get a runner over, they know about it and they let you know. But you just have to suck it up and maintain an even keel.

All the players stay in Poly Tech College. Living in Brooklyn is an experience I will cherish forever—I mean I never even took the subway before I got here."

Photographed in Keyspan Park in Coney Island

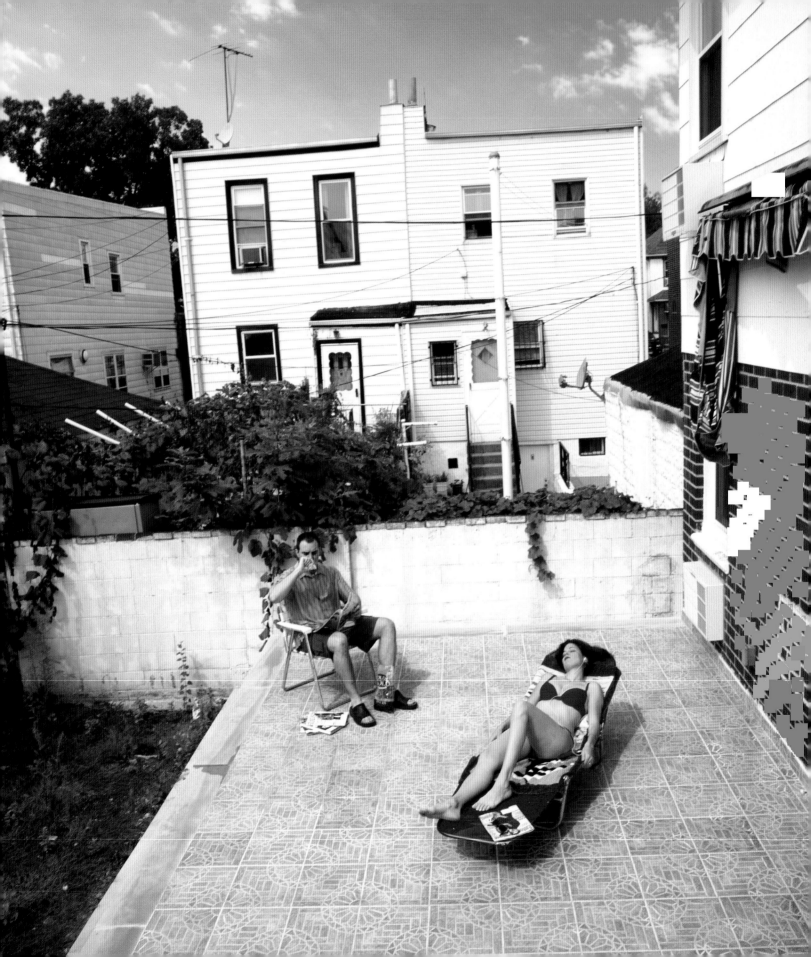

Jason Smollar, 31; Denise Smollar, 31: Lawyer; Teacher (opposite)

Jason: "The memories of growing up in Brooklyn are innumerable. You have to remember that all my 'firsts' took place here. Whether it was the first day of school, the first time hitting a baseball, or the first kiss, it all happened here.

Ah, my home. A man's home is his castle, right? Actually, you become your home's slave. We spent nearly two years fully renovating three floors and pouring concrete outside. Check writing is exhausting. (Actually, since these are Brooklyn contractors, cash is king of the castle.)

This is the backyard, a.k.a. the 'work in progress.' We have a great new tiled patio overlooking our diseased peach trees and telephone poles. We need to put in grass and some sort of privacy wall or bushes. It will host great parties to come, but for now it simply hosts a Weber grill, a radio, and two folding chairs. But we love the backyard. I grew up in a garden apartment. Most of my time was spent in front of the house or in the park across the street. Now I can grab a beer, a folding chair and a radio and sit on my blazing hot patio, while everyone in the surrounding houses and apartment buildings can watch exactly what I am doing. BUT IT'S MINE!"

Photographed in Bensonhurst

Frank LaSala, 62: Retired (above)

"I was born in Sicily and I moved to Brooklyn when I was eight years old. I'll always remember the mixture of nationalities and how easy it was to make friends. You knew just about everyone in your neighborhood. You looked out for one another. I also remember playing stoopball, tag, ring-a-leevio, Johnny on the pony, stickball, and scully. And catching garter snakes in the empty lots and keeping them all summer as pets.

Sitting (hanging out) on your stoop meant socializing with your neighbors, greeting friends as they went by, cooling yourself on a hot summer night. It was a place that allowed you to escape being 'in the house.'"

Photographed in Bensonhurst

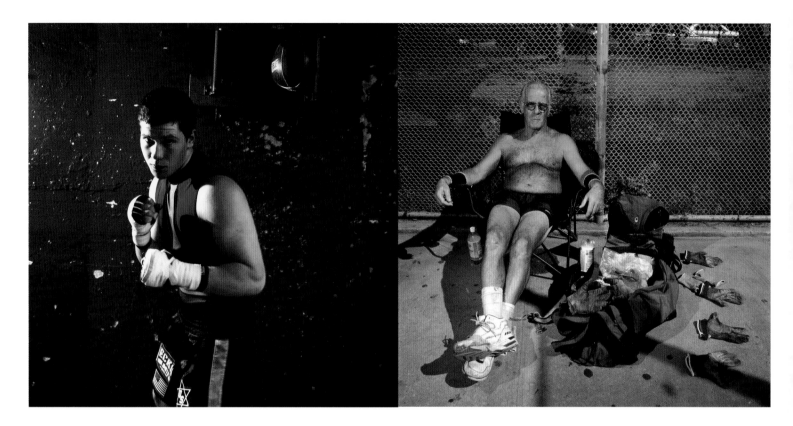

Dmitriy "Star of David" Salita, 23: Boxer

"I came here from Odessa in the Ukraine when I was nine. My dad's mother came here about 27 years ago. They settled in Brooklyn because of the very big, strong Russian community. Because of the big Russian infrastructure the transition was much easier.

I used to go to karate class in Odessa and I continued here. Later on my brother suggested I try boxing and I fell in love with it, from day one.

The boxing part of me might have been developed here, but I remember watching a Mike Tyson fight back when I was still in Odessa. I was four or five years old and I remember I would shadow box between every round. I asked my mother to blow the towel in my face like they were doing to Tyson. I also remember watching the *Rocky* movies and trying to run through the snow. Maybe I got the motivation back then. I started out boxing at the Starrett City boxing club. It was my home. I went every day for seven or eight years, so a part of me is always there and a part of my heart will always be in that place."

Photographed in Gleason's Gym in D.U.M.B.O.

Dick Velde, 59: Handball Player

"I've lived in Brooklyn since I was 20. It's funny, everyone outside of Brooklyn thinks you are either part of the mob or a tough guy. I was down in Virginia on vacation recently and someone asked me to say something in Brooklynese. So I said 'Give me your wallet.'

I come and play handball here all the time. I go through these gloves so quickly because I sweat so much. I have a million of them."

Photographed in Coney Island

Yoel Judah, (age not given): Boxing Trainer (*opposite*)

"People from Brooklyn—if you don't know them they can be the coldest people out there. But if you get to know them they are the best people on earth. The best. You know what I mean?

Raising my sons here—at first it was really tough. We moved around some bad neighborhoods and they got into fights with rocks and bottles—gang fights with 15 other kids. I had to teach them how to fight and box and make something of themselves."

Photographed in Gleason's Gym in D.U.M.B.O.

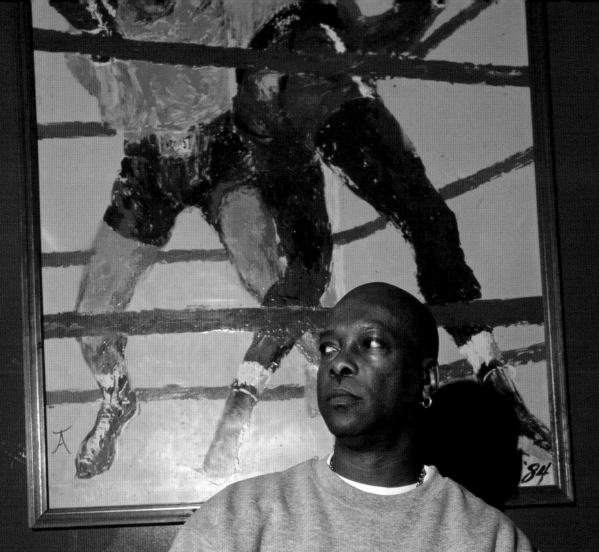

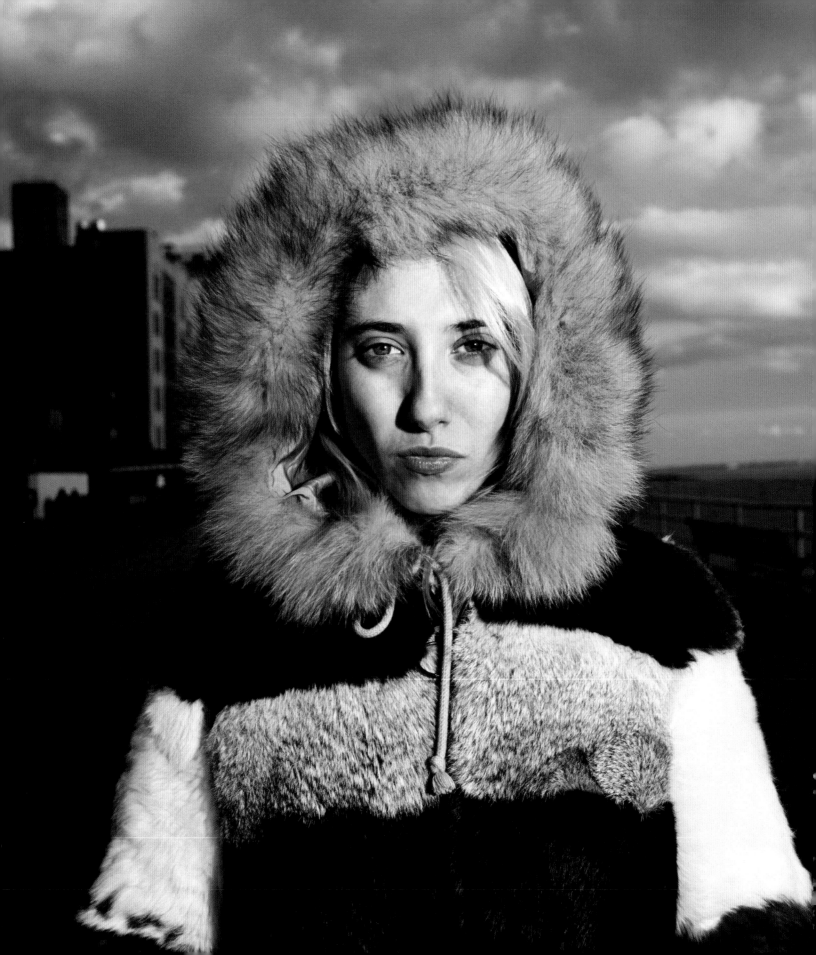

Yana Toyber, 27: Photographer (*opposite*)

"There is a difference between the people in Brooklyn and everywhere else. A difference you always feel. Especially when you grow up here.

Brighton Beach and Brooklyn in general are all about 'the deals'— you can find things here for less money, things you wouldn't find anywhere else."

Photographed in Brighton Beach

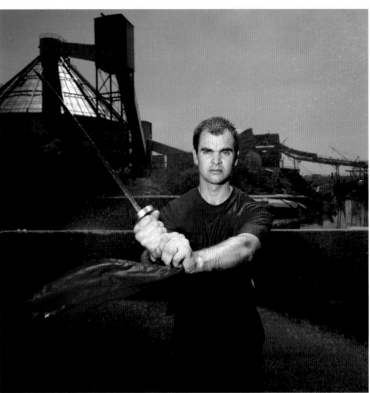

James May, 32: Bartender (*above*)

"I've been living in Brooklyn for nine years now. I came to here from Dublin, Ireland. Basically I needed a change. I landed in Red Hook by chance. I got off the plane, searched around and ended up here, which was good.

When I got here I also did construction to make money. When you are illegal you do construction, then I got into bartending in Brooklyn. I like Brooklyn because it's quiet. It's an escape from the city. You wake up here on a Sunday and there is no noise. That reminds me of Ireland. It's a nice neighborhood. You have waterfront property and I love the water—there are some piers that I go down and just chill out. I also love the old buildings and the cobblestone streets. It's a unique place to say the least. I probably will never move from here. It has changed an awful lot though. A lot of the industrial buildings have shut down and turned into loft spaces that are pushing some of the original people from the neighborhood out.

I got into martial arts when I was young in Ireland—I studied Kempo, which was more street fighting. When I came over I wanted to study something different. There were no Kung Fu schools in Ireland and I was always drawn towards Kung Fu, so it was a chance for me to go and check it out. It's one of the things that I got to do here."

Photographed in Red Hook

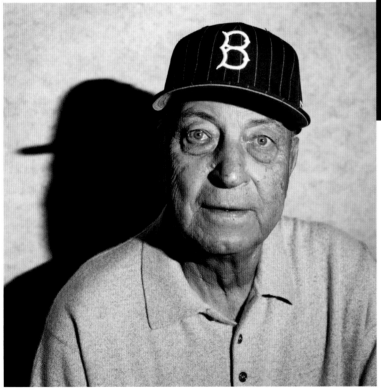

Johnny Podres, 74: Former Brooklyn Dodger (*above*)

"I love everything here in Brooklyn. Especially the food. I love the pizza at this place called Armando's on Montague Street. Brooklyn will always be special to me."

Photographed in Dyker Heights

Dyker Park

Inside the calmly beating heart of Dyker Heights we have wandered unknowingly into a lost tribe of men.

They have built a settlement based on amusement, on 86th and 14th, inside a leafy, subdued park. Worn men dressed in aged plaid smelling of rolled tobacco and aftershave. They pull brims of heavy wool down low, partially hiding pupils that still burn with the eagerness of boys. Obscured eyes that have been wrapped in creased skin—like tiny berries enveloped in a baked piecrust.

Within this congregation of elders, in a location where the sports of the young—basketball and baseball—stand side by side with the games of the old—pinochle and bocce—chance speaks in strange tongues and foreign shapes. Cards from another world are exchanged across checkered stone tables. They are small rectangles with unfamiliar figures, resembling the instruments of a fortuneteller more than the playthings of grown men. Coins, cups, swords, and batons take the place of hearts, spades, clubs and diamonds. Rubberbands are strapped crossways over the slabs—elastic defenders against the wind. The men stare into the unturned deck—summoning the souls of royalty. The concentration of the players, who cradle their cards like captured hummingbirds, is astonishing. Wars and women might be the only things that could distract them from the deal.

Beside them a pale dirt court attracts the attention of dozens. Its stone barriers make the rectangle area something of a stage. And the actors play their practiced parts well. Seasoned limbs heave large ceramic spheres into the air, hoping to place them near

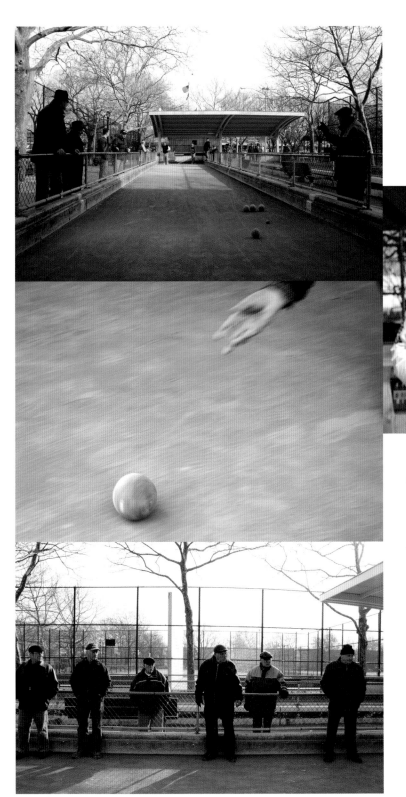

the company of a tiny silver ball. Taunting each other with insults swathed in distant dialects from Mediterranean towns long abandoned, their barbs are the soundtracks of the day. There is laughter, there are groans, and there are choruses of jeers. All of it broken only by the strangely soothing sound of clanking orbs.

And why have they come here? Is it to escape the boredom of grayish living rooms? To stir inside the depths of an early fall day? Is it to challenge their peers for small fortunes? For brief moments of fame and grins of dominance? Is it to flee the loneliness of vanished wives—shards of their broken hearts stashed away all over their homes—in the fissures of sofas, in rusting tin cans filled with the smell of coffee grounds, under pillows swathed in ashen hair, in backyards shaded by thinning fig trees? Maybe all or maybe none.

But still they are here. A moving backdrop of wrinkled fabric pushing fortune towards the limits of dusk—their return to this same spot the only certainty among these games of uncertainty.

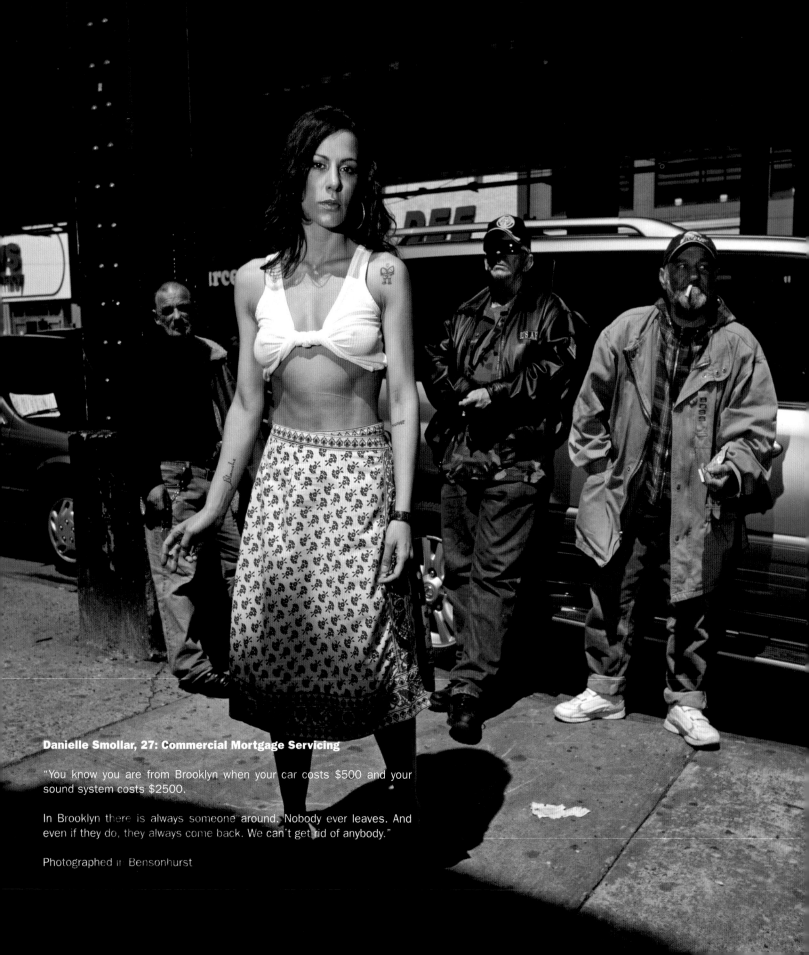

Danielle Smollar, 27: Commercial Mortgage Servicing

"You know you are from Brooklyn when your car costs $500 and your sound system costs $2500.

In Brooklyn there is always someone around. Nobody ever leaves. And even if they do, they always come back. We can't get rid of anybody."

Photographed in Bensonhurst

Patsy: "It's the borough that makes this city great. The people here are fighters—you can't diminish their willpower. Especially mine."

Raymond: "Where am I going? I was born two blocks from here. Why do I need to leave? I don't need to go anywhere. I was born here and I will die here."

Photographed in Bensonhurst

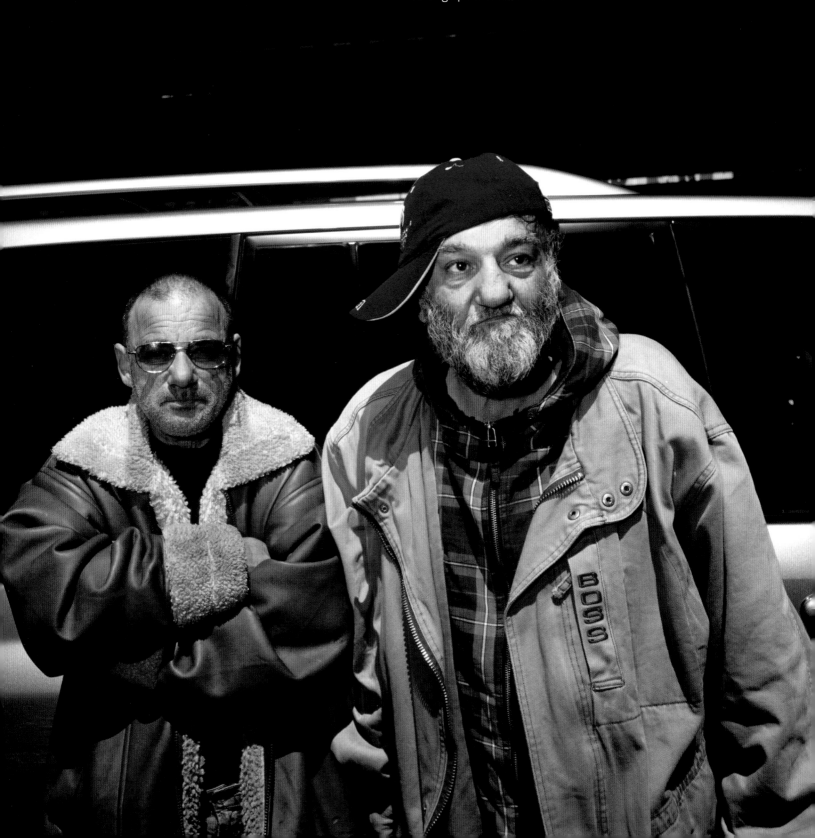

Karen Brooks Hopkins: President of Brooklyn Academy of Music

"I think that B.A.M. has been a part of the community of Brooklyn since it was originally built on Montague Street in 1861. This building behind me, the Peter J. Sharp Building on 30 Lafayette Street, has been here since 1908.

B.A.M. is not only one of the great historic cultural buildings in the country but it's a great building for Brooklyn. The real estate of this institution, with the four movie theaters, two theaters, and the B.A.M. café, is so Brooklyn. There are a lot of different entry points with things going on, music in the café, movies on the screen, the Brooklyn Philharmonic. All of these things happen at once—and that's Brooklyn. That is the Brooklyn vibe."

Photographed in Fort Greene

Melissa Hinkley, 28; Kalil Justin, 8: Graphic Designer

Melissa: "I spent my whole life in Sunset Park. I had a blast growing up here. There were a lot of kids in the street and I was out in the streets all day playing. A real city childhood. We played mostly bad games—we made zips guns and pegged people in the ass. This was also the block where people came off the train, so we would put trip wires and nails sticking out of the ground. We were bad kids, but we also did good things like selling cookies and iced tea and lemonade. We did puppet shows. Anything to hustle some money for candy. We had Woolworth's on the corner—the five and dime place.

This is a good neighborhood, though a lot of shit went down here. A lot of gangs in the early 80s, people that just ran the neighborhood. There were the Assassinators, with this guy named Hicky Wicky as the gang leader. He used to wear this bullet belt everywhere, even to the community pool. I'll never forget, I must have been around nine or ten—and I was with some girls from the block and here is this gang leader buffed out, long hair and goatee, bullet belt and leopard skin bikini. Bam!"

Photographed in Sunset Park

Patricia Dove, 33; Otis the Sea Lion: Trainer at the Coney Island Aquarium

"When I think of animals that feel like Brooklynites I think sea lions and also the Beluga whales. One reason is because of the time when two of our Belugas were sent to Mystic Aquarium in Connecticut for a breeding loan. They developed a bit of a reputation for monopolizing the males and keeping the other females at bay. Regarding their attitudes I recall somebody saying, 'That's because they're from Brooklyn.' They knew they were the best and it's great to have them home."

Photographed in Coney Island

Barbara LaSala, 60: Principal Appellate Court Clerk

"I grew up in such a diverse neighborhood, Boro Park, in the 50s and early 60s. Being of Italian heritage and having close friends that were of Jewish, Greek, and Irish heritages, was a wonderful experience as a child. I not only got to enjoy macaroni and meatballs on Sundays, but lox and bagels on Saturdays, and Greek dishes during the week like moussaka cooked by my best friend's mom, Kate Thorakos. We also experienced each other's religious houses of worship—we would keep each other company whether it was in a church or synagogue and learned to respect each other's beliefs.

Brooklyn has village appeal. Downtown Brooklyn is a perfect example, especially Montague Street. Not only is it lovely to look at—the promenade, the cobblestone streets, the churches, even the Appellate Court on Pierpont and Monroe Place—but it is also a tight-knit community. The beauty of the historical townhouses has such wonderful allure—I love walking along Henry Street in all the seasons. It gives me such a sense of peacefulness. What added to it was working directly for the Presiding Justice of the Appellate Court in Brooklyn in one of the most beautiful judge's chambers I've seen to date, and the judge ordering the best brick oven pizza for lunch from Patsy Grimaldi's. What more could you ask for?"

Photographed on Montague Street in Brooklyn Heights

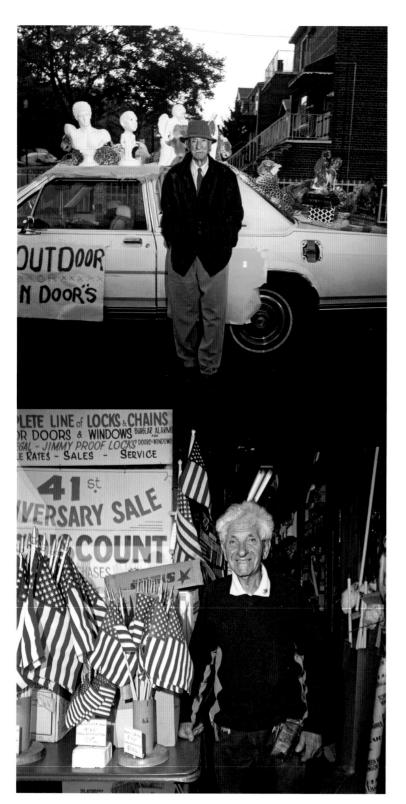

Joe Virgilio, 86: Statue Seller

"I was born in Detroit, Michigan and moved to New York in 1940 when I got married. We went to Brooklyn because my grandmother owned a shoe store on Avenue X. It was a quiet, nice neighborhood back then. Now it's nice, but not so quiet. I used to work for the Ford Motor Company. Now I've been selling these things for almost 20 years. I like statues and things, so this was a good thing to do."

Photographed in Dyker Heights

Cat Hartwell, 25: Member of the Band Fannypack (*opposite*)

"In Brooklyn, especially in my neighborhood in Prospect Heights, everyone knows you and you know them. The whole community—from the guy at the bodega to the girl at the grocery store, to the old Jamaican guy named Sunshine who sweeps the leaves. From the first day I moved here, I knew it was going to be a good neighborhood—a character-based neighborhood with an international feeling."

Photographed in Bicycle Station backyard in Prospect Heights

Seymour Shepetin, 78: Hardware Store Owner

"I like it here so much I don't even know what I like about it. I grew up here and I'll probably be here for the rest of my life. I took over this shop in 1948. Harry Truman was president. My brothers were electricians and after World War II took them, I got the shop. Bay Ridge is such a nice place. Everyone knows me here. They come here for all the odds and ends and I'm happy to help them out. I feel like I keep the neighborhood together with my shop."

Photographed in Bay Ridge

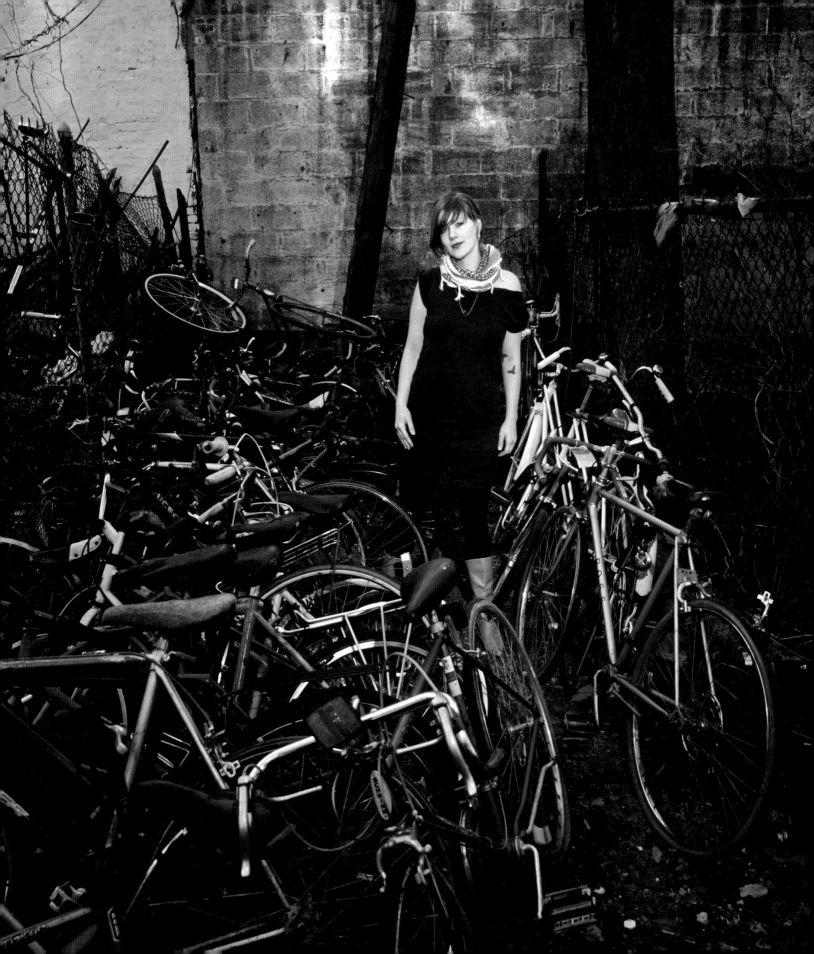

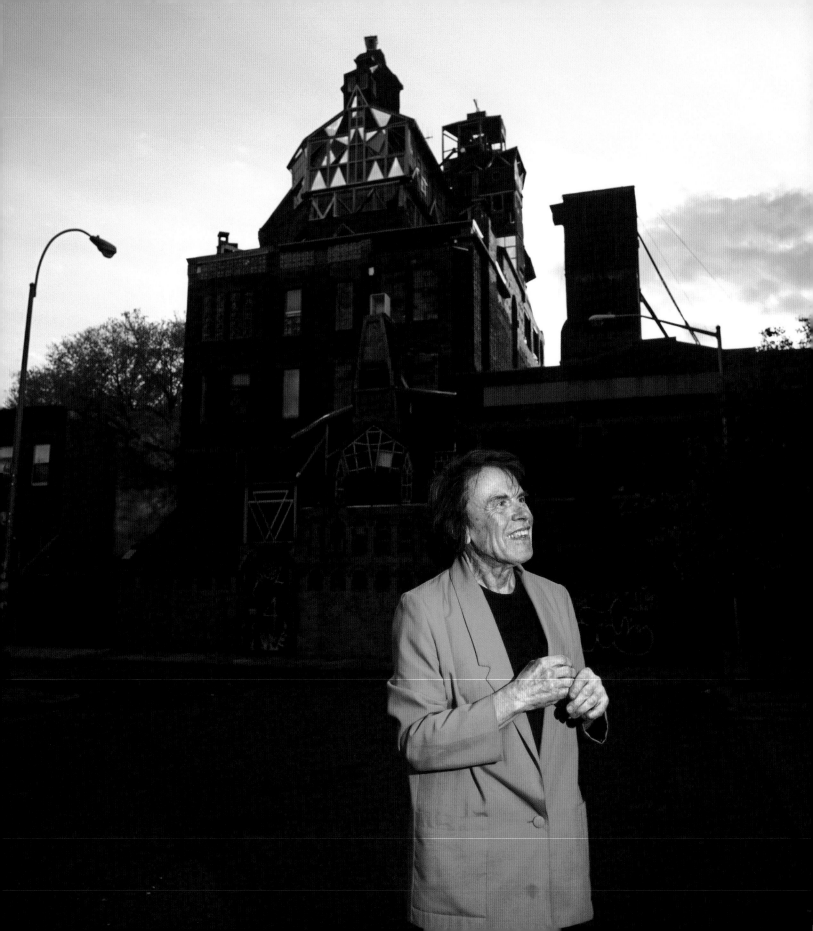

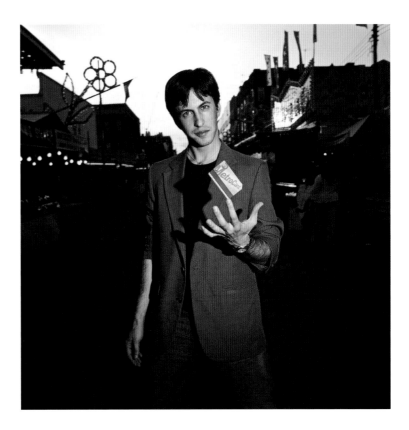

Arthur Wood, 75: Master of Broken Angel (*opposite*)

"I was born in Saratoga, New York and I moved to Brooklyn when I was 19.

The inspiration for this place came from a dream that I was floating over a building. I was surrounded by mist and through the mist I could see all around Brooklyn. I saw the Brooklyn Museum on one side and the bridge on another. Below me was a fountain, which made no sense to me logically, that a fountain would be on top of a building. So I decided it must be a whale's spout and I was in a chair above it. When I woke up I knew I had to build this.

I got the name for the building from a trip on the Staten Island Ferry with my wife. We spent the day walking around and on the streets of Staten Island we discovered an angel and it was broken in seven pieces. My wife, who wasn't my wife at the time, said to me, 'It's an omen, a sign. I'm to marry you.' I put that angel back together again, but after I did we found an intact copy, of which there are maybe thousands. The originals are stiff. Mine is kind of graceful. That's why we call this Broken Angel. I bought the building in 1979 for $2,100 and it was wrecked and vandalized and lying in the street and I'm putting it back together again, better than it was. The building is only a third done. I have been working on this building for over 25 years and it's not even close to finished.

Once the cops came because someone reported a child climbing on top of the 'dangerous' building. So they show up and see him up there and they tell me, 'Did you know there's a child up there?' I said, 'Sure, he's my son.' They realized he grew up here so they left us alone. My son was like a monkey in a cage up there.

I think if you live in a small, tiny apartment, your dreams and ideas are small. If you live in a large place—a place with room and space—you dream big."

Photographed in Fort Greene/Clinton Hill

Ryan Oakes, 27: Magician

"I started magic when I was five—now it's a full-time thing. I have worked everywhere from Bat mitzvah's at the Rainbow Room to small clubs to B.A.M.

Magic has opened more doors for me then you could possibly imagine. From breaking the ice with some tough guy who is standoffish to someone who doesn't speak English. There was a time I was going to get the windows on my car tinted, don't ask me why, and I found this guy who did that out in Prospect Heights. When I pulled in I got a bad vibe from him—he was pretty surly and not very accommodating. I had five or six decks of playing cards in the back of my car. So he asks, 'What are all these decks of cards in the back of your car? Are you a poker player or somethin?' I told him I was a magician and I did this trick for him and instantly he did a 180. He would not stop talking to me the entire time. It was amazing to me to see this transformation of this rough, tough guy who didn't even want to say hello to a little kid.

What would I magically change about Brooklyn? I would rent stabilize all the apartments."

Photographed in Williamsburg

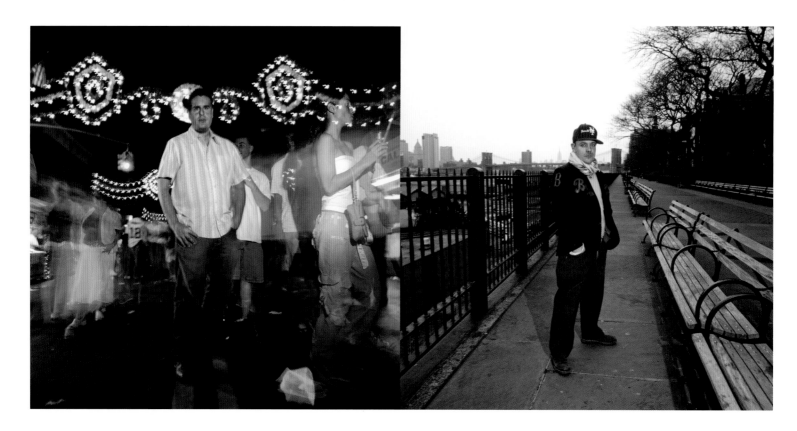

Anthony "Skeery Jones" Scire, 33: Executive Producer for Elvis Duran and the Morning Zoo, Z100NY/Y100 Miami

"What stands out in my mind were those hot summer nights checking out the scenery at those outdoor picnic tables at L& B Spumoni Gardens. I remember Mark Twain J.H.S. in Coney Island, and bike riding from the Caesar's Bay parking lot along the bike path at the side of the Belt Parkway to the 69th street pier. I remember the great movie theatres like the Walker, the Marlboro, the Fortway, the Benson Twin, and, most of all, the beloved Loews Oriental.

Brooklyn is unique, and what's more unique than the 18th Avenue Feast—with lots of buff, shirtless, tattooed guys with pythons wrapped around their necks? Sure, the San Gennaro Feast in Manhattan might have the edge with their version of Sausage & Pepper heros and zeppoles...but the true CHARACTERS are here in Brooklyn.

Growing up in Brooklyn gave me thicker skin. It was a tough town. You had to be streetwise. You had a sense of pride about your upbringing...and you had to develop a sense of humor about life. I took these characteristics with me throughout my broadcasting career. These days I am still strong in my opinions, beliefs, and values. I love to laugh and live life to the fullest, ready for every experience life throws at me."

Photographed at the 18th Avenue Feast in Bensonhurst

John D'Aponte, 30: Designer

"What makes Brooklyn a great place to live? That's the paradox of Brooklyn—what makes it suck is what also makes it great. Like two sides of a coin. It can be completely disconcerting and confusing to be raised surrounded by people who have different social mores. Your parents are raising you a certain way and there's a kid down the block who grows up another way. People have all different kinds of ideas, about religion or politics or social etiquette or how much money their family has and what that really means. But these are the kids that you have to forge alliances with and these are the kids that you make your crew out of. So you get to have some of the closest people in your life represent a lot of different cultures and benefit from them in the longrun. Sometimes it's not crystal clear about how it's a good thing but in the longrun it definitely is.

As far as being a designer, Brooklyn has given me a certain sensibility. You constantly see people from all different walks of life. Living in Brooklyn has been a wonderful primer from a wearable point of view on the many worldly ways of carrying and clothing yourself. From a functional point of view, the idea of waking up every day when you're 14 years old and getting on the subway to go to school makes you very aware of how mentally organized you need to be. And how you really want to carry as little as possible and the manner in which you want to carry those things. It's also made me fetishistic about certain materials; I never could rock a leather jacket because I always knew it was going to get ripped off. Being from Brooklyn has given me an appreciation for materials and attitudes and the first impressions that are determined by them. It's about how you walk when you rock it. That's what expresses your intent."

Photographed on the Promenade in Brooklyn Heights

Grace Villamil, 27; Jennifer Monzon, 27: Photographer; Unemployed

Grace: "I was born in Orange County, California. Eventually I found myself here in Greenpoint.

If I leave my apartment any time early in the morning, any day of the week, the street corners and bodegas are lightly filled with Dominican, Puerto Rican, and a few Cubano elderly. All of them speaking Spanish softly to each other. It's 100 degrees out, they still have long pants, and their guayaberas on, and all the while they are calling 'Buenos dias' to one another from across the street—I love it.

I love riding my bike around and cruising with 'Belice'—that's what I call this 73 Valiant—on hot summer nights, with the yellowish tint of the street lamps shining down. Dodging the open fire hydrants spraying everywhere, passing the streets with men playing dominoes at fold-up card tables, the women yelling at their kids to get out of the street and get out of the water—then running into friends sitting out having a cold beer or something. Wow. I never stopped to think that I DO consider Brooklyn home."

Jennifer: "I was born in Manila, Philippines and I moved to Brooklyn four years ago.

Brooklyn has a great mix of characters and each area has a different vibe. I feel very much at home here. My Laundromat is across the street—I love that! And the best scones are around the corner. Hanging out on my friend's roof on a really hot summer day and having the city as my backdrop. I really love Brooklyn."

Photographed in Greenpoint

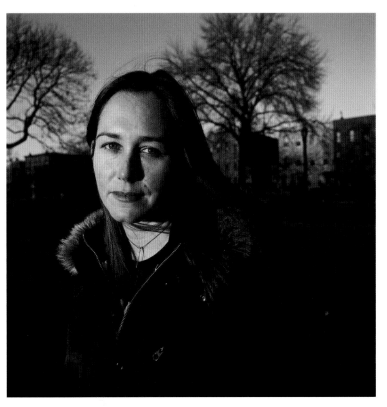

Anna Rieke, 36: Sound Engineer

"The sense of community and variety of people here is amazing. There are Polish people here, Italian people, old people, young. And they care about you. They will ring my buzzer if they see that my car is about to get a ticket, they will come by my apartment and see if I'm okay when I'm really sick. It just feels like home here."

Photographed in McCarren Park in Greenpoint

Feast of Santa Rosalia

Will you meet me where the spirits meet? Where they dance in summer's casket? They have opened the street to footsteps and I've disassembled the before and after. People on top of trash on top of people on top of trash.

I have prayed to you before, Santa Rosalia, here on this Brooklyn boulevard. I've walked the yellow lines; my hands wrapped tight, my lips whispering entreaties. Am I the only one who knows you're the reason we're all here? The gutters are lined with thick, white trucks. The rooftops are the bleachers. Powdered zeppole sugar floats on air and the teenagers are on the hunt. The crowd is twisting and jolting like an animal confused. I'm rowing through a fluorescent tunnel of glittered limbs and too-tight fabrics. Viewed from above we are a boiling valley of drip-drop bomb pops on the move. Will you find me here among the games, between the barks of cons? Will I find you here, alone perhaps, in a slow march-flirt towards the dark?

I'll stray with you, if you ask, to the mysterious safety of the side street. To the liquid quiet of stoop-front Brooklyn. We'll pass the families on stone steps, murmuring in the dark, watching the drifters shuffle from the show. Cigarette and cigar circles burn red in the shadows behind the fences as wayward sprinklers tap wet fingers across our ankles. We'll walk over smeared chalk hopscotch and pass the pop pop of Spaldeens kissing crumbling schoolyard walls. The lofty, elevated subway tracks will be our mountains and our markers in the distance.

We can slip off through the labyrinth of slender alleys to the hidden backyards. Past the tool sheds and their rooftop, Wiffleball graveyards. The children will be swimming in aboveground six-foot circle pools, banking

"Marco!"..........."Polo!"

off the carbon sky. We'll hop metal fences and lie beneath a canopy of sycamores and a hailstorm of fireflies strobing the boxed-in nature. Lets dig bare hands beneath the dirt, below the stone and urban myth, past the scully boards, flipped Topps and doo wop soil. Below the Dutch farmland and the fossils. If we dig deep enough, hard enough, climbing down through the County of Kings, we just might find ourselves tonight.

I come to you one last time, my dear Santa Rosalia. You saved Palermo from the plague in 17th-century Italy. Can you rescue my own faith from plagues of fear and doubt? I offer you my pocket green via elders with antique accents. Labor Day patiently waits with a guillotine smirk. I'll walk along this black spine, dressed in vivid shades, until the final day.

One last time. At least until next year.

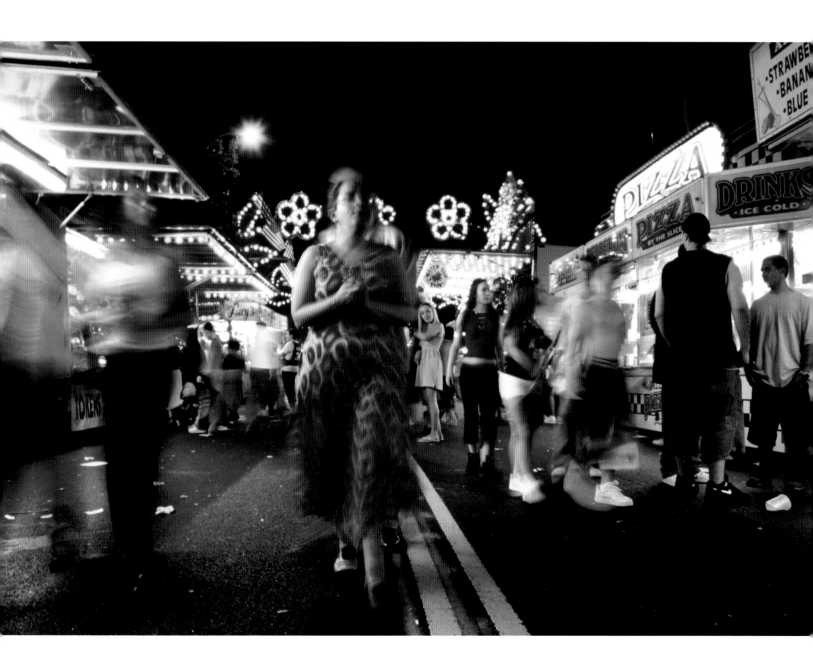

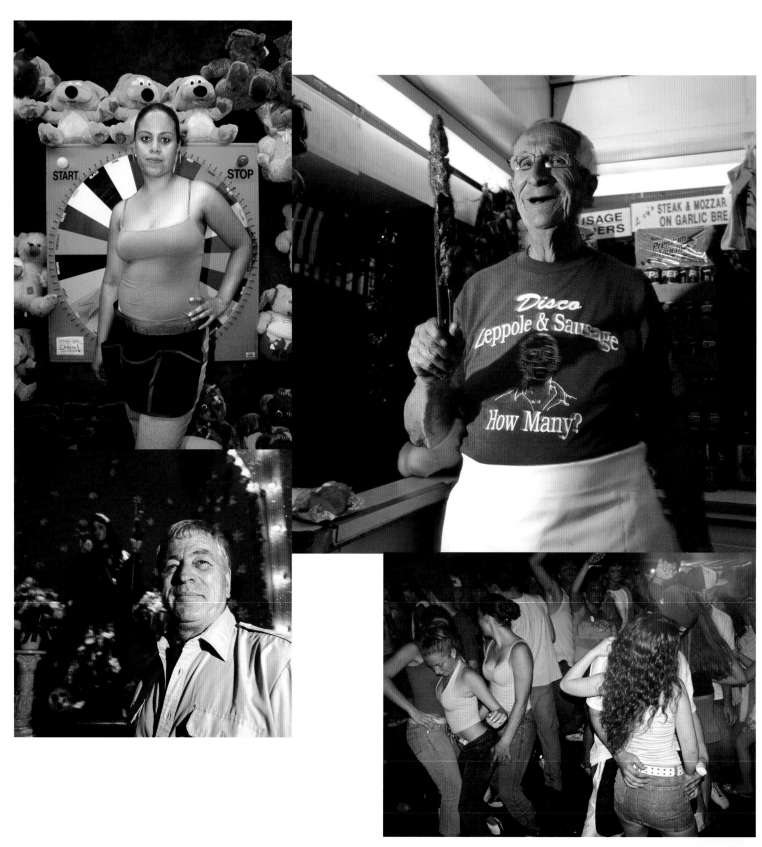

Jimmy Palmiotti, 43; Amanda Conner, 40: Comic Book Creators (*opposite*)

Jimmy: "I grew up on Avenue J and East 34th. It was a very neighborhood-y type of place—you knew which block sucked, you knew which block's kids would throw stuff at you, which block had the karate store where we would buy ninja stars and throw them at the trees and buses. We had a backyard that had a crappy little postage stamp patch of dirt—it was multi-purpose though. We would dig holes in it and light fires. We used to make stop action movies—blowing up action figures with M80s. Then we used to find the refrigerator boxes—that was a month of amusement. We'd use them as tanks, rolling in them like a gerbil until we hit Flatbush Avenue and heard car horns telling us to stop—quickly. It was one of the few places you could skitch or play salugi. Skitching was grabbing on the back of a car after it snowed and letting it drag you down the block. Halloween was fun in Brooklyn because you could egg people; you could put Nair in the eggs. Dropping eggs from the roof of the apartment buildings—we felt like we were in WWII—timing it perfectly to hit someone walking.

I like it here in Gerritsen because it's enough away from the pseudo-Brooklynites wearing trucker hats from trucking companies that don't exist. Thinking they are cool by living 'down under' in Brooklyn and gaining their bragging rights by wearing Brooklyn T-shirts when they just moved here. That drives me nuts. I like the fact that the places I eat in around here are still not 'hot' or on some *Time Out* list because the *Time Out* asshole refused to get out of the train past a certain stop to investigate. I like the fact that it is too far out that excessively rich white yuppies haven't found it yet—nothing against them—Park Slope is nice but it's city hip. Down here, we are one of the last holdouts for real people and old people and families. I also like that it is a melting pot of who cares. A lot of boroughs are dictated by who owns that section or this section—I think it's a lot more meshed than people give it credit for.

Also in the city you can go some place eight million times to eat and they won't know you, but neighborhood places here know you by name. They even start to give you advice on what to do with your life. In Brooklyn, there is free therapy and counseling.

Comics-wise there is no lack of material. The *Monolith* book is about two girls living in Brooklyn that had a monster in their basement—it was pretty easy to write that book. There's a lot of history on Brooklyn in that book. It was my favorite thing that I ever worked on."

Amanda: "I'm somewhat of a mutt—I was born in Los Angeles and then moved to Jacksonville, Florida. Meanwhile I had fallen in love with the TV show *Welcome Back, Kotter* and I knew I would have to move up to the Northeast to find my Brooklyn voice. After moving to New Jersey and while I was working on the *Gargoyles* comic book, I met Jimmy. Later I had the option of buying a place in Prospect Heights or moving in with Jimmy here in Gerritsen Beach, and the second option was just too tempting to resist. I love the fact that out here you are so close to the city but yet you are damn close to being in the woods. Marine Park is right here and there is a nature preserve two blocks away. I love that I can go see egrets if I feel like it."

Photographed in Gerritsen Beach

Gene Kogon, 34; Liz Lawler, 26: Model Agent; Teacher

Gene: "We got married here in Coney Island. It was magical. It was a las-minute decision. We were supposed to get married in City Hall because it was the easiest thing to do. But when I went down to get the license I was mortified. I didn't want that place to be the lasting memory of where we got married. The way they bring you in like cattle. It's like the DMV there.

The day of the wedding we didn't even scout the area—we just came in on a warm, windy Friday in February and walked on the boardwalk and found an empty gazebo. The whole place was empty. So instead of seeing graffiti on the walls and a billion people we didn't know, we actually were looking out into the water. It felt so right and it was better than any big ceremony we could have had."

Photographed in Coney Island

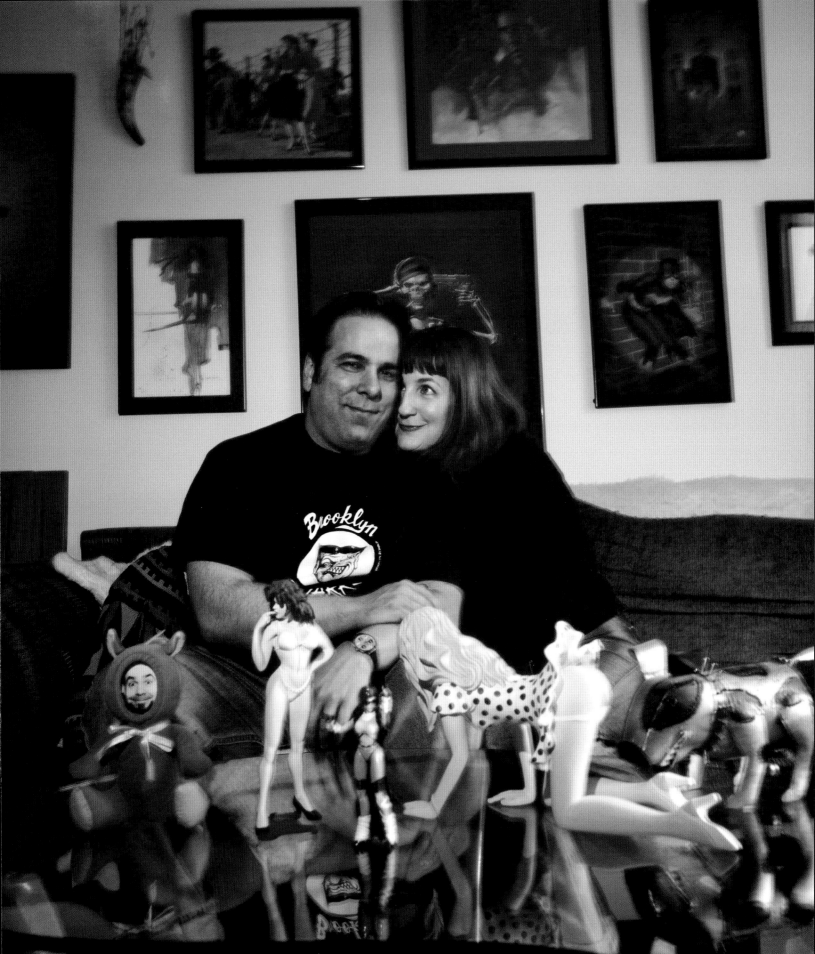

Paula Fox, 83: Author

"My grandmother moved to Brooklyn, to Sterling Place, from Spain in 1899 after the end of the Spanish-American War. I was actually born in Manhattan and I moved to Brooklyn right after a shooting in my neighborhood, 104th Street and Central Park West. I saw a man killed, murdered from a car driving by. The next day I drove to Brooklyn with one of my sons and looked for a place. I wasn't scared, but we very much wanted to have a house and it just made sense at the time. So we came out to Boerum Hill, which is where my friend Jonathan Lethem is from, and we rented a house there for three years. Then one of my novels was made into a movie, a terrible movie. But nevertheless I got $35,000 and I stuck it right on this house here on Clinton Street in Carroll Gardens. This house was $42,000 at the time. Nowadays we'd have to buy a canoe to live in with the cost of houses here.

When we moved into this house, it was the Sicilians in the neighborhood that stopped this area from becoming a slum like Brooklyn Heights was—Brooklyn Heights was terrible after the war. The Sicilians held the fort and held Carroll Gardens together. They had very strong family ties so they preserved the neighborhood. They didn't know they were doing it, but they did. We even bought Sicilian tiles for the bathroom. Now the area is completely gentrified.

My husband and I like to walk a lot. Now we are very old and it takes us a while to get moving, but we still walk to the promenade and Atlantic Avenue. We love the Arabic community here—I think it's the biggest Jordanian community in the country. We love it. It's so interesting here. We've been here 40 years now and it never loses that sense of newness. That sense of vigor. And I love my garden. It is an oasis."

Photographed in Carroll Gardens

Steve Buscemi, 48: Actor and Filmmaker (*opposite*)

"I lived in East New York, Brooklyn until my family moved to Long Island when I was eight years old. We lived at 606 Liberty Avenue and my brothers and I went to school at St. Michael's. My dad went there too, he grew up in this neighborhood. My mom grew up in Bay Ridge.

This was my world over here when I was in Brooklyn.

I was only allowed to go around the block. I remember playing punch ball on the sidewalk, and flipping baseball cards in the schoolyard.

I loved the Yankees as a kid, I can still name the starting line-up for 1963. We used to argue about who was better, Mickey Mantle or Roger Maris. I rooted for the Yanks because the Dodgers had left when I was too young to remember, and the Mets were new and always losing.

There were lots of kids on the block and always something to do. I used to sing in the choir of this church—St. Michael's Church. I had nuns for the first few grades in school. Some of them were tough.

I moved back to Brooklyn in 1991 after living in Manhattan for years. Once my wife and I had our son, we wanted more space and didn't want to pay those city prices. We ended up in Park Slope where some of my friends are from.

Brooklyn is home. I can't say what it is about this place, but it's home to me. It's really more of a feeling. Feeling secure. I love the people in the neighborhood. The guys down in the bagel store, my neighbors, and other parents we've met through our son's school. It does become like a small town.

There was a time when I thought about living in Los Angeles, before I had a bigger profile—it just helps to be out there when you're not known. But after *Reservoir Dogs*, the casting people got to know me and it just wasn't as important. So instead of moving to Hollywood, I moved to Brooklyn."

Photographed in East New York

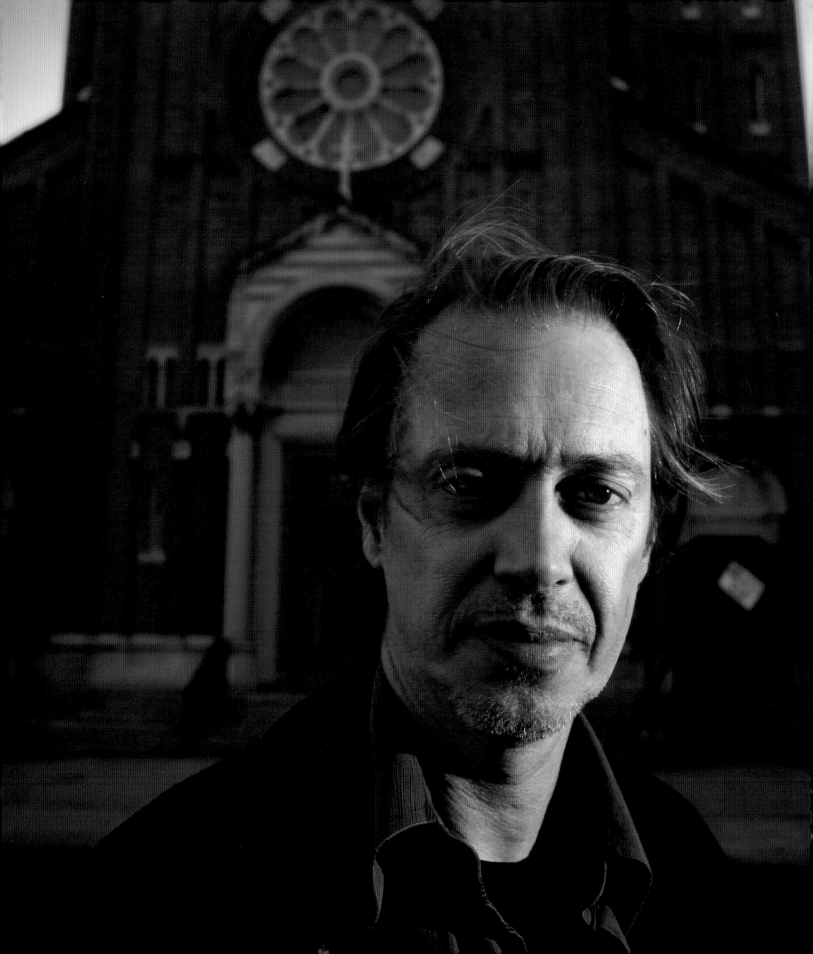

Steve Buscemi

On the 3rd floor of 606 Liberty Avenue we have stepped through a wormhole. It is located in the middle of a small apartment sitting above a deli. Steve Buscemi is with us. It's the morning of October 20.

I'm not asleep.

A few minutes earlier Buscemi is standing on a street corner, in front of the home and school in which he spent the first eight years of his life. He's traveled back to the middle of East New York to see us. We are conducting an interview and a photo shoot. It's early. Sleep still drifts inside his body. But even through this 9 AM haze, you can tell this spot is special to him. He's looking at these corners and slabs of concrete like mislaid photographs found hidden in the pages of an old book.

And then Chance, a well-known personality on the streets of Brooklyn, leans its head out of a top-floor window.

From the apartment above us, the very apartment Buscemi grew up in, a man looks in on our actions.

"I'm Steve, I used to live here as a kid," says the actor to the face staring down at us. "Do you mind if we come up?"

Soon after, I'm climbing a crooked white staircase dressed in slanted sunlight so dramatic it's sucker-punching my early morning eyes, making them tear. As I push down on the backbones of the napping, cranky steps, they let out measured bellows. If I was dreaming, this might be my mind imagining some bizarre ascent into heaven, side-by-side with Steve Buscemi.

But I'm not asleep.

I'm following a man named Michael Rosario as he leads us towards a four-room dwelling on top of a deli. He turns to Buscemi as we go up.

"This is strange. I was just watching one of your movies," he says. "The one where you are flying."

"I'm not sure which one that is," says Buscemi.

"You know, the one with the plane," says Rosario. "It was just on the T.V."

"*Con Air?*" asks Buscemi as we near the top.

"Yeaaaah! *Con Air*! That was a great film!"

Rosario and his family now live in the residence. It's a typical Brooklyn home, lived-in and comfortable. Photographs on walls. Coffee tables and carpets. But as we stand inside the place, after a mere

three minutes, we are undoubtedly in Buscemi's old apartment. It's the early 1960s.

"It was actually in this kitchen where I first started performing," he says. "This is where I got my start. I entertained my parents and my brothers and my relatives right in here."

The eyes of Steve Buscemi are a gift. On enormous silver screens they are twin focal points—chameleon pools of anything, everything. Two coals stoking the souls of imaginary characters, giving them life, grit, compassion, reality. Today they are a million times more powerful. Today they are revealing genuine tales. Moments stored and stowed for years and clamoring into the air like heat rising through an old Brooklyn radiator.

He criss-crosses slowly through rooms and the stories continue as we followed him through doorways and decades.

The times his father climbed through the top of a hallway closet, below a skylight, to unlatch the front entrance when keys were forgotten.

The day his mother's apron caught fire in the kitchen. "Mom, you're on fire," he calmly told her. Disaster was averted.

The time he was hit by a bus across the street from his home—his padded winter clothes saving him like modern armor. The city's settlement money later providing him with a way to go to acting school.

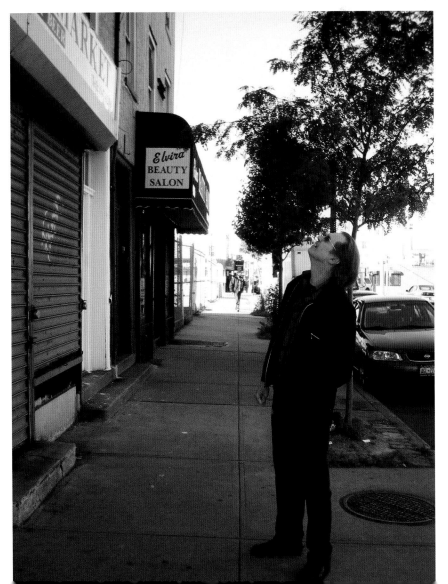

How he slept in the same room as his brothers, the same house as his cousins. How his uncle had a chicken coop in the backyard. His family was all here—until they slipped off to other places.

"One by one they all moved to Long Island. We were the holdouts until we left. My grandmother actually lived here for a long time after we were gone. I used to visit her here."

We were on our way down the crooked stairs soon after that. Back down the white passageway. Back into the streets of East New York and a 2005 morning. As we left Steve Buscemi on the corner of Liberty Avenue he lit up a cigarette. He was still looking up at the buildings above him, still casting those eyes, those compelling eyes, through the air like butterfly nets, searching for his cobwebbed, vanished memories. Smoke filling his lungs, the early 1960s still drifting inside his body.

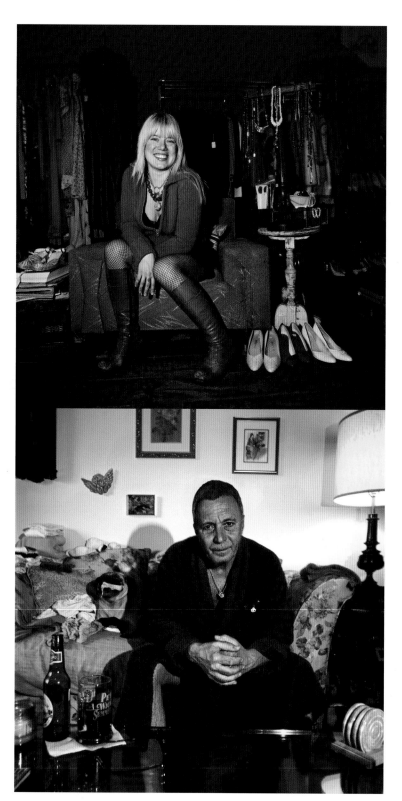

Allison Nowlin, 31: Owner of Vintage Shop Fortuna

"Brooklyn is the world. You can never leave here and still feel as though you have seen the whole world. And here I actually get to meet my neighbors. In Manhattan you can go years without knowing the people who live next to you. In Brooklyn I not only get to talk to my neighbors, but I actually get to watch their kids grow up."

Photographed in Williamsburg

Spike Lee, 50: Filmmaker (*opposite*)

"I was born in Atlanta, Georgia—I came here when I was a year old and it's been my home ever since. We no longer live in Brooklyn, but we have two offices here, we continue to shoot in Brooklyn so I'm still in Fort Greene. When we first moved here I lived in Crown Heights and we were basically the first black family to move into Cobble Hill. Then my mother had the vision to buy a brownstone in Fort Greene when the prices were really affordable—that was around 1968 and 1969.

Brooklyn is basically the same except now property values have gone up, and certain complexions of the neighborhoods have changed. You know, when I was growing up there were no white linen tablecloth restaurants on Myrtle and Dekalb Avenue. But the place is basically the same. My childhood here was very memorable, especially in the summertime—it seemed like we didn't have to come inside forever or at least until it got dark, which on a perfect Brooklyn night seemed like forever. That was also a time when parents didn't have to worry about their kids playing outside."

Photographed in Fort Greene

Mike Smollar, 59: Printer

"Brooklyn is Brooklyn. There's no place like it in the world. And when you travel to other places in the world you really realize that. They got nothin'."

Photographed in Bath Beach

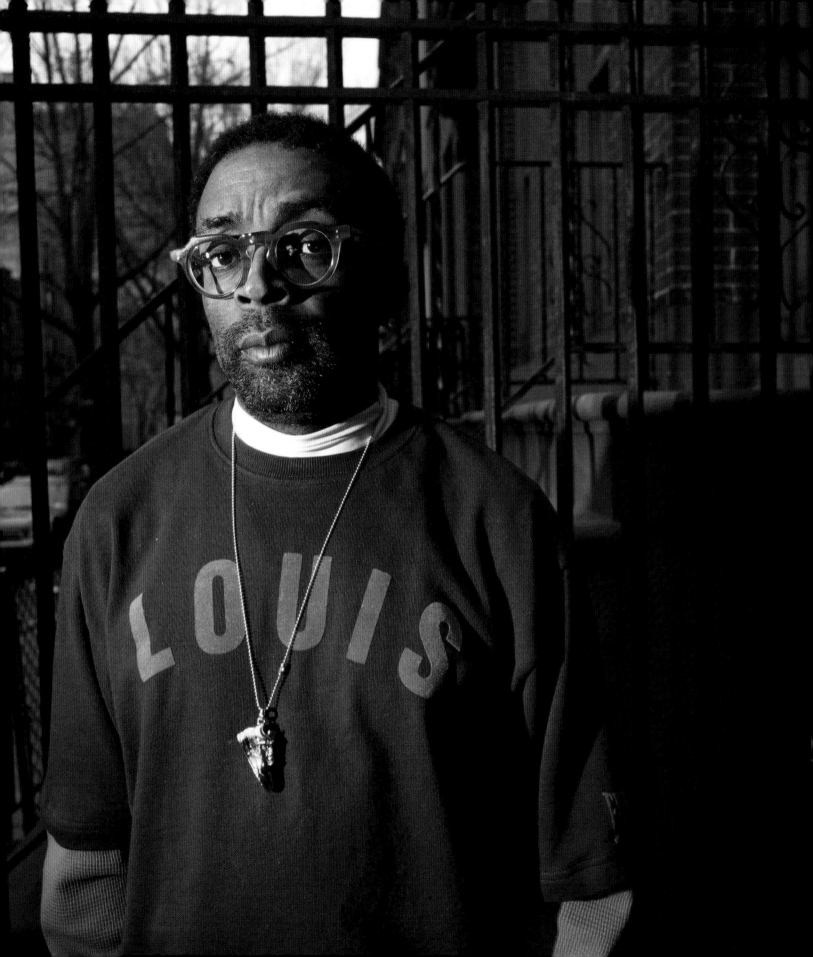

Casey Spooner, 35: Member of the Band Fischerspooner

"I grew up in Georgia and South Carolina and I've been in New York for ten years.

When I first got here I sofa surfed and then I lived over at the Pioneer Hotel on the Bowery. I had four t-shirts, four pairs of underwear, two pairs of jeans, one bag, and an alarm clock. When I came here, what I could carry was what I had.

Williamsburg was the first place that I lived in New York. I first lived in an apartment on Bedford that has since become luxury lofts. At the time I was there though, there was a mouse infestation. Every time I would walk through the apartment I would see three mice—and they did not care. I slept on a futon on the floor and I would find mouse droppings around the bed, so basically I was sleeping with a mouse on my face every night.

As a musician, being here very early on, it was really a community and it was about connecting with people and having a space to work. We recorded our first record on South 6th Street and every recording I've done has been here. Having space is such a big deal. And that is what this neighborhood has afforded me.

This is where I live and work and it's part of my identity. I love this bridge. One of the things that really is great about living in Brooklyn is that you actually get to see the city. When you are in it you don't see it, but when I was recording the last record I would take car service every day over the bridge and there was something always so grounding about seeing the beast you were headed into each day. I would actually take pictures as I would go across the bridge every day to kind of document the travel."

Photographed on the Williamsburg Bridge

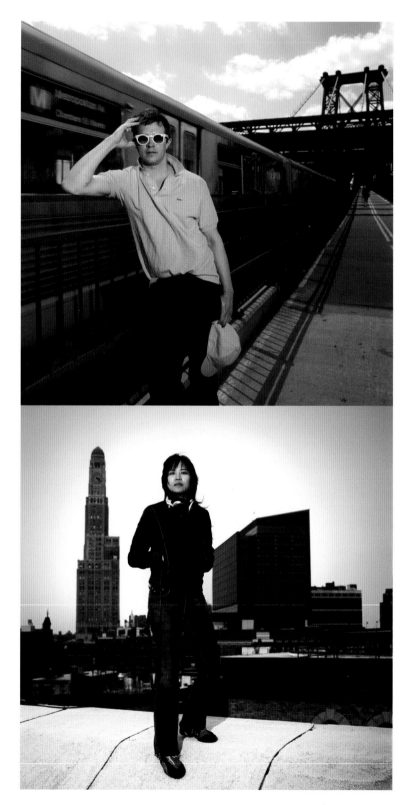

Karla Calderon, 29: DJ/Eclectic by Nature

"What's interesting about Brooklyn is the fact that there are a lot of high-profile restaurants and bars and businesses here, but this place has still somehow remained obscure and humble. I like that obscurity."

Photographed in Park Slope

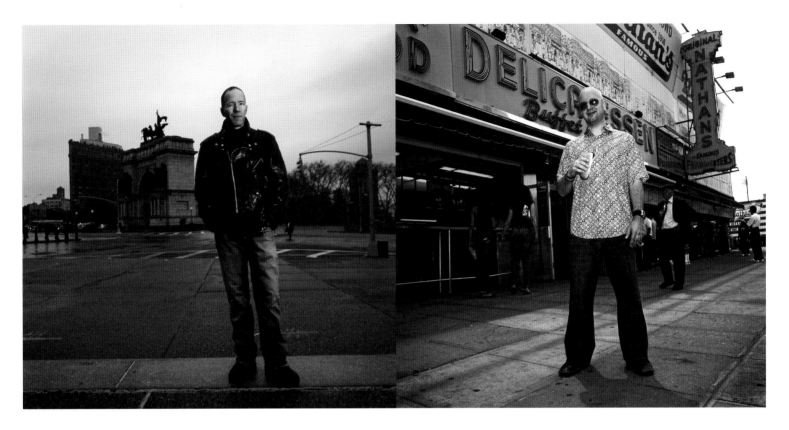

Rick Moody, 44: Author

"Brooklyn is more human in scale than Manhattan or some of the other places in New York. And the topography, the architecture, the unique features of the buildings and its geography—all of that make it unique and funky and interesting.

In my book *The Diviners* there is a scene where an immigrant, a car service driver, is driving over the Brooklyn Bridge for the first time, experiencing what it feels like for someone to do that. I don't think I could have written that without living in Brooklyn."

Photographed in Grand Army Plaza

Ron Scalzo, a.k.a. Q*Ball, 32: Musician

"I suppose just like someone growing up in the cornfields of Iowa or urban Detroit, for me, Brooklyn is and will always be 'home.' There are just too many memories to mention—it's everything, it's my life. I look in the mirror and I see the scar on my forehead from getting tackled in the snow outside my grandparents' house on Bay 48th Street when I was nine. Most of my close friends are from Brooklyn. Three generations of family were born and raised here. I worked many ridiculous summer jobs as a teenager here. My love of pizza, Chinese food, bagels, and Italian heros wouldn't exist if I hadn't been a child here. My first kiss was on a bench by the Belt Parkway, the first girl I ever loved was from Brooklyn. I graduated from college here, I buried my grandparents here.

As a musician I spent my formative years as a metal-head growing up in 1990s Brooklyn. By high school I was playing at the few live music venues in Brooklyn, like the Crazy Country Club, L'Amour, and 315 (none of which exist anymore), not to mention Murrow High School's Battle of the Bands—which I won twice I might add. Take that, Eric Clapton! Being a young musician in Brooklyn really gave me confidence and a competitive edge. We were always trying to outdo each other, even back then."

Photographed in Coney Island

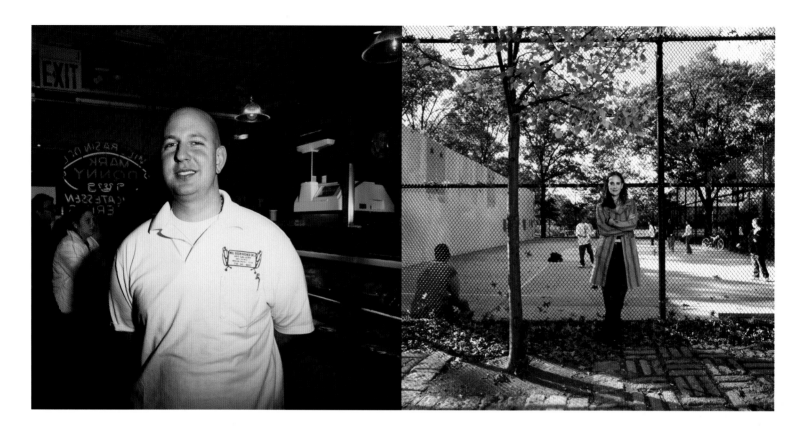

Jordan Schachner, 28: Manager of Mill Basin Deli

"My father Mark opened this deli with a partner in Mill Basin 35 years ago, in 1972. My family was born and raised in Brooklyn. My grandfather had a kosher deli called The Lincoln Deli on Coney Island Avenue and my Uncle had a deli in Manhattan. So I am third generation kosher deli.

I've been here about 14 years. It's a trip. I don't know if you know Jewish clientele or not, but it's a show here. A kosher deli is really an old school kind of thing. There are people who still know about places like this, but there are also people now who don't even know what pastrami is. You know what I'm saying? I still get people coming in asking for a ham and cheese—now more than ever. But we still have people and families that have been coming for generations even though the kosher deli business is a dying breed. There used to be one every two blocks in Brooklyn. Now there's three left in Brooklyn. But we are not going anywhere. We want to keep this in our family and in Brooklyn forever.

We ship all over the US. And a lot of people who call here, they tell you a story about here. Not that you're asking them to talk! But they do. People from Brooklyn know there is good food here and you can't get that out of New York. So they call and reminisce about Brooklyn.

My favorite sandwich? I prefer the PLT—pastrami, lettuce, and tomato. But the staples here are pastrami, chopped liver, and tongue."

Photographed in Mill Basin

Liz Tuccillo (age not given): Writer

"I grew up in Bay Ridge. My best memories from here are connected to the fact that I went to school with kids from kindergarten all the way through junior high. I remember hanging out with my friends at night on Shore Road and at these paddleball courts and having parties down at Shore Road that the police would come and break up.

Now I live in Manhattan and I commute back here every Sunday for 'family day'—an early Sunday dinner at three in the afternoon. My father used to come back to this neighborhood after he moved out and he would say 'Bay Ridge! I forgot how beautiful this place is.' And now I have become my father in that every time I come back I say the same thing. 'Bay Ridge, How beautiful! Look at all the trees!'

As a writer I think my sense of humor was absolutely developed in this park. I feel like I remember the day where I thought either I'm gonna have to be really funny or they are gonna eat me alive. People really like to tease here and give you a hard time. And I felt really different because I was going to an art school, and I dressed differently and I was very liberal-minded. I'd wear these crazy-colored leg warmers and ripped jeans and a crazy hat and I remember thinking 'Just please get me to the subway without anyone bothering me.'"

Photographed in Bay Ridge

Vincent Castiglia (age not given); Sami Hajar, 29: Tattoo Artist; Editor

Vincent: "I like the diversity of this place—there is an energy present in Brooklyn that is characteristic to this place, geographically speaking. I haven't done a ton of traveling but nothing comes close to Brooklyn. The attitudes for the most part are not a good thing, I'm not an idiot myself and I don't appreciate it but this is kind of the center of the world.

I did my first tattoo ten years ago with a sewing needle and ink and that was kind of what catalyzed the whole thing. It wasn't until roughly six years ago that I started doing it with my entire heart and spirit. I work in a few shops, but primarily I work by appointment privately. This is the heaviest art form on the face of the planet. People are laying their lives down with you. You get one body and I'm altering that one body and the implications of that alteration can either be profoundly positive or profoundly negative depending on the result. So I strive to execute everything optimally. I take this on more as a duty than an occupation; it's a spiritual path for me."

Sami: "I grew up in Brighton Beach and in the beginning it was everybody just chillin', hanging out riding their bikes. Then when we got older it was just everybody drinking, smoking pot, robbing people, selling pot, selling crack. But what I remember mostly is all my boys just hanging out, having a good time.

In 1999 I moved out of my parents' house and moved to West 5th and then West 12th. I love it over there, it's awesome. I love the unity of the block; I met my future wife there. I was hanging out on the block one day on the stoop and I walked over to her and she started making fun of me. It was supposed to just be sex and it turned out to be a marriage.

Brooklyn is reality. Everything being true, not trying to hide anything or being fake. But I'm not 100 percent sure about raising my family here. I want them to grow up and know the streets and be street smart but I might end up in suburbia. I don't want them to grow up in suburbia either, but I may not have a choice."

Photographed in Bensonhurst

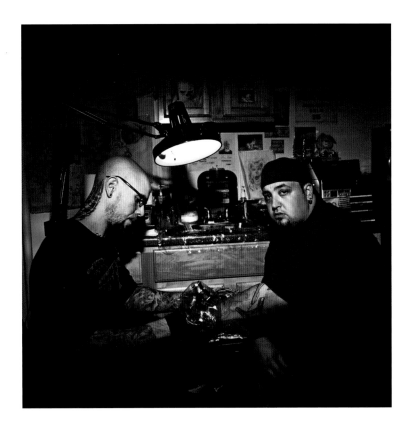

Mike Rodriguez, 43: Owner of Bicycle Station

"If I ever left this place, which I probably never will, I would come back all the time because there is so much to see here. And I feel like I have a purpose here. I've been working on bikes since I was ten years old over on Atlantic Avenue. Biking around Brooklyn is great—if you live someplace like Pennsylvania you have to drive 30 miles to just get milk. Here you don't need a car."

Photographed in Prospect Heights

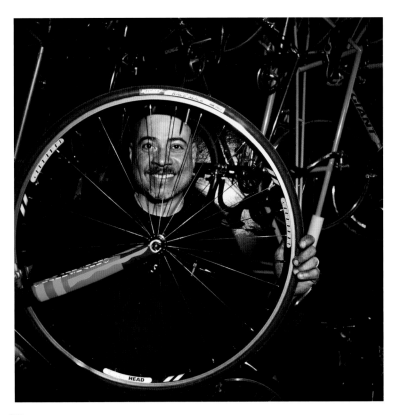

Michael Showalter, 37: Actor, Comedian, Director

"The first time I came to Brooklyn it was love at first sight. It was an epiphany. It was a place I could not believe existed. I decided to move here right away and haven't looked back.

I first lived on Second Place in Carroll Gardens, which is a historic block with all these huge front yards. I had been living in Manhattan for ten years and had never once become friends with a neighbor. When I moved to Carroll Gardens I became very close with the neighbors in my house. We were constantly in each other's apartments, making food for each other, watching TV. It was something I always wished my New York life would be. Brooklyn had a feeling of a big city with a culture but also a small town feel. And it felt like a secret.

Now I live here in Boerum Hill in this big, warm, quiet apartment that is sort of shaped like the state of New Jersey. I have Fort Greene on one side, Brooklyn Heights on another side, Park Slope right here. I love it.

With Brooklyn I really feel artistically and personally I have found my home. This is where I belong. I think it's a romantic place. With my movie *The Baxter*, I used that phrase—the Baxter—to describe the wrong guy. The guy who doesn't get the girl. In every romantic comedy there is this dashing leading man and there is this nerdy guy who doesn't get the girl—the Baxter. In a way Brooklyn is the nerdy guy and Manhattan is the dashing leading man. Brooklyn is the less obvious choice and the road less traveled but it's sort of like if you take the time to really look at it you realize that it has more depth even though it doesn't beg for attention. I also think creatively I have found a muse. It's in my mind. Everything for me is always set in Brooklyn. I'm working on another romantic comedy right now, set in Brooklyn, set in the winter, and I want to show all those ridiculous Christmas light displays that, to me, are so uniquely Brooklyn. It's these cement concrete houses with these crazy displays on Halloween and Easter that are hilarious and very beautiful and charming at the same time."

Photographed in Boerum Hill

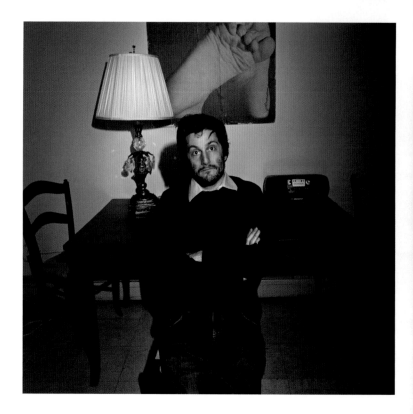

Rosie Perez, 40: Actress (*opposite*)

"Growing up here in Bushwick I loved Sunday dinners, holding court on the stoop, either my stoop or my best friend Gina's stoop—God rest her soul. The park by my house, it had a running track and a football field and bleachers. We used to go up and hang out on the top of the bleachers where you could see the skyline of the city. Learning how to kiss with Juan. I kept getting dissed by other guys because I didn't know how to kiss, so my friend Juan taught me. It took a whole summer of course. A slice from Tony's that was on Whitehall Street—I don't think it is there anymore. But Sunday dinners were special.

After moving to Los Angeles it was a bit of a culture shock, it was depleted of culture, a specific culture. There was nothing to attach yourself to. Nothing and no one. The irony was that you had perfect weather out there, but you were miserable.

Now I live in Clinton Hill. I had always wanted to live there, since I was a little girl. I love the architecture and the trees there.

Growing up here has helped me as an actress because you know people. You know the human condition. You see different ways to live life, but everybody has to live it all together. The human experience and the drama of humanity are played out right outside your windowsill. So you understand. You are sympathetic to human beings but you are also empathetic in a strange way.

In Brooklyn you don't have to dress up to hang out when you leave your house. In Manhattan or Los Angeles or Miami, you always have to wear a costume. In Brooklyn, you can just be."

Photographed in La Marqueta in Williamsburg

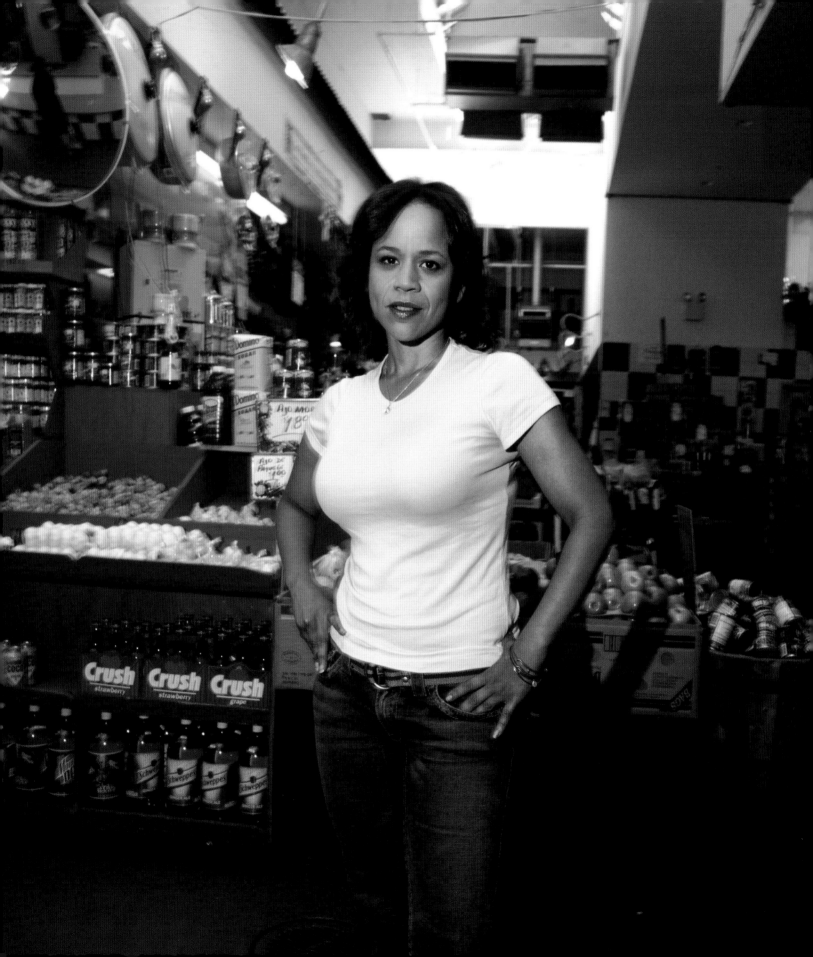

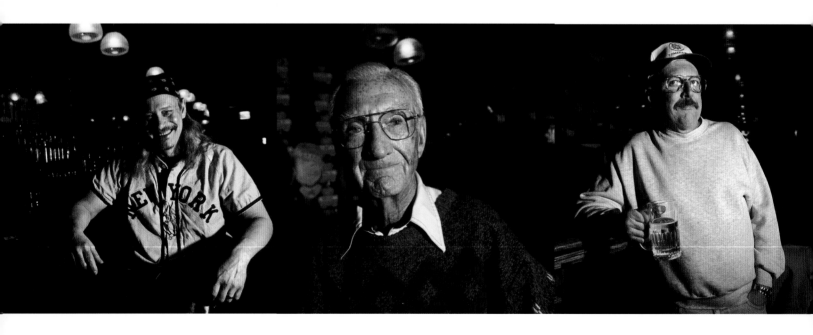

Kelly's Tavern

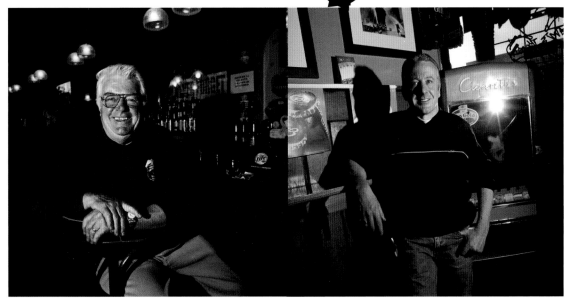

John Nolen, 44: Owner of Kelly's Tavern

"Bay Ridge is the last spot left. Everything has changed and everything changes, even this place, but it still has charm and beauty and everything at your fingertips."

Photographed in Bay Ridge

Steve Schirripa, 49: Actor

"I grew up in Bensonhurst. I used to spend a lot of time here in this park. I used to play basketball here and bring my car around and put the lights on so we could continue playing at night. My best memories of being a kid here are probably when I was young, around seven or eight, and walking with my grandmother on a Saturday up Bath Avenue to the butcher shop, the bakery, the pork store, the vegetable store. You had different stores for different things. Now you go the supermarket for everything and it's not as good. Shopping on a Saturday with your family. That's what I remember.

When I was living here as a kid, I worked for the Parks Department, a fruit store, I was a chimney sweep. I cleaned many a boiler and chimney in Bed-Stuy and Brooklyn Heights. It was good money, but filthy. I remember having a date on a Saturday night and not being able to get the soot off, so you wear a long sleeve shirt and when you're fucking your date you kept your shirt on.

Now I live in Manhattan and I miss Brooklyn. I appreciate it more now. I miss the people. When you know a person and you know their family, and their wife, and their kids, and their mother, and their brothers, there is a whole different sort of friendship. You don't see someone for 20 years and you talk and you pick up right where you left off, like you just spoke yesterday. In other places you know people but you don't know people, you know?

Growing up in Brooklyn gives you an education. Probably some of the smartest people I know never graduated high school. Just growing up here is education enough. With *The Sopranos*, I've known a lot of people like people on the show. Not necessarily wiseguys, but people with those characteristics. The guys on the show—I've been around guys like that. Good ones and bad ones. I'm not imagining what they may be like, I know what they are like."

Photographed in Dyker Park in Dyker Heights

Christian Rodriguez, 19: Jewelry Store Worker

"This store is my family. There are so many memories in this store. My family has owned it for 45 years. Being a kid in this store was great. Everyone in here is an uncle to me. I have two blood uncles and people that work here are all uncles. We know families for so many years. We can't walk around and not see somebody we know. Children of children are our customers. That's part of what makes Sunset Park and Brooklyn special. It has community spirit."

Photographed in Sunset Park

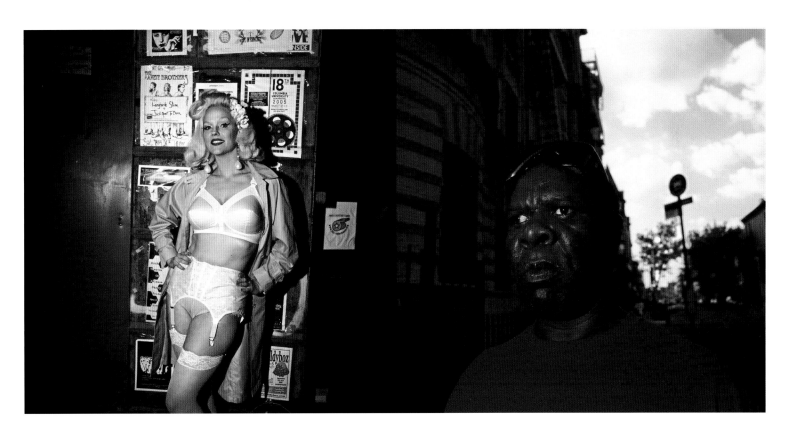

The World Famous *Bob*, 32: Burlesque Dancer

"There are 'Lifers' in Brooklyn. People that love it here so much that they will never leave—and I love that."

Photographed in Galapagos in Williamsburg

Claude Ruffin, 52: Retired Veteran

"I moved to Brooklyn in 1988. I bought a house in Brownsville. At first I didn't like it because I felt like there was no unity in that neighborhood. But the price of the house was good—about $167,000. I think the best thing about here is the people who help me get around. I have a tendency to end up in the street a lot and they are courteous and get me onto the sidewalk. They are always helping me—I remember everyone's voices."

Photographed in Bedford-Stuyvesant

Empire Isis, 20s: Musician

"I grew up in Morocco and Canada and South America. I came to New York and Brooklyn to make my music. I have never lived anywhere else but Bed-Stuy and I would never. I need a certain mixture to feel inspired and I was brought up by Africans so I need to be around West Africans and Muslims and Jamaicans and Trinidadians and Latinos. I make reggae music and all of this keeps me inspired. As a reggae artist I need to live here—it keeps me connected to all the islands, to Africa, to Arabs. This neighborhood has all that. If you go up to Crown Heights you lose the Africans. If you go down further you lose the Latinos. Bed-Stuy has a real even distribution of everyone. From homies to the Yemeni store owners to all the artists here. Plus Brooklyn has a long history when it comes to arts, activism, politics, race riots, all kinds of shit."

Photographed in Bedford-Stuyvesant

Ryan Monihan, 37: Filmmaker (*opposite*)

"I'm a 69er, from Seattle, the CD (Central District) to be exact, been coming to BK off and on since I was four, but living here full time since the early- to mid-90s. My childhood friend Ishmael Reginald Butler, from the group Digable Planets, made it sound 'cool' (like dat) on his records, and I was young and naïve so I bought into it.

Brooklyn is NOT a place. It's a paradigm (to use Brooklynite Iron Mike's favorite word). Let me explain: Back in the late 80s and early 90s, a period commonly referred to as hip hop's 'golden era,' I was stuck spending most of my time overseas and 'surviving' as a professional skateboarder.

Now, remember, I was saying this was during the 'golden era' of hip hop. Well, that era also ushered in the beginnings of wide-scale international touring. And when I'd go to these shows, as was and is the case for all hip hop shows since the birth of the form, the MCs would launch into their audience participation routine. The 'throw your hands in the air, ladies say aaowww, fellas say ho, somebody anybody everybody scream!' Next, without fail something strange and peculiar would happen. Every time, no matter what corner of the globe, the rapper would ask, 'is [fill in the name of the town/country] in the house?' and the local crowd would shout and holler. But then, almost as if making an inside joke, the MC would continue with their call and response line of questioning with the most famous hip hop inquiry of all: 'IS BROOKLYN IN THE HOUUUUUSSSSE?' It didn't matter where the fuck you where, Helsinki to Hong Kong, wanna-b-boys and wanna-b-girls far and wide, hip hop fanatics that only knew five words of English, pimply kids who couldn't point out Brooklyn on a map if their mother's life depended on it, they'd all scream so God damn loud you'd a thought someone was gonna give away a million bucks to whoever could break my fucking eardrum. And I'm just sitting there, every time, laughing, bugging out on the power of a myth, with my fingers lodged firm into my hearing holes."

Photographed in front of the Loews King Theater in Flatbush

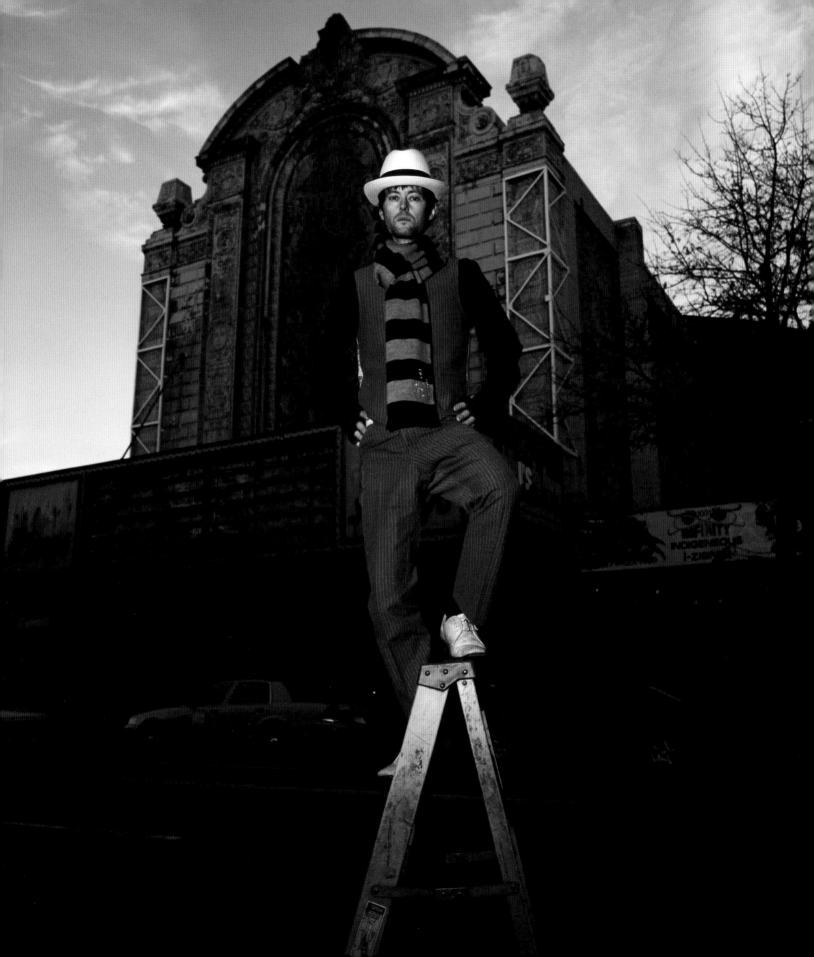

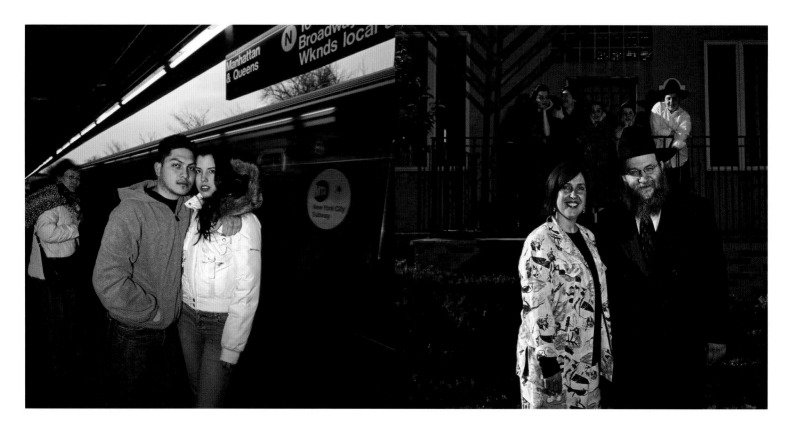

Marlon Gonzalez, 25; Vanessa Gonzalez, 27: Photographer; Teacher

Vanessa: "Brooklyn is home to me. You have your local baker who knows how many sugars you have in your coffee. You have your local tailor who knows your measurements. You actually talk to your neighbors. I'll never leave here."

Photographed in Sunset Park

Rabbi Winner, 52; Esther Winner, 48; Mendel Winner, 8; Chaim Y Winner, 14; Naomi Winner, 10; Chaya Winner, 16; Sara Winner, 18

Rabbi Winner: "My parents came here from Europe—they were survivors of the Holocaust and they came here about 1947. Brooklyn is very special to me for that reason, and I guess for many families like myself, because this borough probably has the largest population of Holocaust survivors than any other place in the United States and maybe the world. Our families found Brooklyn as a very special place to rebuild their lives from the ashes of the Holocaust. Many people lost entire families. One child survived in a family of ten, so you can understand them wanting to rebuild. Brooklyn enabled them to do this. Brooklyn was seen as a blessing. A place that was very hospitable, a place that enabled them to grow and to prosper both materially and spiritually."

Photographed in Brighton Beach

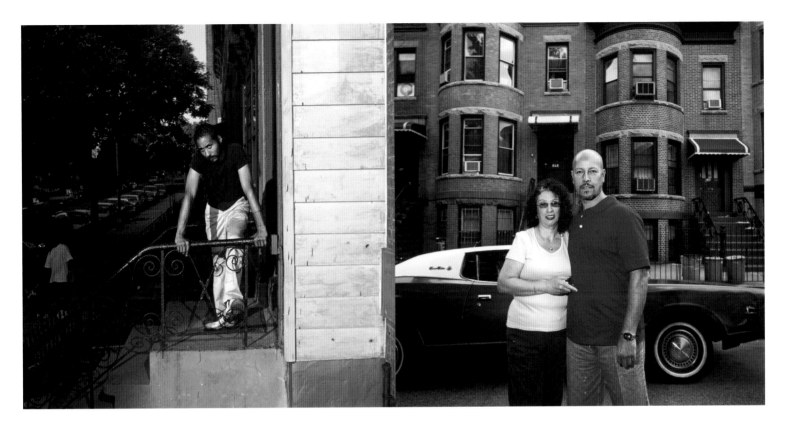

Garnett Thompson, 32: Photographer

"Growing up in Bed-Stuy prepared me to live anywhere in the world. I can go to fucking Palestine right now. Seriously. Growing up here in the mid-80s to mid-90s was a crucible. Crack hit Brooklyn in 1985. By 1987 Bed-Stuy was the murder capital of New York. I used to have conversations with my friends on the phone were I was saying 'Let me crawl across the floor and turn off the lights. Someone outside is shooting.'

I have been all over Europe, and whenever someone asks me where I'm from I say 'Brooklyn.' And they say 'Oh.' And when they ask what part, I say 'Bed-Stuy.' And they say 'Ohhhhh.' You get that extra long 'Ohhhhh' when you say Bed-Stuy.

The neighborhood motto of Bed-Stuy is 'Do or Die.' And that is the pervasive mentality. I love that. This place is Darwinism in action. If you can live here you can live anywhere. You have to always be on point. Every hard part of living in every neighborhood in New York is in Bed-Stuy. We have taken all of the hardest of the hard and put it in action here. And if you don't survive, you don't belong. It's that simple.

But the other thing that is special here is that the culture is so vibrant—it's the flame that we moths gather around. It's dynamic and constantly changing."

Photographed in Bedford-Stuyvesant

Angel Hernandez, 52; Sarita Hernandez, 52: Building Superintendent; Homemaker

Angel: "Down here when I was growing up, over at the 33rd Street Park on 3rd Avenue, it was like the movie *West Side Story*. That's what used to happen down there. To play in the park you had to fight for it—it was the Italians and the Puerto Ricans. The Puerto Ricans lived all over 3rd Avenue. Jewelry stores, grocery stores, bodegas. In the bodegas you would get what ever you wanted and at the end of the week you would pay. They would keep track in a little book. But in the park you had to fight. We used stickball bats, garbage pail covers as shields, chains, machetes, and knives. You had to get respect. It was terrible. I saw heads split open. I even got into a fight with the head of an Italian gang because I was dating an Italian girl. But that was back in the old days.

Now everything has changed. There are Mexicans here now. South Americans, Central Americans, Dominicans, and Chinese."

Photographed in Sunset Park

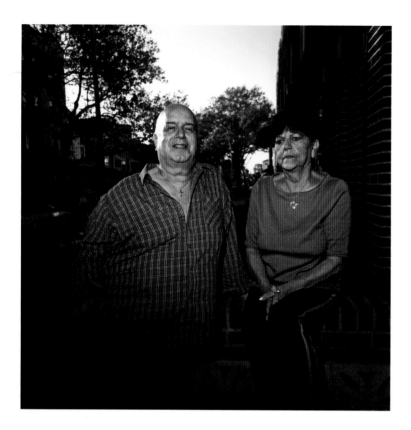

Nicholas LaSala, 67; Lena LaSala, 64: Retired

Lena: "I grew up on Hamilton Avenue in Downtown Brooklyn. Then I moved here to Bensonhurst. I've been here 60 years, in this neighborhood and this house. As a kid we would play hide and seek around here and ring people's bells and run. It was great. I met my husband here—the same guy for 45 years. My uncle from Italy came here and stayed for four weeks—he had such a good time that he said he now knows why everyone loves Brooklyn."

Nicholas: "I love everything about Brooklyn. I came from Sicily when I was nine. Most of my kid life was spent on Bushwick Avenue. I would hang out with my friends, play together, get into fights, go to the diners over there and eat hamburgers and drink cokes all day. Now I love Coney Island, the 18th Avenue feast, Columbus Day parade—you always have something to do here."

Photographed in Bensonhurst

John Gimenez, 29; Amy Hodor, 31: Musician (*opposite*)

John: "Well I grew up in Queens, very close to Greenpoint. My family came out of the North Side of Williamsburg, so we'd go and drive by the 'old house' and the restaurant where my grandparents had their wedding reception. Thinking back, that part of Brooklyn always seemed frozen in time, as if it shut down at some point in the 70s and never woke up. That sleepy, forgotten feeling sums up, for me, a hazy vibe of growing up here. It's a content sadness almost, like living life in sepia tones.

Where I live now borders Red Hook, Park Slope, Carroll Gardens, and Sunset Park. I have the privacy and edginess that comes with living in an outskirt part of town. When I want to get dressed and comb my hair, I can go into town and have brunch. When I'm on my block, I don't have to give a shit. I'm a modern-day frontiersman.

I think Red Hook is amazing; it has what I consider to be one of the best qualities of an NYC neighborhood, inaccessibility. Kings moved to higher ground, building tall walls and moats to achieve this. If I were to move, Red Hook's the direction I would go. My friends would feel like they earned seeing me, maybe spend the night. The eclectic low-rise architecture and cobblestone streets are so valuable.

I love the bits of open space I can find when I'm on my bike—from Shore Road to the riverside factory roads in Red Hook. It gives me a chance to think, breathe, and become inspired. These are the times when I remind myself why I love it here. When Amy is along, we explore the neighborhoods, screaming back and forth to each other. It's a lot of fun and very exciting and really, really dangerous."

Amy: "To me Brooklyn always had a more romantic feeling to it than any of the other boroughs. Nowhere in the US feels like NYC does and nowhere in NYC feels like Brooklyn does. There is a certain mix of history, versatility, and progress in Brooklyn that you don't feel in other places.

I love any spring or summer weekend, riding with John on the Triumph through Brooklyn. We start in Park Slope ride to Shore Road and the pier in Bay Ridge, head back and into Red Hook and then on to Williamsburg, finding something great and inspiring in every neighborhood."

Photographed in Red Hook

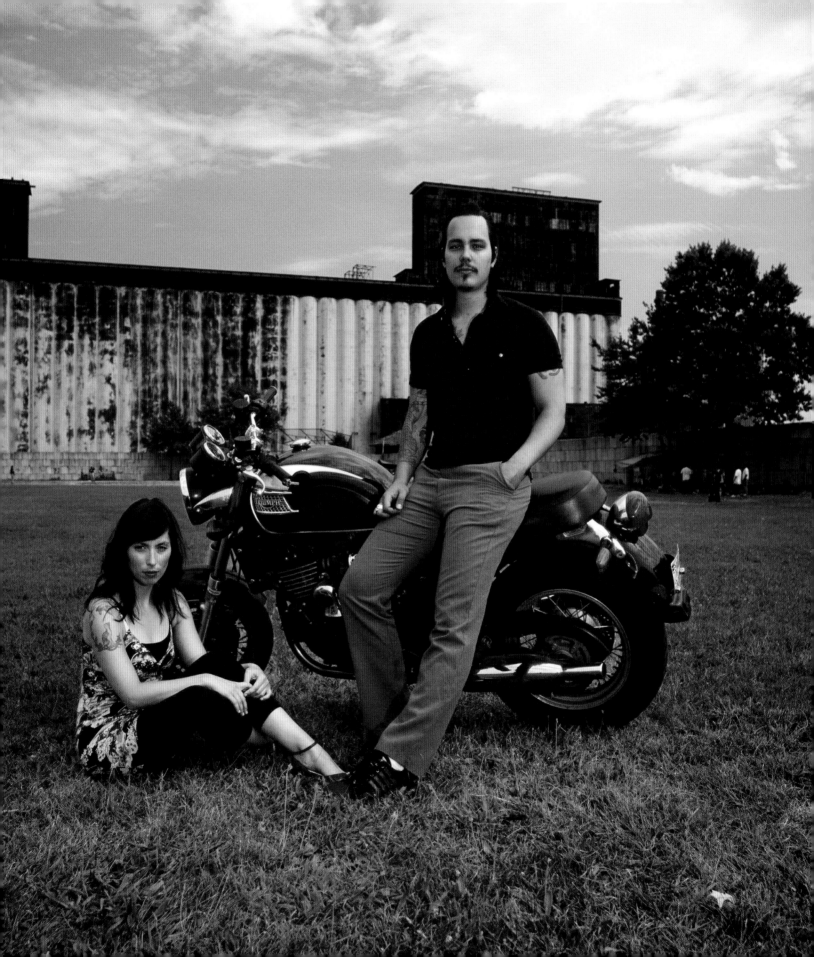

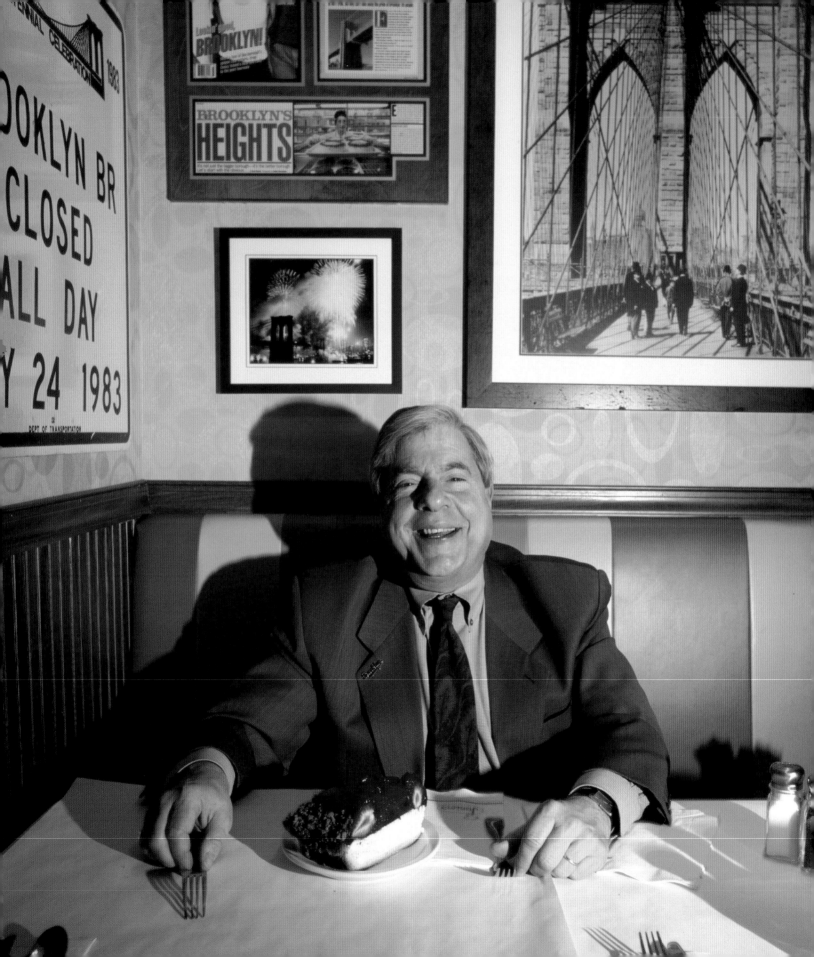

Steve Tarpin, 49: Key Lime Pie Company Owner

"I grew up in Miami. I came to Brooklyn about 20 years ago. I was doing carpentry and woodwork and I had a back injury. So my daughter and I went down to Florida and I brought some Key limes back. I had been making pies for a long time and I made one for a barbecue here. There was a guy who owned a restaurant who was at the barbecue and I asked if I could make them for a steakhouse in Manhattan. That's how it started. It was slow in the beginning. I worked in a studio apartment on Smith and Bergen for four years with two spare tenant-style refrigerators and my regular oven that was held shut with a bungee cord. The neighbors were cool about keeping extra orders in their refrigerators.

Then I bought a panel truck and, knowing it would attract more business, I knew I would have to get a bigger place. I was originally on Columbia Street and then I ended up here around early 2001. So I've been in Red Hook for about seven years now. Sometimes you don't pick a place, it picks you. And honestly, growing up in Miami, I'm more of a water person than a city person, so being here by the water is great."

Photographed in Red Hook

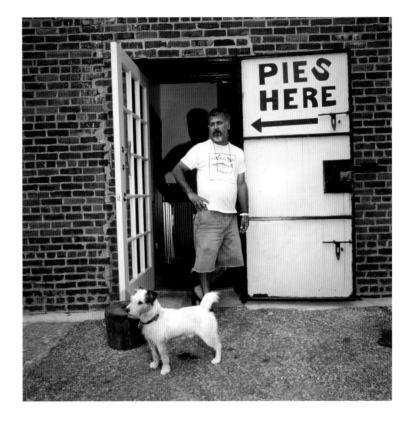

Marty Markowitz, 60: Brooklyn Borough President (opposite)

"If I could pick three things that make Brooklyn special I would say they are the ethnic and religious diversity, the fact that Brooklyn residents live on the edge—there are no introverts here, and the Brooklyn attitude. We know that we are special and that everywhere else is just, well, not as equal."

Photographed in Junior's in Downtown Brooklyn

It's half past noon on the first Thursday of summer and the sun is licking archaic rooftops and drooling on the slow shake of leaves all over Lafayette Avenue. Late for an appointment, moving in a fast step through a slow-paced place, I feel like a walking blink. I am a flesh and bone arrow slicing through the calm of splintered sidewalks and toplit pollen perched on imaginary breezes. If I were stepping along a Manhattan street right now, I would simply be another. A soul lost in the high tide of rushing bodies seeking nourishment. But I'm not in Manhattan. I'm in Fort Greene, Brooklyn, and I feel like I'm anywhere but in the present—anywhere but in the fourth-largest city in the world.

This street, this place, this hour, they seem to be a severed slice of the American South sewn secretly into the middle of the New York City landscape, with hopes that no one would notice. I feel that if get on my knees and scratch and claw at the concrete below me, I could strip away this country façade and reveal the underlying grit of the city, like peeling the top poster off an antique billboard.

It is lunch hour, but the only signs of that are the quiet conversations escaping from an outdoor café clinging to one of the side streets that sneak by me. As I rush forward, I'm floating through an eclectic passageway of habitats—Italianate, neo-Greco, brownstones and frame houses lurch above my shoulders and flip-book through the corners of my eyes. All around me they speak in whispers and sighs. Dusty vignettes descend from their warped skins and open windows. Murmurs of faces seen and lives gone. Conversations of fate. Rumors of renovation. Grumbles about the weather. Some are covered in new nails and fresh layers of paint—boastful old women after a trip to the corner salon. Others crumble and tremble into fatality with each slight wind. They stand about and I slide through unnoticed like a cup's worth of tea poured into the Atlantic.

And within this place that doesn't belong stands a corner house that doesn't quite belong. Coated in the residue of years and faded yellow paint it's the only vision that interrupts my afternoon charge, slowing me to a measured crawl. It is a three-story house told in two parts. The left side is pushed back far from the sidewalk—a sign that it has been there much longer than any other branch of the home. A white porch sits like an open, elderly jaw, waiting for a storyteller, a relaxer, a book reader.

The right side of the home creeps close to the footpath. Propped up on the side of its slightly sullied first-floor window, an old American flag leans. A small garden nourishes long-trunked trees. Shadows and light loiter on its frame. Close by, on the front steps, an old woman stands. She wears clothes from another era and a stare that dips back into that same time. I find that I have so many questions for her. How long have you been here? How many years has this house stood? What is your favorite season? Why have you chosen Brooklyn? I want to squeeze a lifetime's sum of inquiries into this thimble of happenstance. I want to sit on the coffee-colored stone stoop with her and stop this crazy rush—take in a lifetime of these afternoons, one by one. Piece by piece.

But I go by her unnoticed. And as I resume my hurried pace, I know that if I never see her, or this house, or this intersection ever again, it will be a part of me. A cup's worth of memories, poured slow and sweet—into the attic of my mind.

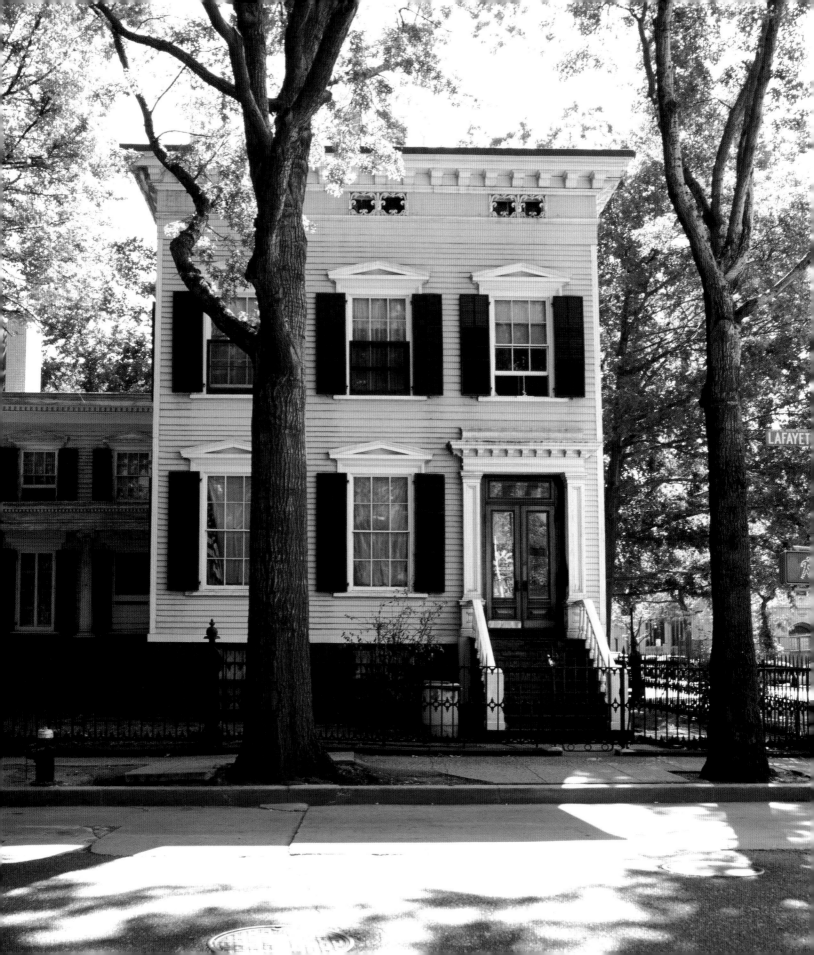

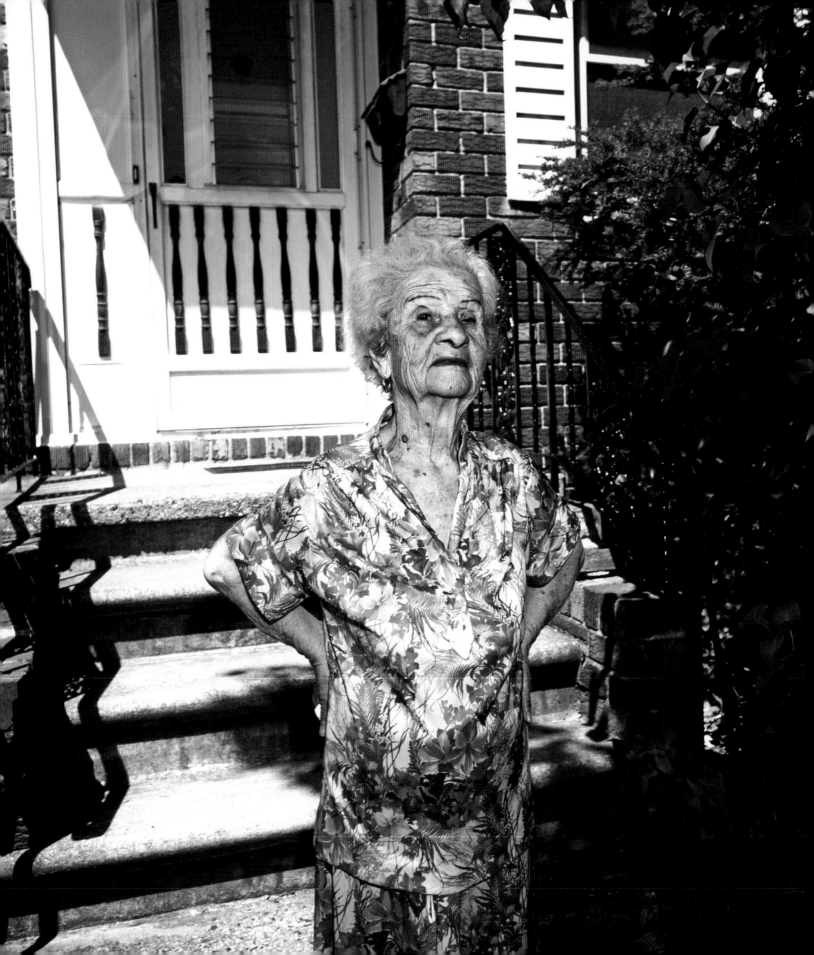

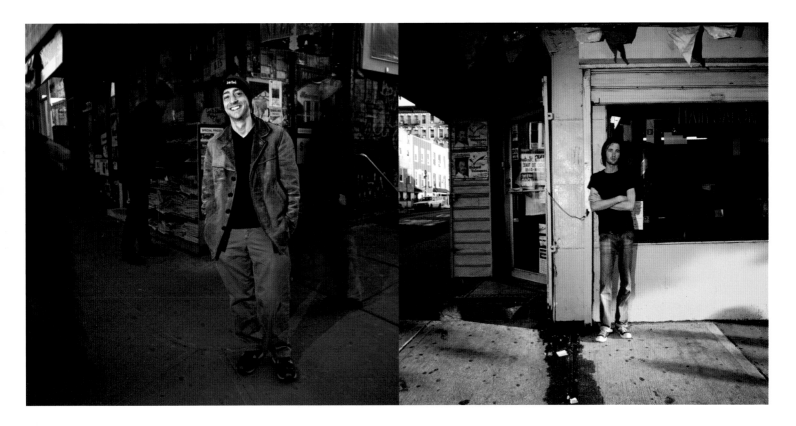

Andrew Casesse, 33: Actor

"There are so many pockets of interesting areas and neighborhoods in Brooklyn, which really gives it a special, real, feel. It's a nice home to come home to."

Photographed in Greenpoint

Dora Zegerman, 86: Grandmother (*opposite*)

"I've lived in Brooklyn a long time, I think 55 years. I lived in a tenement in Coney Island, then in Brighton, on 12th Street. I came from Poland, and then I was in Germany, in a displacement camp. They killed six million, my whole family got killed. I've lived in Manhattan Beach since 1964. I like this place, I like the people. I always went to the beach. I don't know if Brooklyn is better than any of the other boroughs, I don't live in another place, only here. My husband built this house; he built our children's houses too. I like living here."

Photographed in Manhattan Beach

Marcus Congleton, 26: Lead Singer of Ambulance, Ltd.

"I'm from Eugene, Oregon and I moved to Brooklyn in the winter of 1999. I had just turned 20. Eugene is a great place to grow up, but I just wanted to go somewhere that had the most possibilities, the most things happening. I visited a friend who was going to Pratt and as soon as I came here I decided to move here right away. I just thought there are the most things and people here. I probably knew two black people in Oregon, I had never seen a Puerto Rican or a Hasidic Jew before—and that's everyone who lives around me now and it's amazing.

I came straight to Williamsburg when I moved here. It just makes the most sense for me to live here. It's mellow, I like the Bedford area, the cafes, everything about it is really nice. And being comfortable here makes it easy for me to write my music.

Playing to the Brooklyn crowds and New York crowds has been amazing. It's our adopted hometown. We've been touring all over the country and Europe too, and coming back to Williamsburg—I can't think of anywhere I'd rather be."

Photographed in Williamsburg

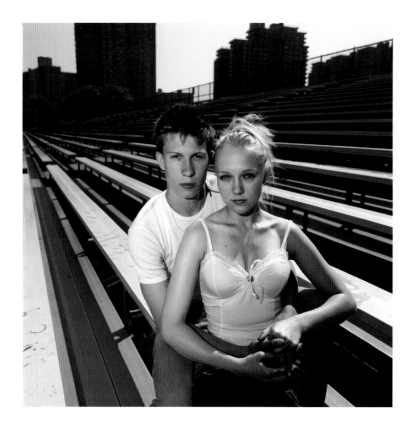

Anthony Danulenko, 18; Jen Freshenko, 16: Students

Jen Freshenko: "I live in Brighton Beach, but I came here from Latvia when I was seven. I love the beach at Brighton. I'm a beach slut. I love to go tanning. Once I went swimming in the dark and the waves were huge and the jellyfish were glowing, but no one believed me. I've seen strange things on the beach. I saw a pig's head once and a dead parrot one time. Also I once saw a whole bunch of these guys dressed in black sacrificing a chicken. It was at like two o'clock in the morning.

I love going to the movies in Sheepshead Bay—everyone's there. I see all my friends. We go at like 11 in the morning, pay for one movie and see like four movies and leave at like 11 o'clock at night. Everyone does that.

It doesn't matter what you do as long as you're with your friends. Usually everyone comes to my house and I feed them. My mom is never home, so everyone comes over and we party. We drink, I cook, we eat, we leave. Then we walk up and down the blocks of Brighton Beach to get sober and keep walking until you hit a dead end and then go home. That's what we do."

Photographed in Coney Island

Maya Azucena, (As Old As I Need To Be): Singer, Songwriter (*opposite*)

"I grew up here in Flatbush. One thing about home—sometimes you don't even know what you like about it—it's just home. But there is something just very powerful about this neighborhood. And when you travel and leave Brooklyn or the neighborhood, you start to realize the things that are extra special.

One of the things I love about this particular place is the West Indian culture and the food, which was such a given living here. When I moved away I was just amazed that you couldn't go to the corner store and get platanos or find a beef patty. To me that was absurd.

The other aspect of it was that I had a great childhood. The Labor Day West Indian parade would go right down my block! Right on Rutland Road. And I felt like me and my friends where the 'inner city Little Rascals.' We would put on full shows on the block. So I have been producing since I was five. I was also really into sports. Most of the time it was ten boys and me. We would run around Wingate Park. That's why it was such a thrill and a life circle thing to perform there a couple of years ago, opening for the Isley Brothers. To perform there for over 8,000 people in a place I remember running around in as a kid was amazing. When I came up to the crowd I was thinking, 'You guys are in MY backyard!'

Hip hop is also such a big part of the landscape here and, like the other things in the neighborhood, is a given in my life. It is Brooklyn. A raw, rugged thing. Saying what is on your mind. Being fearless. FEARLESS ON THE MIC!"

Photographed in Flatbush

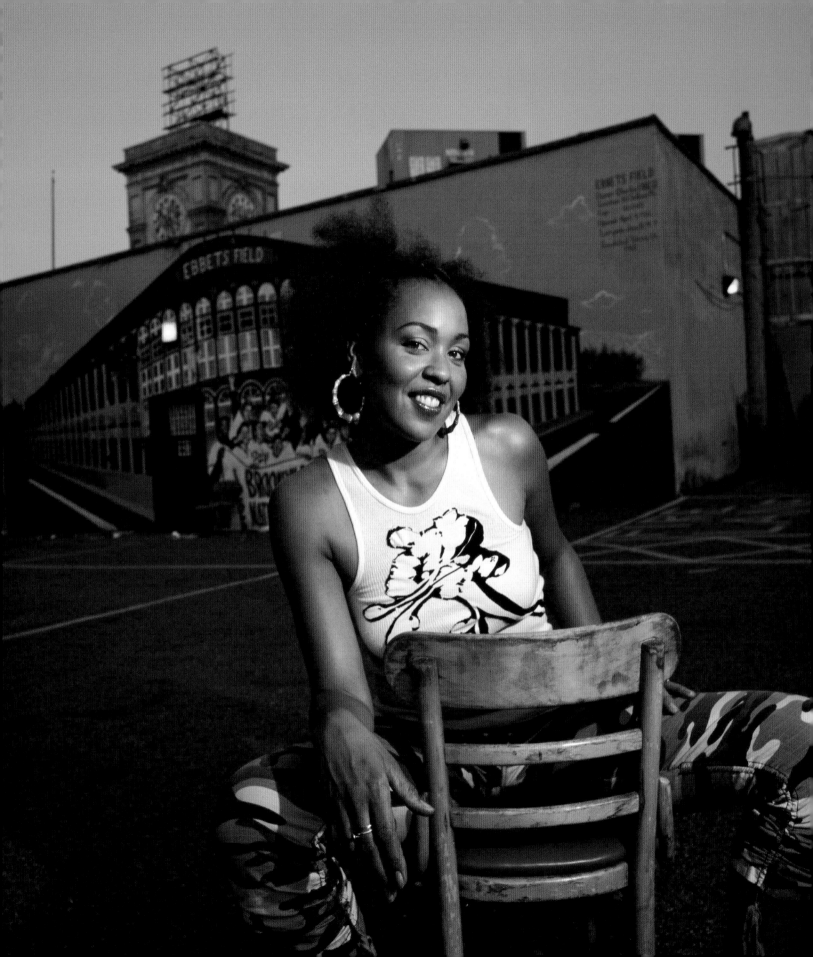

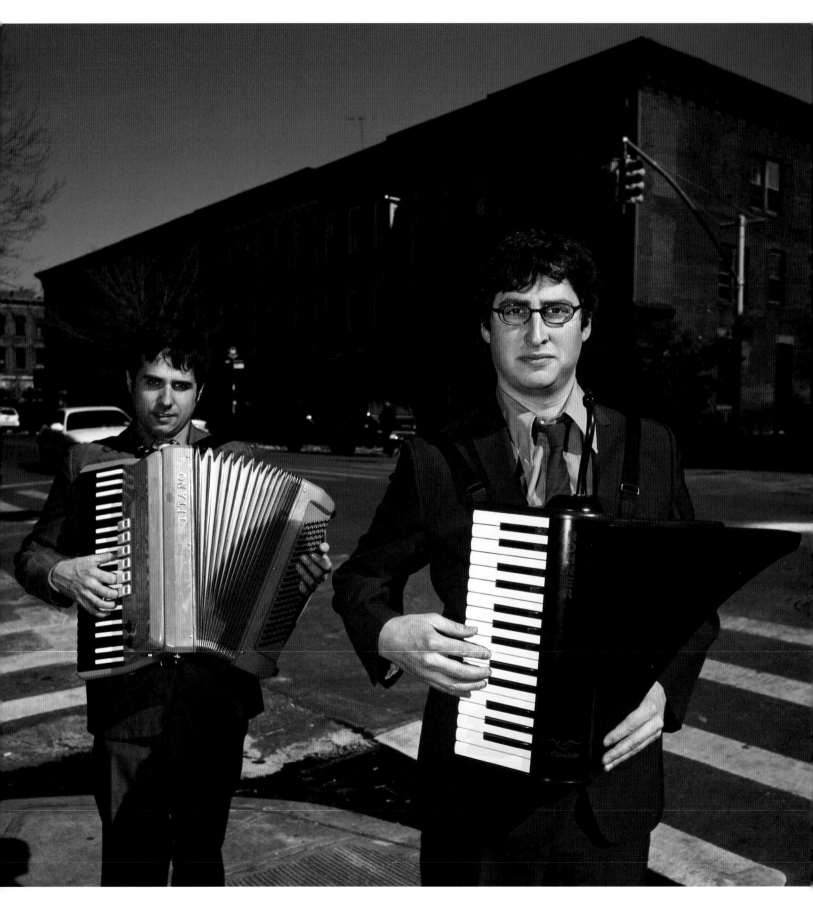

Atif Ahmad, 20; Ali Ahmad, 18; Ammar Ahmad, 17; Amna Ahmad, 13; Aneela Naz, 38; Ateeq Ahmad, 48

Atif: "We moved here from Pakistan about 12 years ago. It really helped us as kids to adjust to living in America because we moved to the part of Brighton Beach that was predominantly Pakistani. Brooklyn is great mainly because of the many cultures that are living within a ten-block radius. We have Hispanics, Pakistanis, Bengalis, Russians, and Koreans all living together. That may not seem exciting, but once you get out of New York you crave diversity.

It's different living here in terms of family. Pakistani culture is very family-oriented, and because most of my family is in Pakistan I miss out on a lot. Some of my best friends and close cousins are getting married these days and it's a shame that I can't make it out there for each one of the ceremonies. But I am who I am today because when we moved to America it was to Brooklyn."

Photographed in Brighton Beach

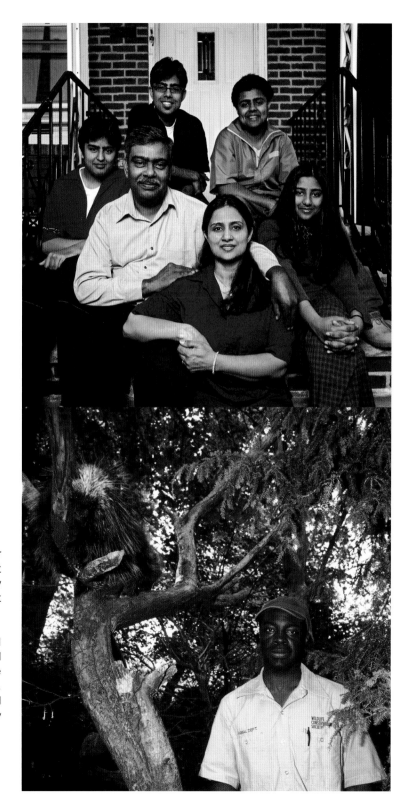

Michael Hearst, 32; Joshua Camp, 34 : Members of the Band One Ring Zero (*opposite*)

Michael: "I'm an extrovert and I always need someone to hang out with. In Brooklyn you get that—you have the guy from the bodega that knows you, the woman in the pastry shop, the owner of the local bar. And this place has by all means shaped our music and what we do. Not so much in the chords, but in our way of thinking."

Photographed in Park Slope

Atu Marshall, 25: Animal Keeper

"I am from Trinidad originally. When I first got here it was the winter and it was snowing. Trinidad is like 90 degrees all year around, so it was amazing for me. The first thing I did was run outside without my jacket and play in the Brooklyn streets. I got a cold, but it was the first time I ever saw snow. I couldn't help it.

My mom actually introduced me to the zoo when I was a kid, and I just fell in love with the place. I volunteered here when I was 16 and became friendly with the keepers and then started working part-time as an animal attendant for a year. Now I am a full-time animal keeper. They offered me the job and I was like 'Yes!' I love everything and everybody about this place. There are people that come here everyday and it makes me smile."

Photographed in the Prospect Park Zoo

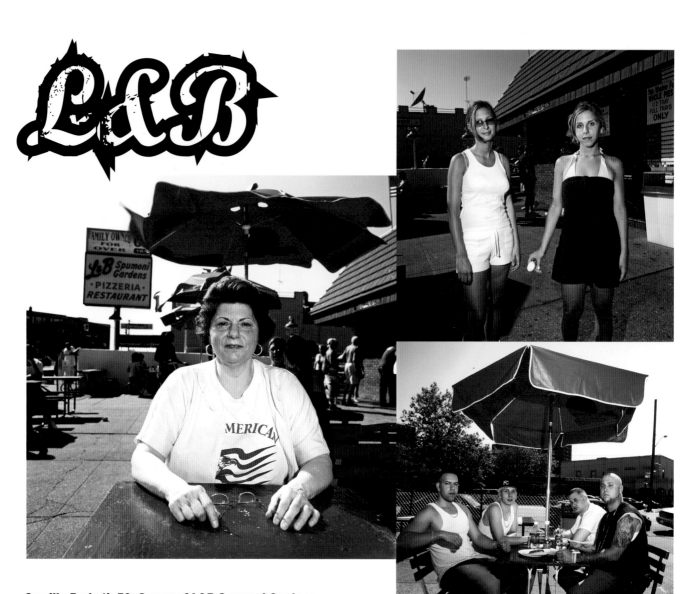

Camille Barbati, 56: Owner of L&B Spumoni Gardens

"My grandfather started this place. It's been open since 1939. We used to make everything in the house. Those days you didn't have to worry about, you know, rules. Like too much fat for this, pasteurizing the milk. But it was still good and no one got sick. It was great growing up here as a kid. Tuesday nights we would stand on the corner and watch the fireworks from Coney Island. Pizza was 15 cents back then—now it's $1.75. So I go way back.

My grandfather made the food, my father made it, my brother made it, and now my sons make it. You can't have strangers run your place because it won't be as good.

This is our time of the year because we have the outside tables—and where else are you gonna find 45 tables outside in Brooklyn? Who could afford this? We were just lucky to have bought this place so long ago. It's just family—we aren't rocket scientists. We are simple people who are happy to have this."

Photographed at L&B Spumoni Gardens in Bensonhurst

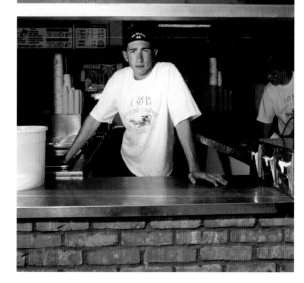

Terence Winter, 44: Television/Film Writer and Producer

"I grew up in Marine Park and attended William E. Grady Vocational High School where I studied auto mechanics. You name it, I did it as a kid—I was always hustling. I waxed cars on weekends, I worked as a waiter in a synagogue, I even delivered meat for a butcher shop owned by Paul Castellano. After high school I moved out of my mom's house and was living in this basement apartment near Kings Plaza. It was Christmas of 1980 and I had just failed in an attempt at the deli business. I was 19 years old and thought I was washed up. I remember waking up and looking around my apartment with its orange shag carpet and bad wood paneling and thinking 'If you don't get out of this place and go and make your way in the world you could theoretically be living here when you're 80 years old.' I decided I needed to get a real education and enrolled at NYU.

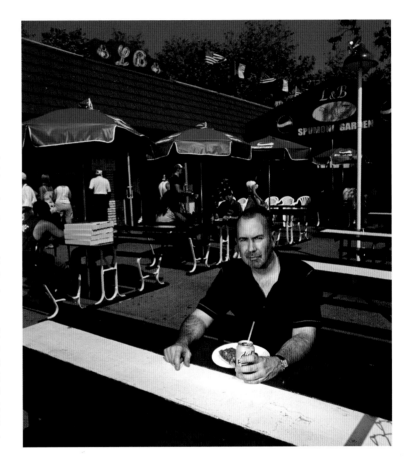

Though I eventually became a lawyer, my deep, dark secret was that I really wanted to be a writer. Once I was able to articulate that to myself it was like the floodgates opened, so I moved to Los Angeles and taught myself how to write television scripts.

I started working on *The Sopranos* after my agent sent over the pilot episode of the show. I put the thing in my VCR and I'm 20 minutes into it and I'm literally shaking—it's the greatest fucking thing I've ever seen. I didn't even finish watching it and I called my agent and said you have got to get me on this show. I'm from Brooklyn, I know these guys, I know that world. I couldn't get on staff for the first season of the show, but I got hired at the beginning of the second season, in 1999. Working on that show has been the greatest experience of my career in every way across the board.

I think growing up in Brooklyn gives you a different sensibility, a way of looking at the world, a certain sense of humor that people on the West Coast don't have. There's more of a comfort level with violence and a tendency to find it funny sometimes, like the Three Stooges—people from the East Coast seem to be much more in touch with that. It sounds terrible, but the writers on the show will watch cuts of our episodes where Tony Soprano will crack someone over the head with a phone and our first reaction is to laugh. Someone once said that tragedy is when I fall down the stairs; comedy is when you fall down the stairs. One of my favorite things when I worked in Manhattan was to sit at this little luncheonette in the winter, across the street from the main post office on 34th, and watch people slip on the icy steps; I'd laugh my ass off. Part of me felt horrible, laughing at ladies holding packages falling down—after all, that's somebody's mother—but I couldn't help it. It is never not funny. And that's something you get from growing up in Brooklyn."

Photographed in L&B Spumoni Gardens in Bensonhurst

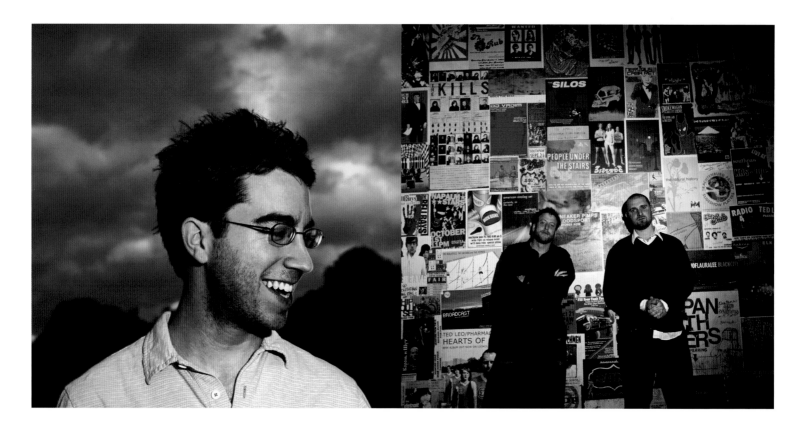

Jonathan Safran Foer, 28: Author

"I grew up in Washington DC and came to Park Slope basically because my brother went to college in New York and I visited him his freshman year. I must have been a freshman in high school, and I just thought it was the most amazing place. It looked like, you know, *The Cosby Show*. Then when I graduated I came to New York, lived in Queens for two or three years, and became friendly with Paul Auster. I came over to his house in Park Slope and, again, I just got the best impression of the neighborhood.

What do I love about this place? Just look around. It has a really old-fashioned type of neighborhood feel. The history is very present in a way that it really isn't in Manhattan, where everything is replaced so quickly. You can still walk by the old *Brooklyn Eagle*; you can still feel the presence of Walt Whitman, Joseph Brodsky. It has the feel of being authentic.

I do miss DC—in a way it's really Brooklyn taken to an extreme. The buildings are even lower, there's even more green, it's even more old fashioned. But DC has just become a museum of itself whereas Brooklyn is a living place."

Photographed in Prospect Park in Park Slope

Matt Roff, 30; Mikey Palms, 30: Owners of Bar and Music Club Southpaw

Matt: "Wiffleball and sewer to sewer football, baby. Hit me by the hood of the white car. That's what I remember growing up here.

There is always something to do here. Once you step outside your door, you can have fun with a garbage can if you're with the right people. I also like the fact that you had to work at having fun—you didn't have video games. Your mother told you to 'Go the fuck outside and go find somebody to play with. Look both ways before you cross, but don't come back for at least an hour.'"

Mikey: "I grew up in Prospect Heights when it was the ghetto. I loved being exposed to all the wonderful social deviants at such a young age. Understanding classism and having that kind of exposure to all the ethnicities of this place. Learning about them and eventually learning how to respect them.

It's the largest borough and there are more than 75 different languages and dialects spoken here. We are everybody. We're a planet. MC Lyte said it first, right? 'Brooklyn the Planet.'

Owning this place, Southpaw, it's what I've wanted to do since I was a baby boy. I've been a music lover since I was very young. This is my dream. This is my clubhouse during the day and a center for the arts in Brooklyn at night. A lot of people feel like rock and roll started in Brooklyn years ago down on Flatbush Avenue at the Paramount. We are just continuing that musical tradition."

Photographed in Park Slope

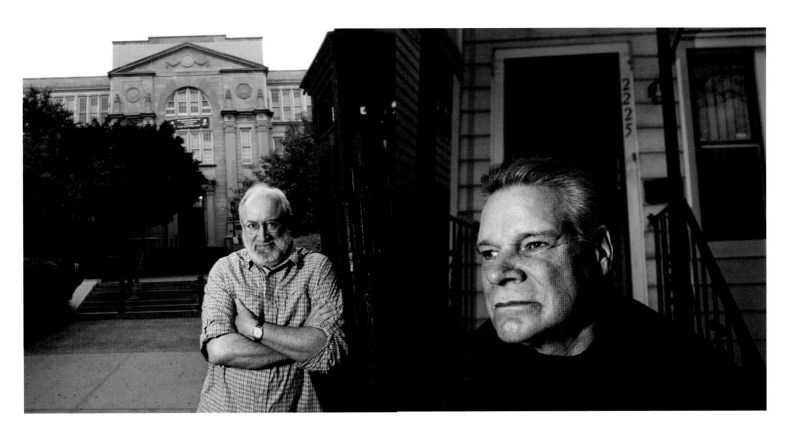

Howard Wallach, 58: Retired Teacher

"I grew up here in Brooklyn on Woodruff Avenue in Flatbush and I started teaching at this high school in 1968 as an English teacher before eventually switching to teaching Photography. I was 22 and I wasn't much older than the kids in that class. You know—I was just one of the guys sitting in the back of the class and all of a sudden I had to teach.

As a Photography teacher, from very early on, I encouraged the students to shoot what they knew—their circumstances and their friends and family. I tried to convince them that the things around them were their visual wealth. Their surroundings. And I would fight with them over that. They would say 'there is nothing interesting here— I'm gonna go visit my uncle in Jersey and photograph there. Then I'll get good pictures.' And I would say, 'Go out in your driveway, you'll get good pictures there. I know the neighborhood you live in and there are interesting pictures there every second. This place is a million times more interesting than anything you'll find in Jersey.' From the beginning I think we recognized that one component of our visual wealth was Brooklyn and we really exploited that. We had night portfolios of the Gowanus Canal, images of all the Brooklyn train stations, photos of the storefront churches of Brooklyn. We used the Brooklyn urban landscape, the people of Brooklyn, Brooklyn interiors, the social organizations, the gangs, restaurants, newsstands—it was an endless well of inspiration."

Photographed in front of Abraham Lincoln High School in Coney Island

Ken Siegelman, 61: Poet Laureate of Brooklyn

"I belong in Brooklyn because no one really belongs here. The ethnicities and diversity is amazing. And changes do occur here, but with each change, things still stay the same.

Brooklyn has definitely affected my writing, even in the last 100 poems—several of which were engineered from thoughts of coming out of Brooklyn. And the content of many of the poems was affected by the sensitivity of being from here and being sensitized to the moment and being sensitive to the differences of my surroundings. Brooklyn has done that."

Photographed in Gravesend

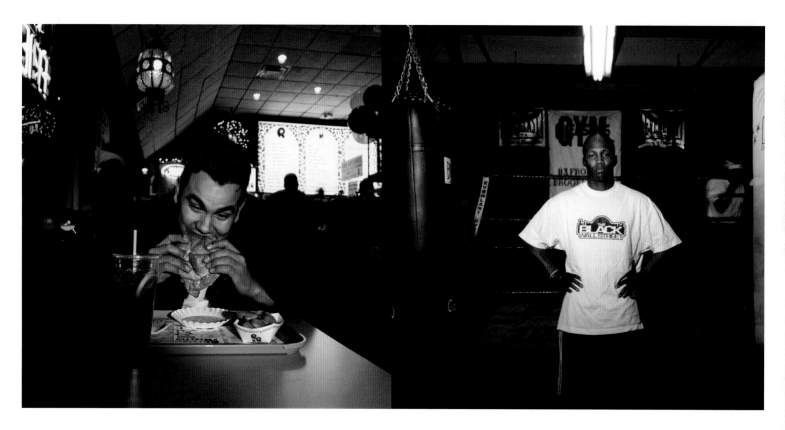

Carlos Molina, 27: Teacher

"I have had several near-death experiences in Brooklyn. The majority of these close calls involved errant vehicles. Any sane person would just pick up and move out of the state as soon as possible (most likely to an area with a low vehicle-to-person ratio.) My hometown-based vehicular mishaps bring about the perfect metaphor for life in Brooklyn: get knocked down, pick yourself up, dust off a little bit and go about your business. People from Brooklyn are just built from sterner stuff and that is important to have in the world we live in. That means that there are two and a half million people with a crusty exterior and gooey center. I can't picture myself being surrounded by any other type of people.

Roll-n-Roaster was a stone's throw from my apartment in Sheepshead Bay. Going there was a bittersweet experience for me because I loved the food but hated the ex-girlfriend who worked the counter. I would stand in line and insane thoughts would just race through my head: 'Does she see me? Is she telling everyone what a horrible human being I am? Did she spit in my food? Will I be chased into the parking lot and beaten senseless?' A roast beef sandwich, cheese fries, and an iced tea where the reward for enduring this level of anxiety and humiliation. It was always well worth it."

Photographed at Roll-n-Roaster in Sheepshead Bay

Zab "Super" Judah, 27: Boxer

"Brooklyn is a great place. If you can live here, you can live anywhere in the world—because you have to struggle in Brooklyn. But it's a good struggle. It makes you stronger. It made me a much tougher boxer."

Photographed in Gleason's Gym in D.U.M.B.O

Al Torre, 62: Professional Handball Player (*opposite page*)

"I've been playing handball for 40 years. I started playing with a Spaldeen and then I graduated to the hard ball. It's therapy for me. After working I come down and play. I was recently inducted into the Handball Hall of Fame in Tucson, Arizona. It was a great honor.

Brooklyn is the mecca for handball players. Especially here in Coney Island. You have so many great players here."

Photographed in Coney Island

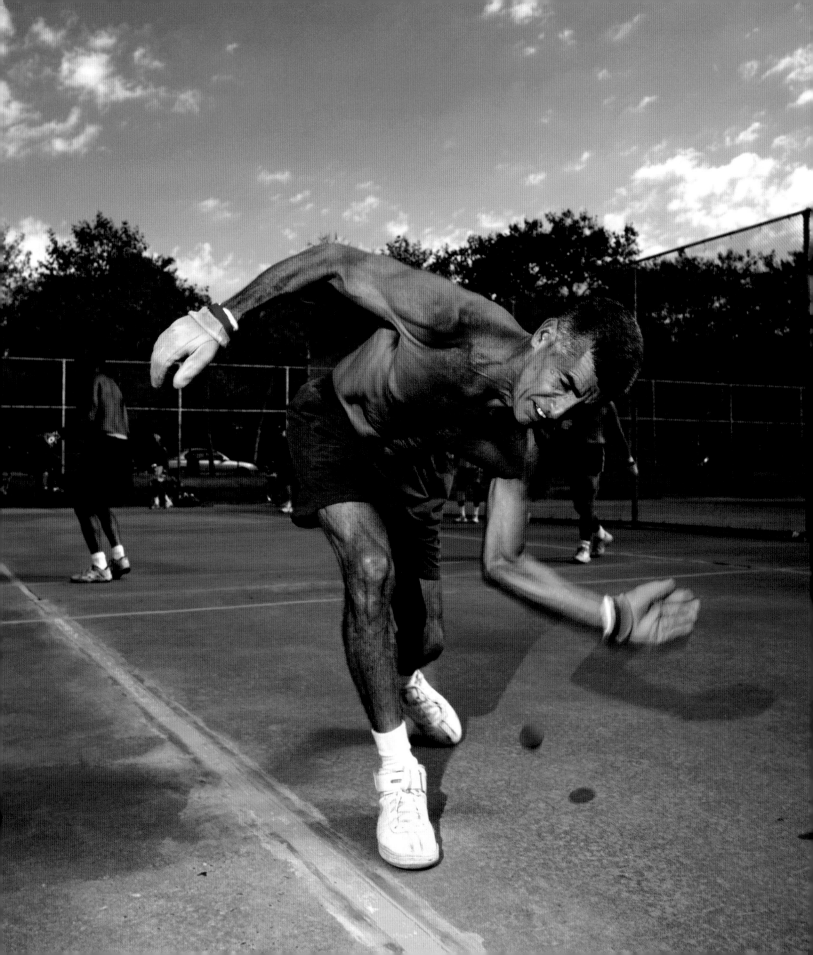

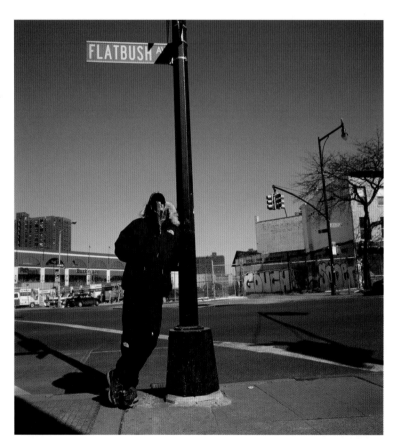

Gouch, 20s : Graffiti Artist

"Growing up here you have to pay your dues—and after you do that you feel like you belong."

Photographed in Prospect Heights

Jean Grae, 30: Musician (*opposite*)

"I was born in South Africa and I came to New York when I was three months old. I grew up in the Chelsea Hotel in Manhattan. I later had a studio in Clinton Hill that I worked out of—so that was my first taste of Brooklyn. Eventually I ended up in Bushwick, in the real industrial section. It was interesting, I lived in that apartment for about a year and then I moved about five blocks away. And I loved that apartment, but it was so fucking loud. That was around the time of the raggaeton explosion, so my apartment was basically a raggaeton club combined with the fake ice cream man and his truck across the street. At 11 o'clock at night he would be out there. And I wasn't so bothered that he was parked and selling drugs outside the playground, it was the fact that his ice cream song loop didn't go eight bars—that it only went four. It only did one section and it drove me crazy—you started hearing that section in your sleep.

So a friend of mine in that building was into real estate and she told me about a place here in this neighborhood that was huge. I like it over here. I like that fact that gentrification isn't here yet, but that it's coming really, really quickly. And I have a stoop now and a beautiful apartment. My mom came here and said 'You can't move from here.' Besides that, my building has been described as a sitcom. The girl that told me about this place pretty much hand-picked the people that moved in here. So it's a real family—a real community in the building. So at five o'clock in the morning people might knock on your door with some beer and you'll be like 'Okay, why not. Come on in.' It's that type of place. That's something you don't really find.

Except for early-90s Manhattan, we didn't really have a music community. So it's nice to have a Brooklyn music community. We're all just strange and we seem to have found each other. It's interesting to find people that you normally wouldn't have hung out with or met. And in addition I get to throw really, really loud parties."

Photographed in Crown Heights

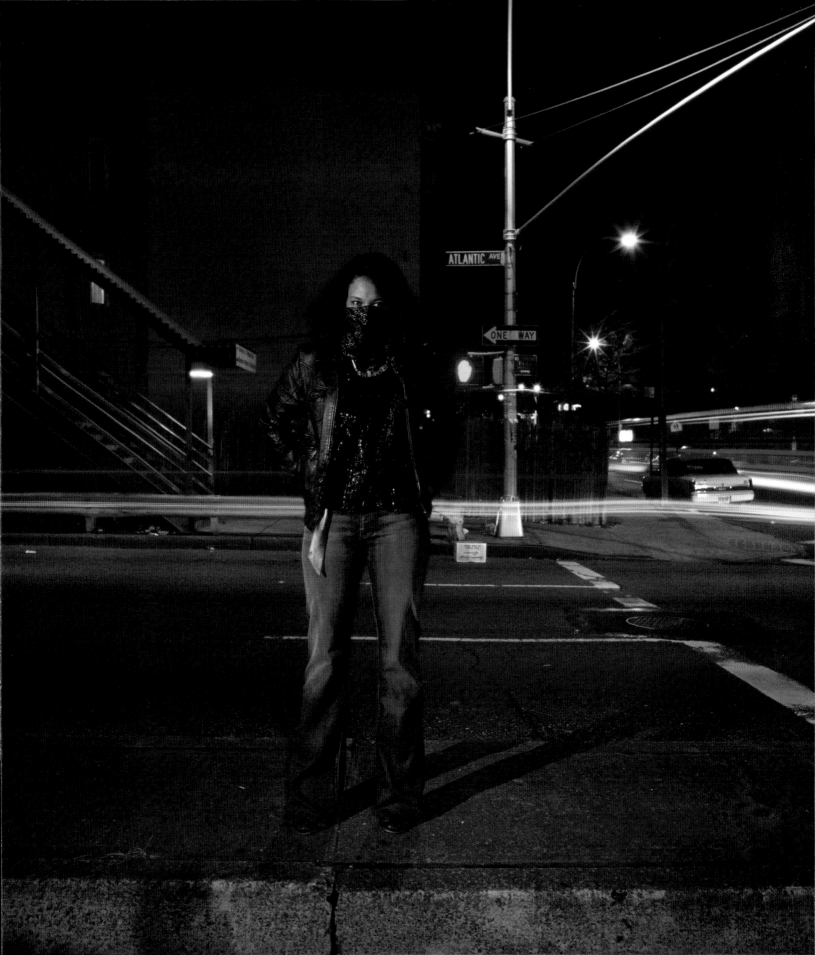

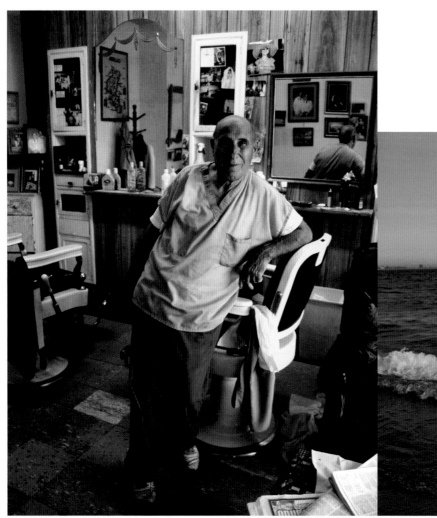

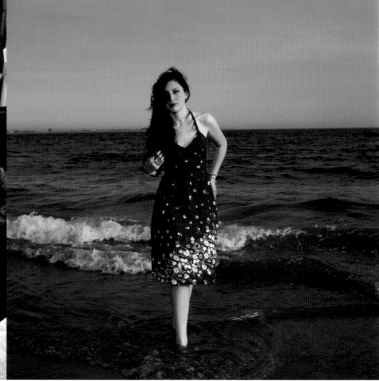

Dominick Guarnera, 75: Barber

"Here in Brooklyn you can do whatever you want. If you want to drink, you can have a drink. If you just want to pass your time, you can do that also. I love this place."

Photographed in Bay Ridge

Saskia Kahn, 16: Student

"When I was younger I didn't like living here at all because I always wanted to live in Manhattan. But then I embraced my inner Brooklynite. The great thing about Brooklyn is that it has this underground pride that we're from Brooklyn and Brooklyn is better than any of the other boroughs. We use Manhattan to entertain us but then we come back to our own special, unique neighborhood.

A big plus of living in Manhattan Beach is having the beach so close. The neighborhood is also enclosed in a way and has this family feeling. There are not many stores and you're surrounded by water on either side. The great thing is when you can bring people who live in Manhattan out to your house. You get them to come out to Brooklyn and it's like a little mini-vacation for them."

Photographed in Manhattan Beach

John Ventimiglia, 42: Actor

"I grew up in Teaneck, New Jersey. My parents came here from Sicily and they moved to what was actually Queens, but they called it Brookalino. It was Ridgewood, which is on the Brooklyn/Queens border. That was the neighborhood that a lot of the people from Sicily moved to. We then went out to the suburbs. I came back to Brooklyn in 1993. My wife and I found a place in Cobble Hill with a big garden and great neighbors. There was an old Italian lady, Angie, who lived upstairs and became my aunt and mother right away. We'd fight and make up and fight again. She was like a Fellini character, with a lot of make-up. My neighbor Sonny had a language I'd never heard of before. He'd say things like, 'In the old days, alright then John, in the old days, mean to say. Alright then John, mean to say?' Me and him would sit and drink beers and talk about growing tomatoes together. We were there for six years until we moved over here to Park Slope.

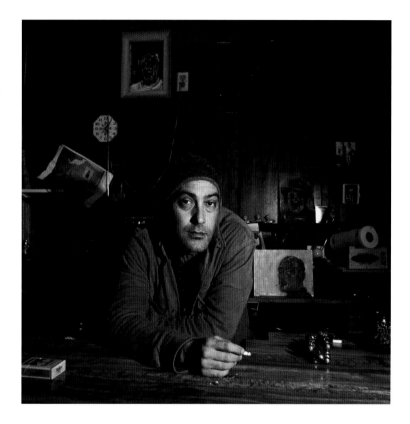

I got involved with this place because I knew the guys here. They used to sit in the back room and play cards. This place is called the His and Hers Social and Athletic Club. The social part was easy, it was the athletic part that took some imagining. The athletic part was all the stubs for all the horse and football betting going on. They knew me from *The Sopranos* and they knew I'm Italian so they took me in. They would ask me for signed pictures for them and their wives. Wives with names like Cookie. Then when they moved out of here, I made a proposition to the not-for-profit organization that owns this building. I wanted to have art exhibitions, things like that here, and they said 'okay.' These are some of my paintings behind the bar. I also come here to rehearse.

What do I love about Brooklyn? The stoops. I'm a big stoop guy. I love talking to neighbors on stoops and in windows. There were always a lot of old people around leaning out of windows and they always had a lot of stories to tell. They took a liking to me. They would bring me food. Make a sauce for me. I would just walk down the block and stop and have a half-hour conversation with a lady in the window. Seventy-eight-year-old ladies throwing me down cigarettes.

I like the coin-operated rides that are on the streets all over the place. They play old songs. I used to put my kids on them and they teach you the words to songs like, 'When You're Smiling.' And then your kids go around singing 'When you're smiling!' It's great."

Photographed in the His and Hers Social and Athletic Club in Park Slope

We met him on a main avenue in the middle of a classic Bed-Stuy afternoon, August already with shoes kicked off, resting comfortably in New York City. The type of late afternoon that you can sit in for decades. Soak in. A summer afternoon you want to trap buzzing in a bell jar, punching holes in the lid to let it breathe.

His name was Billy T. Thomas. A wisp of a man grown like a willow. He was excited to see us.

"Take my picture," he said beaming. "You know you wanna take my picture."

Dressed in a black suit jacket and tie and a grin that stretched from Montauk to Midwood he owned each street he strut across—his head arriving before his long body. His gait, his demeanor, his clothes—who dressed like that on the weekend anymore?—pulled all eyes and attention into his gravitational pull. Even when he stood still he was vibrating like a snapped car antenna. Through a gap in his smile he tossed out rhymes and anecdotes that lit up the block, rivaling the lush light from above.

"How old are you?" I asked him.

"I'm older than cold water and sweeter than salt!" he repeated a number of times until we were all laughing at his enthusiasm.

"What do you love about Brooklyn?" I ventured.

"What's not to like?" he countered, his eyes dancing around, his smile growing larger. "Just look around ya."

The light on the walls behind him was that sumptuous, profound light that enhances life itself, making every moment a cinemascope still. An amber veneer cast across aged brick and weary telephone lines as if Hopper had reached down from above and coated the scene with his brush strokes.

And when the Hasselblad was raised, his body came to life. Billy T. was a tempest of limbs and poses—swaying like Oz's scarecrow, pausing only for momentary clicks, the camera trying desperately to keep pace, to hold his energy in stillness.

"How 'bout this?" he threw at us. "You like this?"

Bursting through postures and attitudes he continued, "You know you like this one. You gotta have this one."

Then, when his momentary waltz was through, he bowed slightly to us and shuffled down the street, my eyes following him until Billy T. Thomas was nothing but a black spot in the distance.

"Did you catch him?" I asked.

"I'm not sure…I'm not sure," said Seth, looking at his camera, seemingly cursing its sluggishness.

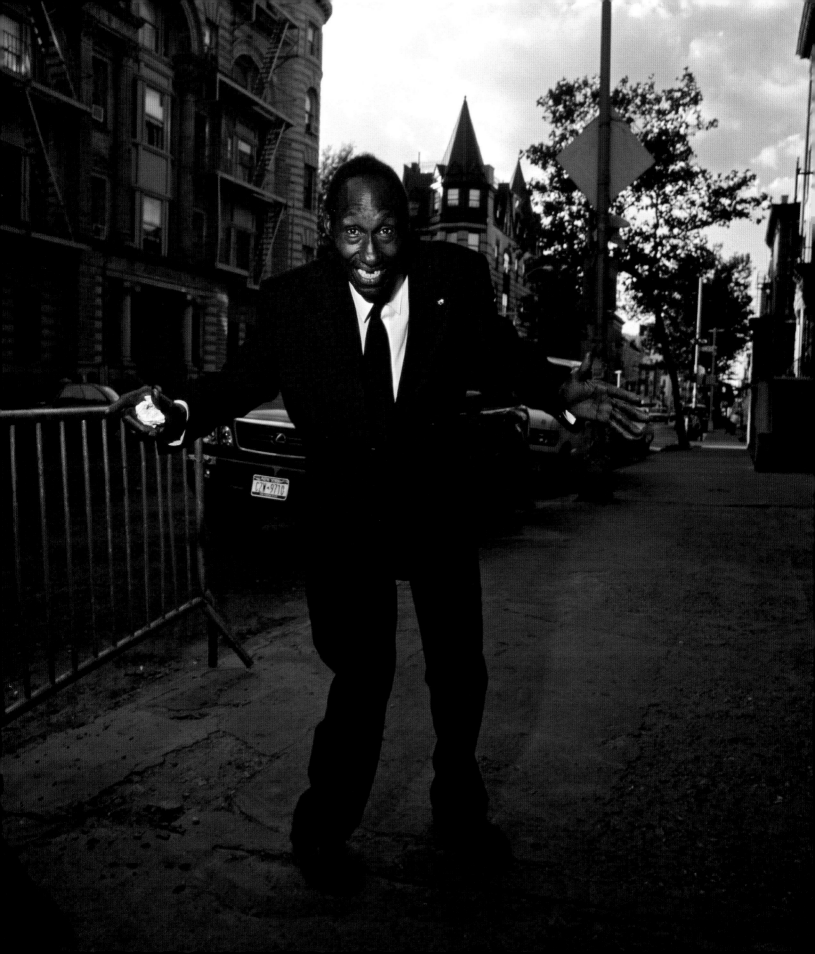

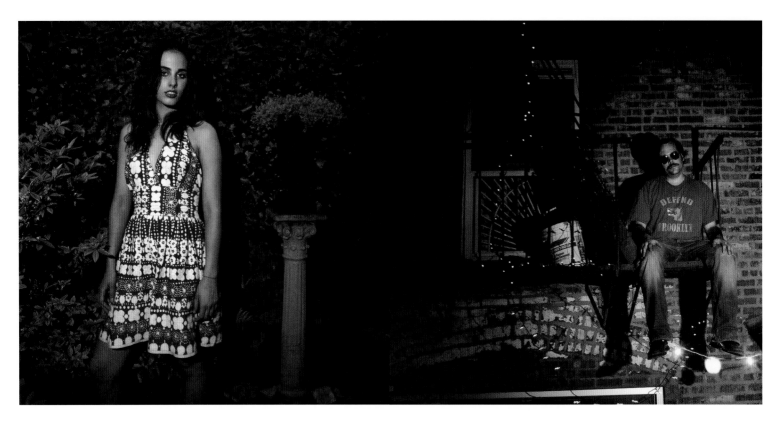

Sophie Auster, 17: Musician

"Brooklyn is more intimate than the city. Especially in Park Slope—it's a small town in a way. I used to go to the Berkeley Carroll school, which is really close by to my house, over on Garfield Place. I went there from kindergarten all the way up to eighth grade and all the kids lived close to each other and everyone would watch each other's homes. There's also a good mix of people here and always some odd little things going on—people playing their guitars in the street, yard sales, kids playing in the schoolyard of PS 231.

I think the quiet atmosphere where I live has inspired me as a person and an artist. Hustle and bustle and noise can also do that, but separation from that can also inspire you. I have both because I come home from Manhattan into this quieter atmosphere. It's also nice being surrounded by artists and meeting all of my parents' interesting friends—many of whom live in the neighborhood. People who live in Brooklyn are just generally cooler than people who live in Manhattan because they are not so caught up in the scene of the city."

Photographed in Park Slope

Chance Johnston, 32: Owner of Boogaloo Bar

"Brooklyn's a diverse place, it's the real New York—it's gritty. I've heard some of the most incredible music here and met some of the coolest people. I used to go out to the Lower East Side and spend my dot-com money at the bars, but now I own a bar. I'm a small business owner on a dirty block in Williamsburg. We're the only ones who have an address on our door, so the city is always fining me and sending me to court for the garbage on the block, because there's no other person to give a ticket to."

Photographed in Williamsburg

Amy Sohn, 31: Writer

"I grew up in Brooklyn Heights. I loved growing up there. I ended up going to Hunter in Manhattan and made friends there, but certain friends were not allowed to come to Brooklyn to visit me. Which bewildered me because if you got off the subway and looked around Brooklyn Heights, you would see it was a pretty nice place to be. But that just goes to show you what the climate was like in the mid-1980s—there were kids who weren't even allowed to ride the subway with their parents. Later I spent time in Cobble Hill and now I live in Park Slope.

I love the great history of Brooklyn writers—that helps inspire me. I've written two novels and both of them are set, at least in part, in Brooklyn. So it's definitely affected me as a creative person. My second novel started out as my response to the yuppie culture and the parent culture and living in Cobble Hill and wanting to set something in that world. It was also a book about someone who was having a little bit of trouble separating from her parents, so I needed her to be living in the same neighborhood she grew up in. And that's what I love and hate about Brooklyn—you are always running into people that you know. You can be having a fight with a boyfriend in the street and your parents' friends are walking by. Always embarrassing.

Park Slope is a little crazy to raise a kid in—I mean you walk down 7th Avenue on a Sunday afternoon and there are 100 strollers per block warring for sidewalk space. But you know once I'm one of those people I'll appreciate having the community. You know you can breast-feed anywhere in this neighborhood, you have a million preschools, some good public schools, so I'm looking forward to having my child here. And I really wanna raise a city kid. I grew up riding my bike across the Brooklyn Bridge with my dad, eating Italian ices, pickles from the barrel and knishes. I want my kid to have the same experience. I want them to have a really open mind—something that growing up in Brooklyn gives you."

Photographed in Harmony Playground, Park Slope

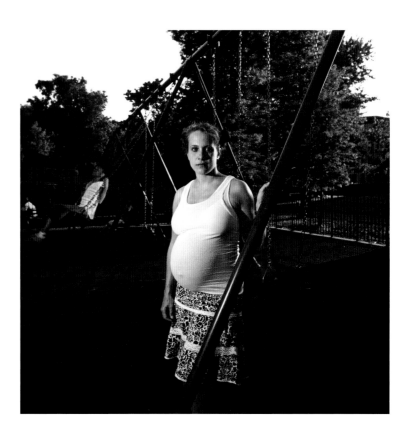

Donald Basmajy, 67; Roy Basmajy, 63: Dry Cleaners

Donald: "This business and neighborhood have changed so much. We've been here since 1975. Bay Ridge is a lot younger and everything is laundry these days. If anyone opened this business today they would be crazy."

Photographed in Bay Ridge

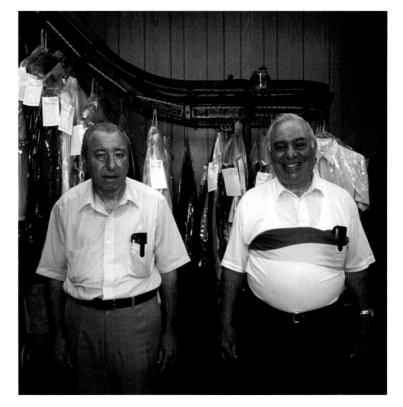

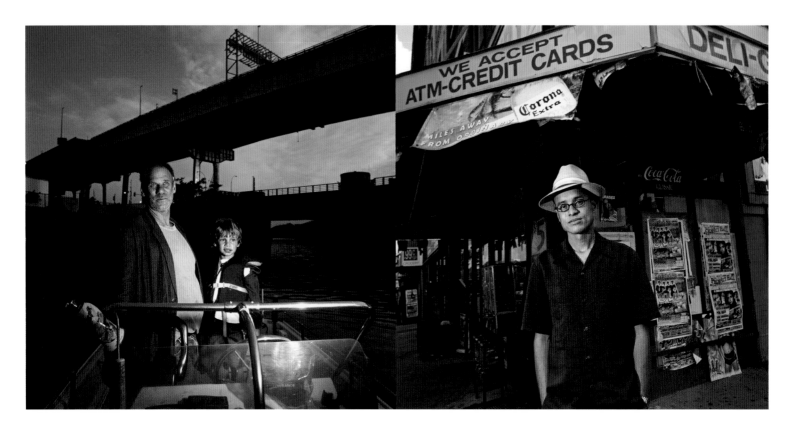

David Lefkowitz, 50; Sam Lefkowitz, 6: Writer

"I'm originally from Atlantic City and I was raised in the Bronx. I moved here to the Gowanus neighborhood seven years ago, just before the flushing tunnel opened. What made me fall for this place was that fact that it is a porthole. The canal is an opening to the Atlantic Ocean. That is what brought me here. That was the fascination. It gave me access to this wilderness that nobody cared about. For some reason the whole world turned its back on this maritime city. Out here it's a totally different point of view. Suddenly you are a spectator looking at the city and you haven't even gone anywhere. You are in a wilderness. Manhattan is the most made-over island in the world. Yet the water remains timeless. And, on top of that, there is hardly anyone one out here."

Photographed in the Gowanus Canal

Martin Cuevas, 34: Musician

"On return trips to Brooklyn from my current home in San Francisco, I've found myself standing, more than once, at what once used to be my front door on Coney Island Avenue. What made this a great neighborhood? An eclectic mix of ethnic groups graced these streets from the late 70s throughout the mid-90s. Puerto Ricans, Cubans, African Americans, Jews, Orthodox Jews, Hasidim, Italians, Irish, Mexicans, Muslims, Russians all shared and fought over what was considered the neighborhood. Territories were split between the east and the west, with each side squabbling over a landscape with fortified positions at the D and F elevated subway line waiting areas. How is this great you may ask? All the different kinds of food available to you and all the different curse words in different languages you could pick up as well.

And what about the 4th of July in Brooklyn in the 80s? You were either a participant in the slaughter or an unprepared victim. Your choice was simple. Arm yourself with a healthy supply of bottle rockets and a trusty lighter whilst making your way to the nearest accessible rooftop. As the unprepared approached, the festivities would then commence. If you chose to venture out without the aid of a shield of some sort (usually the first garbage can lid you could find), then you were in for a harrowing trek. Riot gear would not have been out of the question in those days."

Photographed in Sunset Park

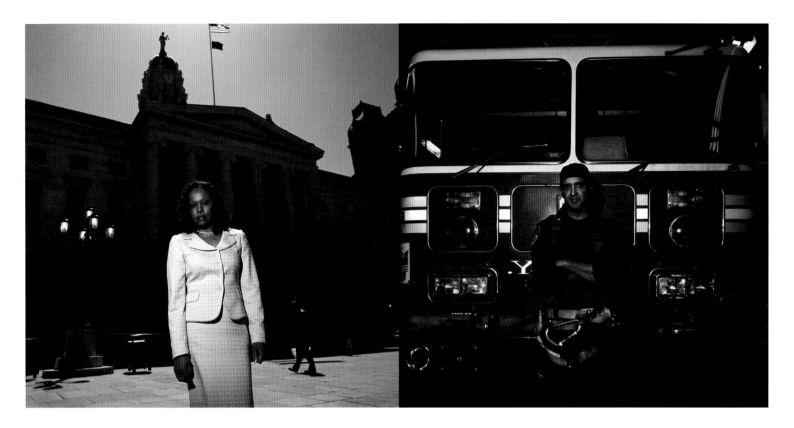

Yvonne Graham: Deputy Brooklyn Borough President

"I grew up in Jamaica and came to Brooklyn—East Flatbush, in 1979. I have lived and worked in Brooklyn ever since. My husband's family lived here, and at the time the Caribbean community was taking root in Brooklyn—so it was a natural place to be. I came in April and everything looked quiet and normal. And then one day it was beautiful outside and I went out and I'd never seen so many people in my entire life. I didn't know where they came from. Then I realized they were hibernating.

I started working here in 2002 when Marty Markowitz took office. Brooklyn is the most diverse city in America. So it gives you the opportunity to develop model programs that can be replicated not only in other places in the country but around the world. The blend of cultures also gives you the opportunity to just be savvy about world issues because you are dealing with people from all over the world who come with their own characteristics and their own cultural baggage. So you are forced to learn about those cultures and interact with those people. Only Brooklyn has that. Brooklyn has a spirit that cannot quite be described, you have to experience it. I think that is why so many people are moving here. They want to experience it. That spirit is infectious. They just have to find housing!"

Photographed in Brooklyn Heights

Leo Tineo, 36: Fireman

"I was born in Williamsburg, moved to Bushwick, and I work in Brownsville. I'm a true Brooklynite. I liked growing up here—my most vivid memories are just hanging out in the neighborhood with my friends. Playing stickball, skully, Chinese handball. My father also had a bodega in Bushwick, right on Knickerbocker and Jefferson Avenue. It was called Quisqueya.

I became a fireman in early 1999. I got this job because I was a swimmer at Bushwick High School and my coach happened to be the head of the Parks Department. He took all of us ghetto kids and gave us jobs as lifeguards in Coney Island. I did that for 13 years, and one of my supervisors was a fireman and he gave out flyers about taking the test. I never thought about being a fireman, but thank God I did, it's a good job.

And I saw a lot of crazy stuff in Coney Island. One time this lady was just dragging herself on the sand, it was the weirdest thing. She had a long cape or dress on and she looked like she had just come out of the water. Like a fucked-up mermaid just dragging herself back into the water."

Photographed in East New York

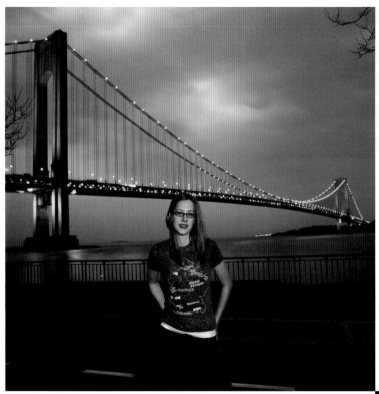

Terra Miller, 31: Human Resources Manager (*left*)

"My life has taken me to this wonderful place. I don't feel that I was seeking Brooklyn out; some unique force drew me here. Every step in my life brought me a little closer to Brooklyn. I grew up in Duluth, Minnesota, I moved through many places and experiences in Ecuador, Mexico, Germany, Boston, Connecticut, and now Brooklyn. Brooklyn is where I was meant to be.

Living near the Verrazano Bridge and the waterfront in Bay Ridge reminds me of the Charles River in Boston and Lake Superior in Duluth. In Duluth we are mostly Norwegian, part of my family comes from Norway, and it turns out that Bay Ridge was a Norwegian community back in the late 1800s. My family came to this country through this place, and as my grandfather tells me, my ancestors have brought me back.

A very significant Brooklyn experience took place for me in Coney Island. I got on the Cyclone with some friends without really fully understanding this creaky roller coaster from 1927. As I fell down the first drop, I quickly accepted the fact that my life was about to end. As it turns out, I survived the Cyclone, my life changed, and I now know what is means to be 'Brooklyn Tough' and a Brooklynite."

Photographed in Fort Hamilton/Bay Ridge

Bruce Benkel, 53 : Owner of Bruce's Bagels (*right*)

"I grew up right here in Flatbush. I started working here in this store when I was around 15 years old. When I first started out I thought doing this was cool. Knowing how to twist and make bagels by hand was something cool. I came in here at an early age and I stuck with it.

The bagels in Brooklyn are the best because of the water. But what's also very important is how they're made. I happen to have one of those old-fashioned army mixers that really makes it somewhat more distinguishable than anyone else's because of the way it mixes the dough—it comes out like cement. Today's new mixers never give you the same density—it's too whipped, too smooth, too silky, and the bagels come out too fluffy.

I eat them almost every day. If I'm not eating a bagel, I'm eating Italian bread. My favorite bagel is probably the everything bagel. The garlic and salt are also good. Originally there were only three or four types of bagels—plain, onion, garlic, and salt. The everything bagel and the sesame and the poppy and the cinnamon raisin are pretty recent bagels. They've only been around for 15 to 20 years. And even though the cinnamon raisin is pretty popular and good, it's getting a little more towards cake then bread. So things are changing."

Photographed in Flatlands

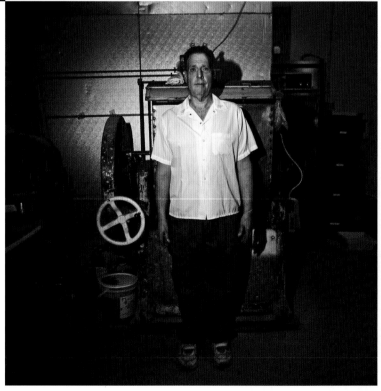

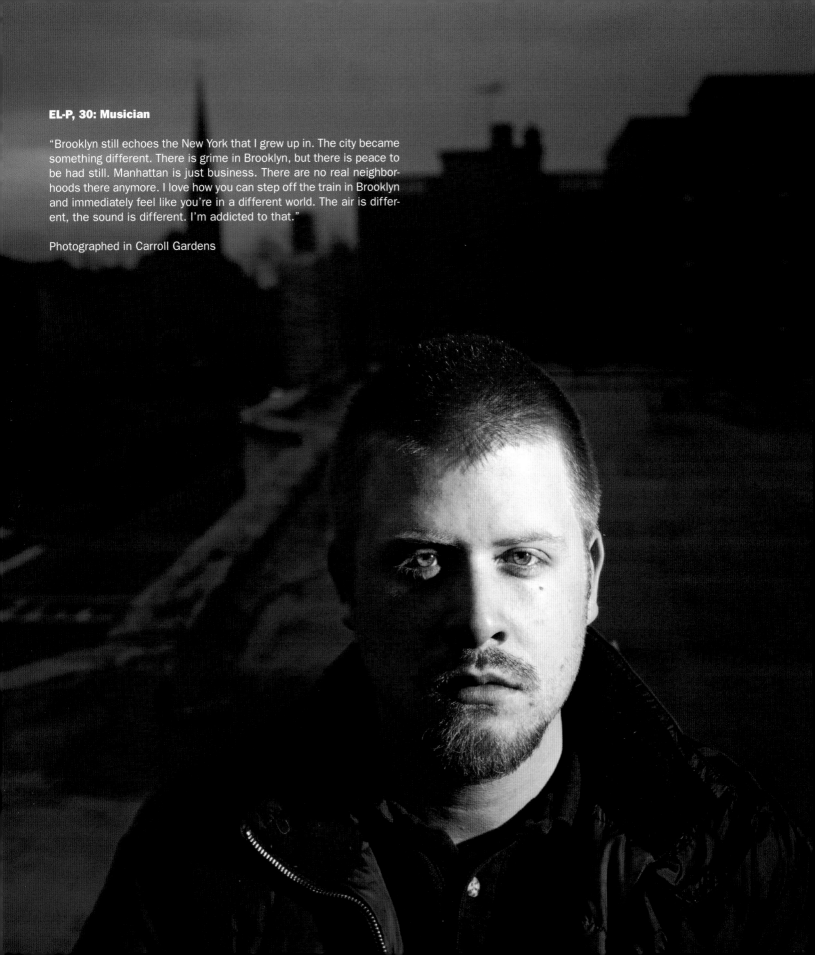

EL-P, 30: Musician

"Brooklyn still echoes the New York that I grew up in. The city became something different. There is grime in Brooklyn, but there is peace to be had still. Manhattan is just business. There are no real neighborhoods there anymore. I love how you can step off the train in Brooklyn and immediately feel like you're in a different world. The air is different, the sound is different. I'm addicted to that."

Photographed in Carroll Gardens

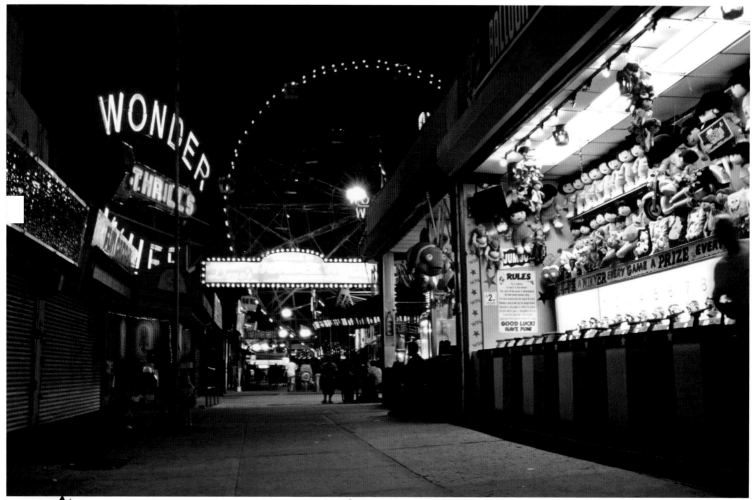

Coney Island

My father would often talk about Coney Island like it was his home-land. Like he wasn't in fact Italian, but actually Coneyislandese. This man, born in a rumor of a town in the back hills of Sicily, flitting from tenement to tenement in Manhattan and Brooklyn, finally settling deep in Bensonhurst. But the dunes of Coney were where he felt most comfortable—heaving his skinny, tanned body through sand and dark sea. Living off found nickels and sauerkraut and sun. Descending into the grains like a burnt tree limb dropped into a tub of silk.

On an island that is no longer an island. A place named after rabbits with not a rabbit in sight.

For me, this place was a different realm. It held altered visions; changed charms. Dilapidated and broken by the time I encountered it, it was an emaciated shadow of its original form. A ghost town jam-packed with souls eating yesterdays by the mouthful. Hucksters, slender and twitchy and angled like animated Egon Schiele drawings. Thin walls with chip-paint-lettered promises of freaks and the eccentric. A hung-over

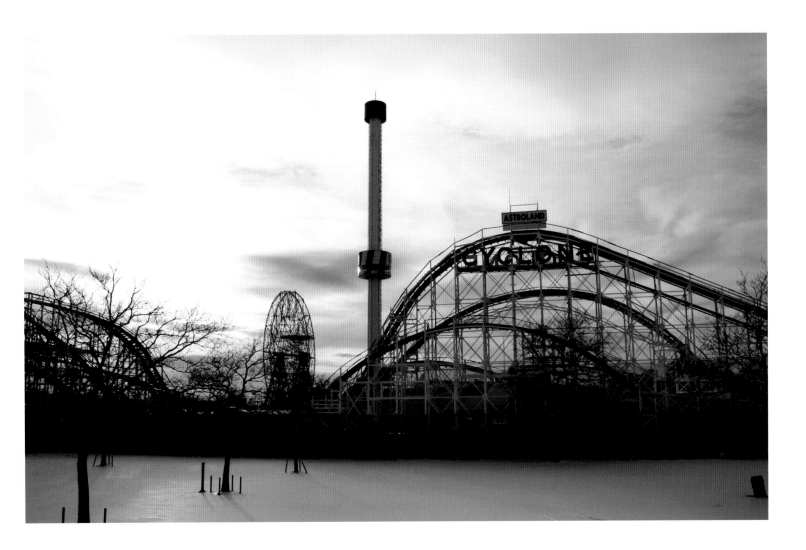

gaze in its aging, blood-shot eyes. The 1939 Parachute Jump, the magical totem of Brooklyn, watching over it.

And I loved it all. In each and every season.

Spring and autumn. Slowly shifting my feet along the boardwalk, its planks etched and battered with recollections. I would habitually gawk at the cracks and imprints on the windswept lumber looking for signs of the past, reading them like the hieroglyphics of Brooklyn.

The depths of summer. Going to the fabled beach, the last stop on the subway. Visions of apartment buildings and concrete through the scratched windows of the train replaced by views of wooden coasters and a monstrous Ferris wheel with cars swinging like earrings in the breeze. People carrying coolers, tugging at clothing, pulling on buttons, loosening strings, waiting for the first feel of sun. The silver cars disintegrating like cotton candy into salt and liquid, their doors opening and emptying us—with a bursting moan—from the outskirts of everywhere directly into the sullen swell of the grey Atlantic.

Unforgiving winters. Sitting scarved in a warm car seat in front of Nathan's, with the heater breathing ketchupy air on my face. Shaking a tightly closed, white paper bag to evenly disperse salt and sauce over french fries.

Coney Island was and still is like a great grandparent to the people of Brooklyn. A bit aged and weathered, but always ready to recount tales of the past. Forever willing to fill our senses with accounts of the glory of Dreamland and Luna Park and Steeplechase, all operating on primitive electricity and the thrill of primordial contraptions. Here is a place that should have been paved over decades ago. Turned into co-ops, Kmarts, strip malls, drive-thrus.

How can it possibly still exist? This fairy tale graffiti kingdom. This rusty basin of reminiscences.

But somehow it remains—its rides spinning like massive, absurd engines, fueling the spark and imagination of New York City. It is our lovely, bizarre bundle of silver linings whenever Brooklyn seems all too much.

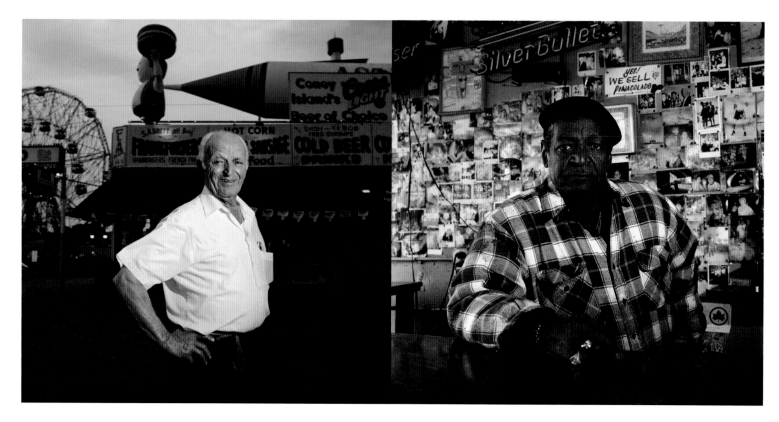

Paul Georgoulakos, 75: Owner of a Restaurant on the Coney Island Boardwalk

"I'm originally from Greece. I've been here for over 50 years and owned this place for 35. My family came here because it is the 'land of opportunity.' My father lived in Newark, NJ and worked as a milk-man. He had to change jobs and then we ended up in Brooklyn. I came to Coney Island originally for a typewriting job as an apprentice—and here I am.

I like this place because it is something that you own and built from scratch. I used my hands to make a living. Of course the fresh air, the ocean, the people. I will never leave here—I'll go to my old country as a vacation, but Brooklyn is my country now. "

Photographed in Coney Island

Sam Rodriguez, 78: Bartender at Ruby's Old Thyme Tavern

"I have been here in Coney Island for 55 years—I'm from Puerto Rico originally. When I got to the New York employment office, they sent me to Coney Island. I was a porter for a while and eventually a bartender here. The ocean, the boardwalk, and the friends I have met have kept me here. The people in this bar treat me like a human being and part of the family—which I like."

Photographed in Coney Island

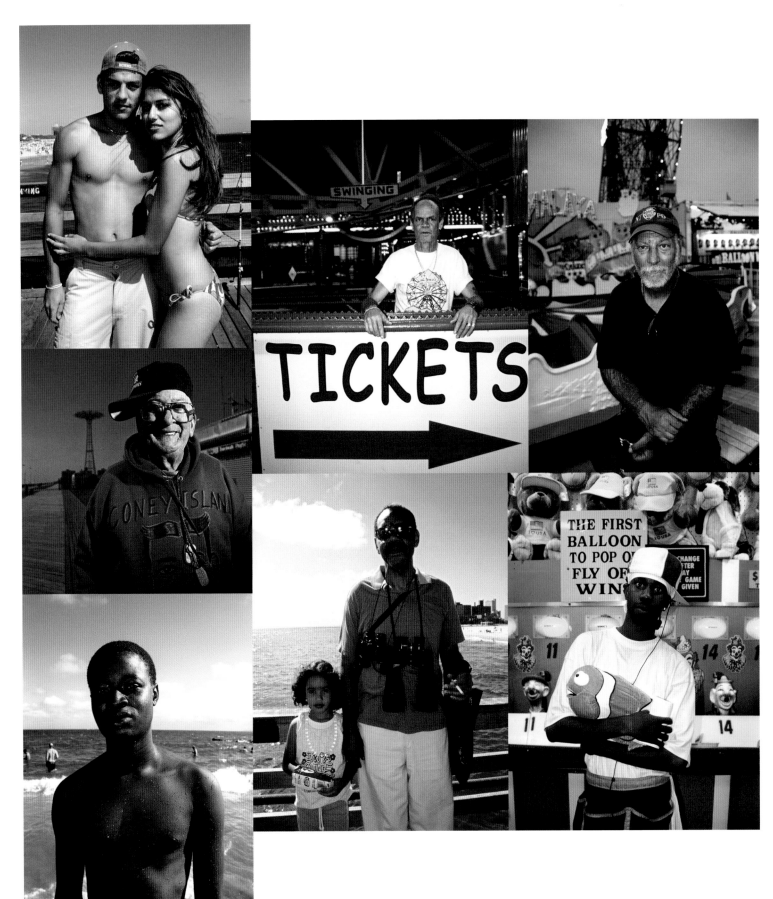

Galen Polivka, 35; Tad Kubler, 32; Craig Finn, 33; Franz Nicolay, 27; Bobby Drake, 29: Members of the Band The Hold Steady

Tad: "I moved away from Boerum Hill, which was a great place to live, because I constantly found myself drunk on the G train after visiting my friends here in Greenpoint. I thought it would be easier, safer, and a lot less hassle if I moved up here."

Franz: "There's this bar down here called the Blue Lady Lounge that none of us can figure out what the fuck is going on in. But, besides this place, it's our favorite neighborhood bar. They were doing this thing for a while where if you bought three drinks you would get a free t-shirt. And they had these random old Miller Lite t-shirts hanging up everywhere. They stopped doing it because we were going to have our whole summer wardrobe provided by that place. But it's things like that that make this neighborhood great.

There are very few other places in the world where you can play all kinds of music like you can here. Jazz, hip hop, country. Brooklyn invites everybody. And you can play with the best of everybody if you want to. They are basically the cream of the crop from every small town and city across the country."

Craig: "In a lot of ways, lyrically, our album *Separation Sunday* has a lot to do with myself growing up in Minneapolis, and being in a different place enabled me to see the forest for the trees and actually think back and compare the two experiences.

And while the cost of living is high here, it's sort of like the cover charge. You pay $40 bucks to get into a great theater or a great club. You pay $800 a month to get into Brooklyn. Membership has its privileges."

Photographed in the Pourhouse Bar in Williamsburg

Emma Sullivan (no age given): Owner of Long Island Restaurant

"I've owned this place for 50 years now. I took it over from my father in 1955. I was raised in this neighborhood, in Brooklyn Heights. It was a place that ran dances and picnics, a place that had its own soccer team, a place that was really one big family. It's a place where I married the neighborhood boy and so did almost every other girl. Now everyone comes here to show me their babies and their family. It's still a family place. I just sold over $5,000 worth of Girl Scout cookies. I had to put the beer away just so I could fit the cookies."

Photographed in Cobble Hill

Jody Storch, 35; Amy Rubenstein, 66; Marilyn Spiera, 67: Vice President; Owners of Peter Luger Steakhouse

Amy: "We took over the restaurant from the Luger family in 1950. After we received a four star review in *The New York Times* in 1967 and a national book in 1968, the place became incredibly popular. Remember, nobody used to come to Brooklyn to go to a restaurant. Nobody used to come to Brooklyn for anything, really! And now this is the 22nd year in a row Zagat picked us as the top steak house in New York.

These days we are doing some new work on the restaurant, which was built in the late 1800s, but still keeping the old feel to it. People don't want to see changes here. They love the classic feel of the place. We work hard to keep it the same. When we first got the place it had no air conditioning. It was a fight to put in air conditioning. The menu has hardly changed as well. There has always been steak and potatoes, onions and tomatoes, lamb chops, and a daily special. If you wanted dessert, the waiter used to run outside to the candy store, buy a Mrs. Wagner's Pie, and put it on a green dish with a big slice of cheddar cheese on it. The customers and the waiters used to bring in empty glass jars so that we could fill them up with the sauce.

When my father took over there wasn't even a scale to weigh the meat. Peter Luger always said if you trust somebody, you trust somebody. A week after we put the scale in, the meat guy went out of business because he was just killing us.

This place is simple—we are not pretentious. We give people the best possible steak dinner you can have in huge quantities at a reasonable price. Peter Luger's is a real place as compared to some of the baloney you get in Manhattan."

Photographed in Williamsburg

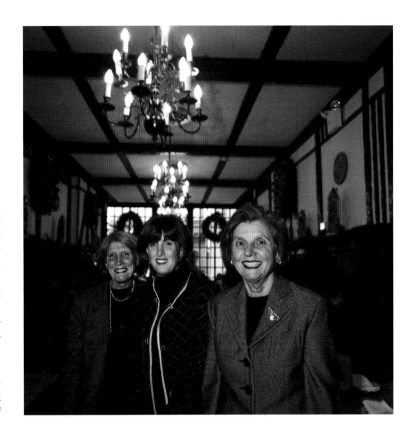

Christoph M. Kimmich, 66: President of Brooklyn College

"Brooklyn College is Brooklyn's college—having the name of the borough in its name is a source of great pride. Its students, most of who come from Brooklyn, are immigrants or the children of immigrants and as such are representative of what has characterized the borough from the beginning—talent, smarts, ambition, motivation, and hard work.

You want to know something that many people don't know about Brooklyn College? Until the 1930s, when the City purchased the site on which the campus was built, the grounds served as the annual staging area for the big-top shows of Ringling Brothers and Barnum and Bailey."

Photographed in Flatbush

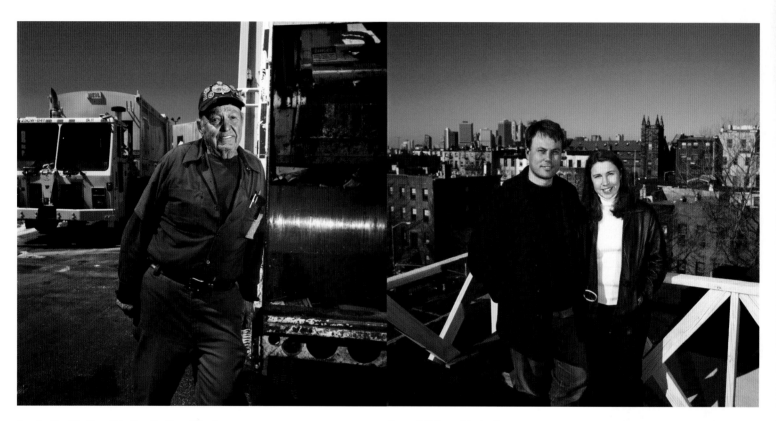

Louis Gagliotto, 77: Sanitation Worker

"In my era—and this is my era, not your era—kids in Brooklyn had respect. They went to school. There was no hanging around on corners. And if you did something bad they'd tell your mother and father and you would go hide under the bed.

I've been doing this job for 51 years, riding on the back of that truck. It's kept me young. I clean my route everyday and the people here treat me nice. They are all good people. When I stop doing this, that's when I die."

Photographed in Bath Beach

Greg Atkins, 36; Julie Atkins, 26: Chief Of Staff to Brooklyn Borough President; Account Executive

Greg: "Brooklyn accepts not only immigrants, but people like myself and Julie from Boston and Oklahoma. Brooklyn has the character and the characters. It is the American Dream."

Photographed in Carroll Gardens

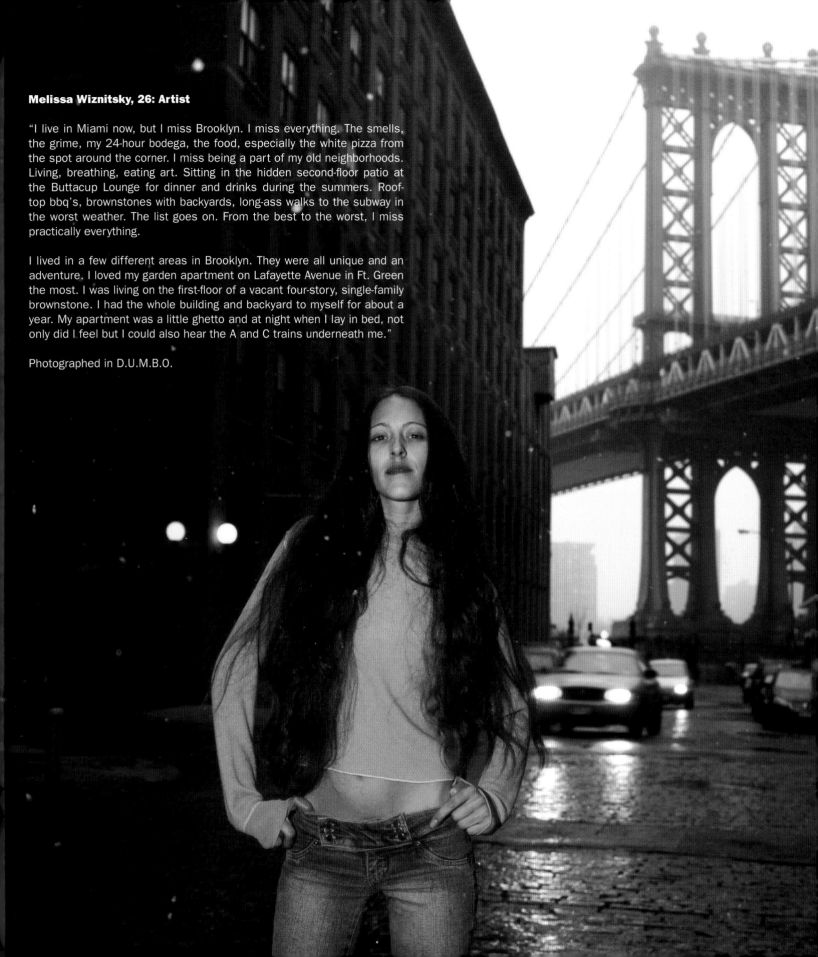

Melissa Wiznitsky, 26: Artist

"I live in Miami now, but I miss Brooklyn. I miss everything. The smells, the grime, my 24-hour bodega, the food, especially the white pizza from the spot around the corner. I miss being a part of my old neighborhoods. Living, breathing, eating art. Sitting in the hidden second-floor patio at the Buttacup Lounge for dinner and drinks during the summers. Rooftop bbq's, brownstones with backyards, long-ass walks to the subway in the worst weather. The list goes on. From the best to the worst, I miss practically everything.

I lived in a few different areas in Brooklyn. They were all unique and an adventure. I loved my garden apartment on Lafayette Avenue in Ft. Green the most. I was living on the first-floor of a vacant four-story, single-family brownstone. I had the whole building and backyard to myself for about a year. My apartment was a little ghetto and at night when I lay in bed, not only did I feel but I could also hear the A and C trains underneath me."

Photographed in D.U.M.B.O.

Ken Taylor, 54: Vice President and Director of Operations, Green-Wood Cemetery

"I grew up in Brooklyn a few blocks from the cemetery. When we were kids we used to play in here. Back in those days we would slide through the fence and sit inside.

I've been working here 38 years. I started as a high school kid cutting grass. Basically I oversee the entire operation and I actually live on the cemetery grounds in a house that was built in 1876. It's not weird to me but it's weird to friends and acquaintances. And you have a hell of a time getting a pizza delivered to my house. If I call and tell them the address, they say, 'yeah sure.' We still actually maintain two other residences on the property.

The cemetery was first created in 1838. The first burial was in 1840. Since then it has become the place to be buried. Even more than that, during the 1800s this was the second-most popular tourist attraction in New York State—Niagara Falls being the first. When it was designed and built in 1838, Green-Wood was the first major planned landscape. This was before there were any city parks. Thousands of people would come out here just to tour on a Saturday afternoon. It became so popular that they decided they needed something like this in Manhattan. Green-Wood was the forerunner to Central Park. People came here and still come here from all over the world. Some of the luminaries of the 1800s are here: Peter Cooper, Samuel Moss, Elias Howe, many inventors. And of course Charlie Ebbets, Peter Tilyou, Leonard Bernstein, Boss Tweed, the list goes on and on.

Every religion under the sun is represented here. Christians, Jews, Buddhists, everyone. And we are still an active cemetery. We still have land, we are still selling plots, and we've got one of the most modern crematoriums in the country. On an average year we do about 1,500 burials and 2,000 cremations.

My favorite place in the cemetery is probably Battle Hill. Not only does it have a lot of history, but it also has a beautiful view of the harbor, the Statue of Liberty, and the New York skyline. We have a statue of Minerva dedicated to freedom that stares out at the Statue of Liberty. The two of them gazing at each other and the Statue of Liberty facing these hills of Brooklyn where all that blood was spilled during the Revolutionary War."

Photographed in the Green-Wood Cemetery

Shige Moriya, 38: Video Artist and Founder of the Cave Gallery (*opposite*)

"I grew up in the countryside of Japan and came to New York 13 years ago. I wanted to create a community for art and artists. In Japan there are really no art communities. And after the economic bubble burst in Japan years ago, there was no money for art. So I decided to move here and learn how artists survive in this town.

When I first got to Williamsburg everything was completely different. If you saw a parked car it was burned. For real. Also there were no people at nighttime. If you saw a person at night in the street they were probably a prostitute or people who wanted a prostitute. I thought that the neighborhood would grow a little bit, but not like this.

In the beginning lots of artists and people would stop by here and sleep here for three days or three months on the couch. I liked the way we didn't lock the door when I first moved here. If you were a friend, at that time, I gave them a key so they could come in anytime. Now I don't do that anymore because my girlfriend says no more."

Photographed in the Cave Gallery in Williamsburg

Is there any better Brooklyn morning to try on than the loose fabric of an early Sunday morning?

In the tender time before movement. Within the acoustic shadows of city-sound.
Among the brewing twitch of locked eyes and the ferment of final dreams.
Between the clicking dialogue of "Don't Walk" signs.
Beneath the dying slip-glow halos of timed electric streetlamp.
Before the throwing of the breathing switch.

And on this Sunday morning, the quietest of mornings, we have woken to the season's first snow. With the hush of a billion pins puncturing the bloated sky, a frozen sea arrives patiently through the glow of a crimson overnight. A drawn-out sigh concealing the world.

And if just for a morning, the quietest of mornings, Brooklyn is the most innocent place on earth.

It is on this day, wearing this Sunday skin, that we are visiting the dead.

Making our way to the Green-Wood Cemetery, where the famous came to lie, we leave behind the arctic streets and faces sipping from Greek-style coffee cups and enter through gothic gates deserving of kings. What we find behind the entrance is a landscape one can hardly associate with the word *city*.

We tread into a heaving bedspread of uncracked white, stepping across hills carved eras ago by moving ice. A forest of curled trees have shed the last leaves of autumn—misplaced chandelier jewels. Lakes appear at various turns, the water half frozen. In total, 478 acres of dirt, flora, and liquid.

All this life for the lifeless.

A director of Green-Wood leads us through this final destination for the renowned. Nearly 600,000 souls have arrived since 1838. There is no apparent order to this place. The headstones are not like you would imagine—arranged in rows perfectly organized, like lines of children on a class trip. Instead we find a chaotic maze of marble highlights

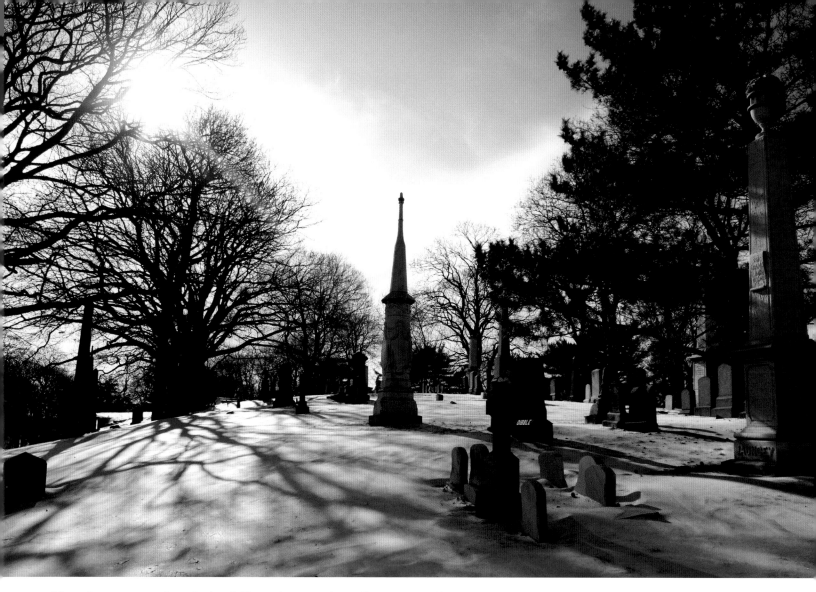

positioned to accommodate the land. Through a search we discover the famous names: Leonard Bernstein, Jean Michel Basquiat, Henry Ward Beecher, De Witt Clinton, Charles Ebbets, Frank Morgan, Boss Tweed. Mixed between are markers for people whose creations have gained more fame than their creators. The inventor of the soda fountain. The creator of the paper clip. I begin to speculate if this is where the literary characters of Brooklyn have ended their journeys as well. Will we stumble unwittingly across the graves of Tralala or Augie Wren or Francie Nolan?

On our way through we pass a family of Chinese gathered around a box of fire. They are here for an early celebration of the festival of Ching Ming—cleaning their ancestor's grave, burning incense to ward off spirits, lighting fire to fake money so that it can be used by the deceased. The flame and the presence of humans are jolting in this panorama of clear stillness.

We watch them and surrender. Our sins forgiven. The calm undertow sinking us as we listen for whispers of a Brooklyn elapsed.

"Do you believe in ghosts?" I ask the director.

"Absolutely," he responds without hesitation. "But there are no ghosts here. I grew up in a haunted house. It wasn't a bad spirit, but we knew it was there. But here I have never seen or felt anything."

Moving further we climb a series of hills shaped like the soft curves of an eyelid closed. We reach a peak, the highest in Brooklyn, that looks out towards the harbor. There sits a memorial to the fallen soldiers of the Revolutionary War and a statue of Minerva commemorating the Battle of Brooklyn. Across the waterfront the copper lady holding a book and a torch looks in through the mist of drifting snow.

We can see outside the gates that the city, in fits and starts, has shuddered to life. The Brooklynites have reluctantly hauled their tired, cold remains out from beneath heaps of blankets. The snow is being pushed aside and snuffed; the corruption of innocence through shovels and spades. On this hill, even surrounded by all this death, it's heartrending to imagine an exit from here—to contemplate leaving this serene place. This gap in the hustle of a city. This land of eternal Sunday mornings.

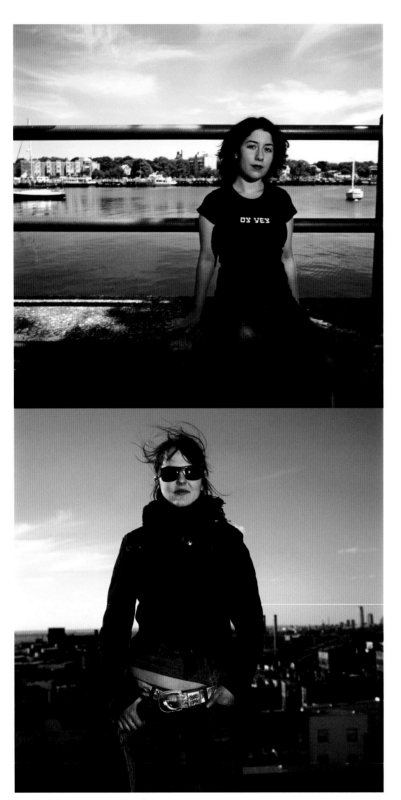

Sara Schwimmer, 29: Founder of Chosencouture.com

"I often joke that I was from Brooklyn before it was cool. I remember visiting colleges when I was in high school, and when the tour guides asked where I was from, they would always shoot me a look as if I was packing heat when I said I was from Brooklyn! Now when I mention that I'm from Brooklyn, people are really impressed. It's amazing how much Brooklyn's image has changed.

Most people, even those from Brooklyn, have never heard of Manhattan Beach. Because it is a peninsula, it has the feel of a private, gated community even though it isn't. I grew up just three blocks from the beach and two blocks from the bay. My grandfather, who was a builder, built the home I grew up in and many others in this neighborhood. Because of that I have a really deep attachment to this place."

Photographed in Manhattan Beach

Miana Grafals, 31: Photographer and Video Artist (*opposite*)

"I love living in a place where there is always something new to discover. Finding the unexpected makes me feel alive and connected and I am always running into unexpected things here. Take this place for instance. Who would ever imagine that you could be standing in Brooklyn on the seashore surrounded by thousands of snow-covered mussel shells? Knowing that exactly ten minutes from this location I can grab a slice of the world's greatest pizza makes my world even more complete.

When I first moved into Brooklyn I was awoken in the middle of the night by a bird singing very loudly near my bedroom window. This bird's song went on extensively for at least an hour. Words cannot describe this odd yet enchanting song. I had never heard any other bird that gave a song like the one I heard at 3 AM that morning. What kind of bird is up at three in the morning?! A Brooklyn bird. I can only say that I honestly believe it was Brooklyn's way of welcoming me home."

Photographed in the Jamaica Bay Wildlife Refuge in Canarsie

Yelena Jouravlev, 22: Student

"The people here are more intense, more genuine, more everything. They are working class people who are rough around the edges. I just don't know where else I would ever go."

Photographed in Park Slope

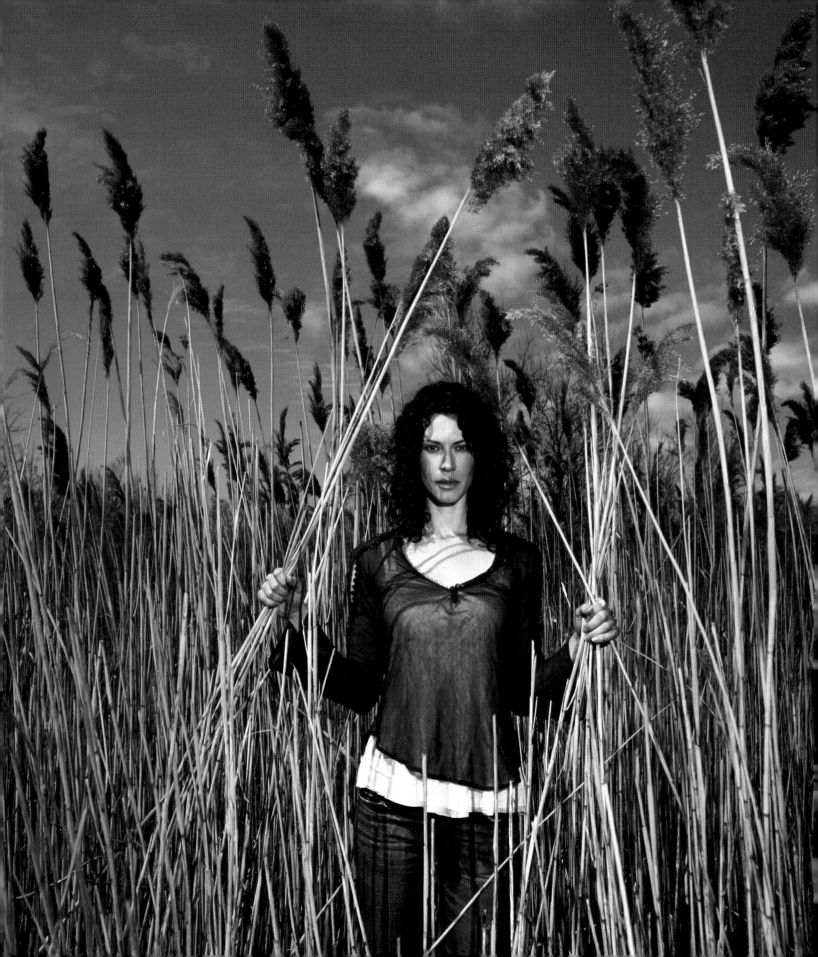

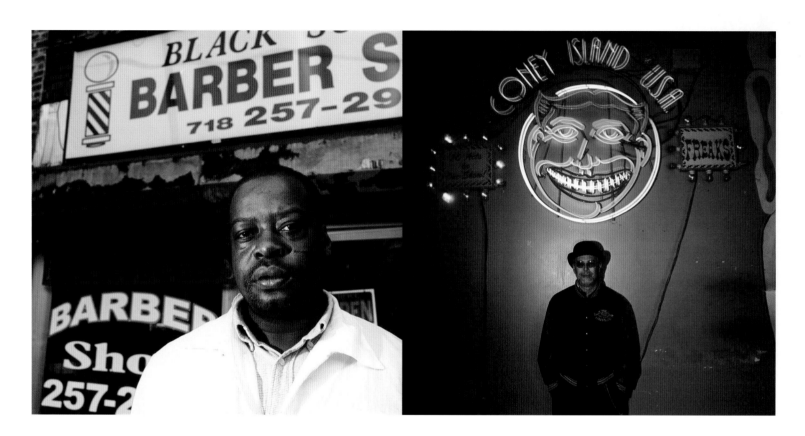

Antonio Fields, 41: Barbershop Owner

"I grew up in Crown Height and Brownsville. I own this shop—I've owned it for 16 years. I worked for a barber across the street and that went out of business, so I opened this shop right here. I have practically raised some of the kids in this neighborhood. Some of the kids whose hair I used to cut, now their kids are here sitting in the same highchair.

What makes Brooklyn different from other places? The attitudes. People have that attitude here. People are a little tougher coming from here."

Photographed in East New York

Dick Zigun, 51: Director of Coney Island Freak Show

"When I came to New York with two degrees in theater I didn't go to Broadway, I came to Coney Island. A lot of people saw this place as a paradise doomed—a place from their childhood that burned to the ground. I had no personal sorrow connected to this place. I had more objective eyes. I saw Coney Island as a staging ground, something we could turn into the National Center of Americano Bizarro. A place of culture and influence. I was probably half brave and half stupid."

Photographed in Coney Island

Josh Martin, 25: Worker at McSweeney's Brooklyn Superhero Supply Co.

"All of Brooklyn is a neighborhood. All of Brooklyn is a community."

Photographed in Park Slope

Mike DeBernardo, 44; "Little Girl," 12: Dyker Heights Resident

"You guys want some wine? I've been out here forever. I hate these lights—one goes out and the rest follow. But I love the neighborhood. This neighborhood only gets better. I wake up on a Sunday, I walk to 13th Avenue to get a bagel, I don't need a car. What more do I need?"

Photographed in Dyker Heights

Louise Ciminieri (No age given): Owner of Totonno's Pizzeria

"There are lots of other places to go, but there really is no place like Brooklyn. You can leave here but you usually end up going nuts when you do. My son went to live in Las Vegas for a while and he just wasn't happy and didn't know why. It was because he was homesick. People just miss this place.

We've had this pizzeria for 81 years. My grandparents and my family used to live in the back apartment in this place. And trust me on this one—they are still here. They are still here.

You wanna know the second best pizza place in New York? My other locations."

Photographed in Coney Island

Mazouza Tayeh, 20: Student

"I was born in New York and my family is from Israel. My family came here because America is the thing. I live in Sunset Park. I like the houses and the neighbors, because they watched me grow up.

Recently my family was having a barbeque and my brother's best friend came by after he was stabbed with a screwdriver, five times. It was really scary and my mom was drenched in his blood. It was the first time I'd ever seen anything like that in my neighborhood, and now I look at it differently.

My husband is coming here soon from Jordan. He's never been to America and I'm bringing him to Brooklyn. I think he'll think it's dangerous here, but I want to stay here so I'll try to convince him to stay. If he sees the bloodstains from my brother's friend, he'll think, 'Oh my God, I don't want to live here.' I want to introduce him to Brooklyn and show him what we have."

Photographed in Abraham Lincoln High School in Coney Island

Tim McLoughlin, 46; Johnny Temple, 38: Writer; Publisher of the "Brooklyn Noir" Series

Tim: "I don't know anything else and I still don't. The only time I've spent outside of Brooklyn was six weeks in Europe in 1976. And when I was there I was terrified at what I might miss and that everything might change while I was gone. My fears were realized when I came back and beer and soda cans changed. They used to have a pull-tab where the ring and oval tab actually separated from the can. When I returned they had switched to the top we have now where the cutout is forced down and stays attached. Probably done to reduce litter, since the old pull-tabs were always all over the streets.

I used to know this guy I lived near that was 72 years old and had never even been to Manhattan. I asked him why one day and he said "What for?"

Brooklyn was the first true suburb of Manhattan, and I think in a way that caused people here to grow up with a sense of longing. I think there were angst-ridden kids here back in 1780."

Johnny: "This neighborhood has the cultural heart that I was interested in when I started a publishing company. It's a diverse neighborhood that is a fountain of cultural activity and a place with a literary legacy. Spike Lee is around here, Richard Wright wrote *Native Son* in Fort Greene Park, the Marsalis brothers were from around here. Rosie Perez. Fort Greene, and Brooklyn in general, is simply a quirky, idiosyncratic, eclectic place—something that I think we capture in the 'Brooklyn Noir' series. It is an incubator for creators. And plus there are so many fucking weird people here. And they only get weirder. It is a land of characters."

Photographed in Prospect Heights/Fort Greene

Jonathan Ames, 40: Author

"When I walk down to the waterfront of Brooklyn, I am always struck anew. The water views are amazing. This place is quieter than Manhattan, there is slightly less vibration here. There is everything you could ever want here yet it still has some places that remain undiscovered."

Photographed in Boerum Hill

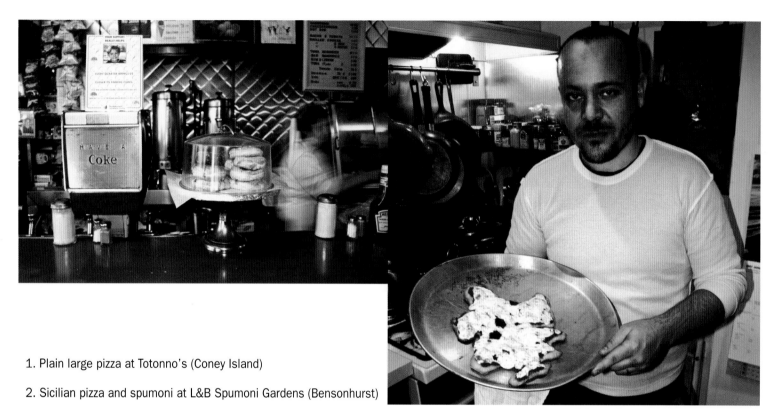

1. Plain large pizza at Totonno's (Coney Island)

2. Sicilian pizza and spumoni at L&B Spumoni Gardens (Bensonhurst)

3. Sausage and peppers hero, brociole hero and zeppoles at the 18th Avenue Feast (Bensonhurst)

4. Hamburger and cheese fries at Roll-n-Roaster (Sheepshead Bay)

5. Spanish/Chinese cuisine at Corona Restaurant (Sunset Park)

6. Cuchifrittos at La Marqueta Food Market (Williamsburg)

7. Hot dogs and cheese fries at Nathan's (Coney Island)

8. Cheesecake from Junior's (Flatbush)

9. Falafel and hummus at Sahara (Midwood)

10. Uncle Louie G's Ices (Park Slope)

11. Grandmama pizza at Nino's (Bay Ridge)

12. Ice Cream at the Brooklyn Ice Cream Factory (Brooklyn Heights)

13. Thai cuisine at Sea (Williamsburg)

14. Sweet plantains and chicken burrito at Bonita's Mexican restaurant (Williamsburg)

15. Turkey Burger at The Divine Artiste Café (Bedford-Stuyvesant)

16. Sushi at NaNa (Park Slope)

17. Chocolate and cherry ices at Keyspan Park (Coney Island)

18. Vanilla egg cream at Maple Lanes Bowling Alley (Bensonhurst)

beverages consumed on this journey:

19. Raw clams at Randazzo's (Sheepshead Bay)

20. Everything bagel and cream cheese at Bruce's Bagels (Flatlands)

21. Chicken parmesan hero at John's Deli (Bensonhurst)

22. Swirl cone from Mr. Softee (86th Street corner in Bensonhurst)

23. Coffee, peanut butter, and dark chocolate bars at Jacques Torres Chocolates (D.U.M.B.O.)

24. Porterhouse for two at Peter Luger (Williamsburg)

25. Two slices at Smiling Pizzeria (Park Slope)

26. Beers—Bar Rope, Abiline, Pourhouse, Farrell's, Kelly's Tavern, Ruby's Old Thyme Tavern, Sunny's (various neighborhoods)

27. Two glasses of rosé wine (Brooklyn Navy Yard)

28. Four slices at DiFara's Pizzeria (Midwood)

29. Key lime pie at Steve's Authentic Key Lime Pie (Red Hook)

30. Turkey sandwiches, french fries, and macoroni salad at Mill Basin Kosher Deli (Mill Basin)

31. Jarred peaches from the Kriegel backyard (Midwood)

32. Brooklyn-shaped pizza from John D'Aponte's kitchen (Park Slope)

33. Fox's U-Bet Syrup (Brownsville)

34. Chocolate egg cream and glazed donut at B's (Greenpoint)

ACKNOWLEDGMENTS

This project and this book could never have been realized without the help of dozens of people who assisted us in the process of attaining subjects, promoting this endeavor, and navigating this vast place we call Brooklyn:

Atif Ahmad, Emily Prawda-Weiss, Linda Cantor, Reinhardt Hartzenberg, Yana Toyber, Stella and Michael Toyber, Amy Sohn, Yelena Jouravlev, R.A. The Rugged Man, Orion Ray Jones, Marlon and Vanessa Gonzalez, Pete Miser, Mary Record, Danny Simmons, Marty Markowitz, Shayna Kulick, Justin Kaflowitz, Liz Willen, Jason Lampkin, Garnett Thompson, Paul Auster and Siri Hustvedt, Kathryn Frazier, Rina Ortega, Deb Ham, Kenan Juska, Jonathan Ames, Frank Tuccillo, Aaron Bisman, Michael Hearst, Joshua Camp, Nora Yeung, Oi Pin Chan, Fran Hackett, Johnny Temple and Kara Gillmour, Linda Kushner, Michael Corrente, Steve Schirippa, Ryan Monihan, Ron Scalzo, Anthony Scire, George Kalinsky, Annmarie Modugno, Clara Kim, Rebecca James, Lorin and Lara Wiener, Saxon Eldridge, Kara Van Abeele, Lisa Moran, Gene Breseler, Rashida Wallace, Sami Hajar, Steven and Alicia Costas, Taj Reid, Jake Dobkin, Shepard Fairly, Simon Steinhardt, Roger Gastman, Vanessa Hidary, Josh Neuman, Gabrielle Sierra, Liz Koch, Kathryn Hilbert, Michael Variano, Jason Roth, Paul Hanley, Edward Pachetti, Dave Campanaro, Robin Insley, Kimberly Hill, Eva Chien, Shannon O'Keefe, Jeanine Fijol, Theresa O'Rourke, Paul Moakley, John D'Aponte, Veronica Gretton.

Rosie Perez's hair by Nadia Vassell and makeup by Juanita Diaz.

Special thanks go to Kellie McLaughlin and everyone at Retna.

Special thanks also go to Sara Rosen, Craig Cohen, Daniel Power and everyone at powerHouse.

Very special thanks go to Greg Atkins for his hours of endless help, Jane Helmick for a wonderful website, Carlos Molina for his help finalizing the book and for the author photos, Jason Smollar for legal advice, Terence Winter for his preface, Howard Wallach for his guidance through the years, Miana Grafals for her help and video work, Terra Kushner for her assistance, and the LaSala and Kushner families.

And thank you to the hundreds of people that took part in this project. We couldn't have done this without you. Brooklyn!

Anthony LaSala is a senior editor at *Photo District News* magazine and has freelanced for a host of other publications including *Time Out New York*, *Billboard*, *Yankee Magazine*, *Sights*, and *TV Guide*. LaSala also edited the book, *The World's Top Photographers: Nudes*, published by RotoVision. LaSala was nominated as photo editor of the year by the International Photography Awards in 2003 and 2004. He is a curator at the Alice Austen House in Staten Island, New York.

Seth Kushner is a freelance photographer and has worked for a large variety of clients including *The New York Times Magazine*, *Time*, *Newsweek*, *Vibe*, *YRB Magzine*, and *Business 2.0*. Kushner was chosen by *Photo District News* magazine as one of their "30 Under 30" in 1999 and was a winner in their Photo Annual Competition in 2002 and 2006. Kushner's work is sydicated by Retna Ltd.

www.sethkushner.com

Both writer and photographer were born in Brooklyn and currently reside there.

Terence Winter was one of the writers and executive producers of *The Sopranos*, which recently completed it's last season of production. In 2001, together with Tim Van Patten (shared story), Winter won both the Writers Guild Award and The Edgar Award for his episode "Pine Barrens," directed by Steve Buscemi. In 2004 Winter won two Emmy Awards, one as executive producer of *The Sopranos* for Outstanding Drama Series and one for Writing in a Drama Series for his episode "Long Term Parking." In 2006, he again took home the writing Emmy, this time for his episode "Members Only." Before joining *The Sopranos*, Winter wrote and produced an eclectic group of shows, including *The Great Defender*, *The Cosby Mysteries*, *Xena: Warrior Princess*, *Sister, Sister*, *Soldier of Fortune*, *Diresta*, and *Eddie Murphy's The PJs*. His first feature film, *Get Rich or Die Tryin'*, starring 50 Cent and directed by Academy Award nominee Jim Sheridan, opened in November 2005. His next film, *Brooklyn Rules*, starring Alec Baldwin and Freddie Prinze Jr., is scheduled to be released in 2007. A native of Brooklyn, Winter received a BA from New York University and a JD from St. John's University School of Law.